From Drawing to Painting

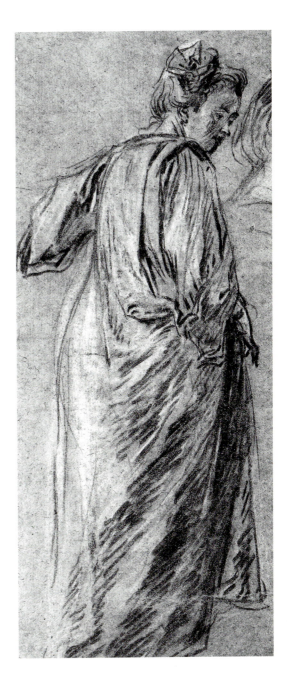

From Drawing to Painting

Poussin, Watteau, Fragonard, David & Ingres

Pierre Rosenberg

The A. W. Mellon Lectures in the Fine Arts, 1996

The National Gallery of Art, Washington, D.C.

Bollingen Series XXXV:47

PRINCETON UNIVERSITY PRESS

Princeton, New Jersey

HALF-TITLE: Antoine Watteau, *Back View of a Woman Standing, Turned to the Right, and Leaning Forward; Study of Her Head,* c. 1716 (detail of fig. 96)

TITLE PAGE: Antoine Watteau, *Peaceful Love,* 1718 (fig. 97)

COPYRIGHT/CONTENTS PAGES: Jean-Auguste-Dominique Ingres, *View of the Villa Medici,* 1807 (detail of fig. 150)

PAGE 1: Nicolas Poussin, *The Massacre of the Innocents,* c. 1628 (detail of fig. 59)

Published by Princeton University Press
41 William Street, Princeton, New Jersey 08540

In the United Kingdom: Princeton University Press, Chichester, West Sussex

This is the forty-seventh volume of the A. W. Mellon Lectures in the Fine Arts, which are delivered annually at the National Gallery of Art, Washington. The volumes of lectures constitute Number XXXV in the Bollingen Series, sponsored by the Bollingen Foundation.

Designed by Susan Marsh
Composed in Adobe Garamond by DIX!
Printed in Hong Kong

10 9 8 7 6 5 4 3 2 1

Library of Congress Cataloging-in-Publication Data

Rosenberg, Pierre.
 From drawing to painting : Poussin, Watteau, Fragonard, David, and Ingres / Pierre Rosenberg.
 p. cm. — (A. W. Mellon lectures in the fine arts ; 1996)
 (Bollingen series ; XXXV, 47)
 Includes bibliographical references and index.
 ISBN 0-691-00918-x (alk. paper)
 1. Drawing, French. 2. Drawing—17th century—France. 3. Drawing—18th century—France. 4. Drawing—19th century—France. 5. Painting, French. 6. Painting, Modern—17th–18th centuries—France. 7. Painting, Modern—19th century—France. I. Title. II. Series. III. Series: Bollingen series ; XXXV, 47

NC246 .R673 2000
741'.092'244—dc21 99-088620

Contents

Preface

WHEN I WAS HONORED with an invitation to deliver the A. W. Mellon Lectures, I immediately began to worry: What on earth would I talk about?

Then it occurred to me that few art historians have given equal consideration to painting and drawing. I had undertaken, in collaboration with Louis-Antoine Prat, to write the catalogues raisonnés of the drawings of five of the greatest French artists: Poussin, Watteau, Fragonard, David, and Ingres. I thought it would be interesting to compare and contrast their drawings with their paintings. With the help of these exemplary artists, whose work I felt I knew well, I sought above all to understand the role they assigned to drawing and how their drawings enabled us to gain insight into their creative processes, the better to exploit it. I was fully aware of the ambitious scope of the project.

I gave my lectures at the National Gallery of Art, Washington, D.C., in English, as is customary, on 14, 21, and 28 April and 5, 12, and 19 May 1996. For the present volume, I retained the original structure. However, I have altered the illustrations and adapted material originally presented in a public forum to the written form. And, of course, I have added notes to the text.

Few French people have been called on to deliver the Mellon Lectures. André Chastel, in 1977, dedicated his discourses to the sack of Rome. In 1955 Etienne Gilson had dealt with a particularly thorny issue: art and reality. I mention, purely out of vanity, that Gilson's successor to the twenty-third seat of the Académie française, Henri Gouhier, was my predecessor of the same seat.

I must add that I was not the first Rosenberg to deliver the Mellon Lectures. My illustrious homonym, Jakob Rosenberg, enjoyed that privilege in 1964. He took as his topic a basic problem with no obvious solution, on quality in art.

I am left with the agreeable task of thanking all those who have assisted me in the editing and publishing of these Mellon Lectures, above all Véronique Damian and Benjamin Peronnet in Paris, Henry Millon and Therese O'Malley at the National Gallery of Art, and Patricia Fidler, Curtis Scott, and Kate Zanzucchi at Princeton University Press.

I cannot fail to mention, in the United States: Joseph Baillio, Keith Christiansen, Alvin L. Clark, Isabelle Dervaux, Anne d'Harnoncourt, Suzanne Folds McCullagh, George Goldner, Kathleen Lane, Edgar Munhall, Joseph Rishel, Marion C. Stewart, Nicholas Turner; and in Europe: Avigdor Arikha, Maryse Bertrand, T. P. Besterman, Arnauld and Barbara Brejon de Lavergnée, Emmanuelle Brugerolles, Ulf Cederlöf, Michael Clarke, Ghislaine Courtet, Philippe Durey, Mathias Frehner, Marie-Christine Grasse, Rosamund Griffin, Diane Hudson, Sophie Jugie, Alastair Laing, Patrick Le Mouëne, Annie Madec, Josette Meyssard, Véronique Moreau, Hélène Moulin, Hans Naef, Anna Ottani Cavina, Louis-Antoine Prat, Patrick Ramade, Marie-France Ramspacher, Agnès Reboul, Laurent Salomé, Jacques Santrot, Dominique Sauvegrain, Antoine Schnapper, David Scrase, Arlette Sérullaz, Margret Stuffmann, Daniel Ternois, Maria van Berge-Gerbaud, Christine van Wersch-Cot, Georges Vigne, Jon L. Whiteley.

I would like to emphasize that the subject I have chosen to tackle, it is well understood, is enormous. To my great disappointment, I was unable to explore all of its aspects, as will soon become clear. Further, the problems that I have raised, unfortunately, cannot be fully elaborated without even more illustrations than the generous number included here.

Introduction

ALL MY LIFE I have harbored twin passions for painting and drawing. One might think such a double interest is common. In fact, surprising as it may be, that is not at all the case. Specialists in the field of drawing are rarely interested in painting, and vice versa. In every country one finds that the two fields remain distinct. In most museums, departments of drawings and paintings are separate. In some countries, drawings are combined with prints (as in the British Museum) within an all-inclusive museum that is also—or has been—a library. Sometimes one location is exclusively devoted to drawings and prints (such as in the Albertina in Vienna). This division between painting and drawing, which has historical explanations, is not only arbitrary and artificial but also rests on a serious misunderstanding of the creative reality. Worse, it has been said that there is no (or very little) connection between the two fields, between two disciplines that should be autonomous, not to say independent. In sum, specialists in both drawing and painting, who address as many drawings as they do paintings, who demonstrate equal interest in drawings and paintings, are rare and have always been so. (I mention as an example, with no intention to compare myself with him, Bernard Berenson.)

How did the five artists named in the title come to be selected for this book? I have undertaken, in collaboration with Louis-Antoine Prat, to write their catalogues raisonnés. Nicolas Poussin, Antoine Watteau, Jean-Honoré Fragonard, Jacques-Louis David, and Jean-Auguste-Dominique Ingres are among the greatest of French draftsmen. The catalogue raisonné of Poussin's drawings appeared at the end of 1994, that of Watteau's drawings at the end of 1996. The rest will follow in this order: David (in 2000), Ingres, and Fragonard (or Fragonard before Ingres).

Why catalogues raisonnés? The *catalogue raisonné*, a term used in French and in many other languages, organizes the complete list of an artist's works. It entails studying these creations in close detail, with the most scrupulous attention; attempting to track down these works in museums or private collections, in auction houses or galleries—often a difficult task; examining all the documents related to these works or that bring us closer to them, going through archives and written evidence,

sale catalogues, museum and exhibition catalogues, photographic documentation, artistic and private correspondence. Finally, it requires *seeing* the artist's works and, above all, knowing how to distinguish the genuine from the fake (or, more precisely, from the wrongly attributed). It demands, in other words, becoming completely familiar with an artist, penetrating his inner world, the better to know him, and striving constantly to understand him better, to give him life.

Why these five artists? For two reasons, both of a practical nature: either catalogues raisonnés of the drawings did not exist (David, Ingres), or, if they did, they were outdated and impossible to find in bookstores. Moreover, the previous catalogues raisonnés for Poussin, Watteau, and Fragonard arranged their drawings by theme, whereas Louis-Antoine Prat and I made the decision, ambitious and difficult but to our minds essential and indispensable, to propose a date for each of the sheets we catalogued and present them in chronological order.

A third reason, which leads me back to my own experience, legitimates the choice of these five artists: throughout my career I have often studied the paintings of these great artists. My first exhibition, in Rouen in 1961, was called *Poussin et son temps* (Poussin and his time). I wrote the catalogue entries of Watteau's paintings for the large monographic retrospective in Washington, Paris, and Berlin in 1984–85, as well as the exhibition catalogue for *Fragonard*, held in Paris and New York in 1987–88, and I published a catalogue raisonné of Fragonard's paintings. To my regret, I have published less on David and, especially, on Ingres, but I have always deeply prized their work and have examined it, whether drawn or painted, with the closest attention.

One might still ask, Why these five names rather than Jean-Siméon Chardin, François Boucher, Eugène Delacroix, or Edgar Degas, to limit the field to France and to those artists who have not yet become the subject of a catalogue raisonné? Once again, my answer may prove disappointing. Chardin, whose work I dearly cherish and on whom I have often written—I admit preferring him from time to time to Poussin—made scarcely any drawings, and these were often not very good, with the exception of the wonderful pastels from the last years of his life.

Boucher, on the other hand, was prolific. I have studied his early drawings and paintings, but I had no desire to devote several years of my life to him. Delacroix, I confess, does not inspire me. I acknowledge his genius but it holds no attraction for me, and I do not understand him well (can we understand what we do not really appreciate?). As to Degas, another pure genius, a team of art historians has decided to tackle the catalogue raisonné I would have been unable to write. Ultimately, I chose these five artists simply because I love their works. Had I attempted to deal with all painter/draftsmen, regardless of nationality and period, instead of limiting myself to these five names, I would have

had to make do with generalities and commonplaces, which would have compromised the results of my investigation.

Why the title *From Drawing to Painting*? I have undertaken to study the drawings of these five artists and their links (or lack thereof) to their paintings. How, why, and for whom did they draw? What status did they confer on their drawings, and what role did they play? How, and thanks to whom, did these drawings come down to us? How do these drawings lead us to a closer understanding of the artists' intentions, their creative processes, to a deeper sounding of their universe? These are some of the questions I asked myself and that I set for myself to resolve, without aspiring to define the genius of these artists—a truly impossible task.

I had first thought of devoting a lecture to each of my five heroes— my five victims! I abandoned that idea. I thought it would work well, instead, to compare them in each chapter of this book. These comparisons and contrasts should bring to light and clarify elements that might not emerge from the separate study of each artist.

A final word: I say little about the theory of drawing, and I do not tackle questions of aesthetic philosophy related to the drawings. I do not offer general abstract bases. Ideas and concepts find little purchase in my lectures. My goal is to stay *as close as possible* to the works themselves. I reproduce as many as I can, and I illustrate the related contemporary pieces that I cite—all in effort to remain *"visual."* It is the direct contact with the paintings and the drawings, their daily practice, to which I would like to bear witness.

Chapter 1 Five Exceptional Artists

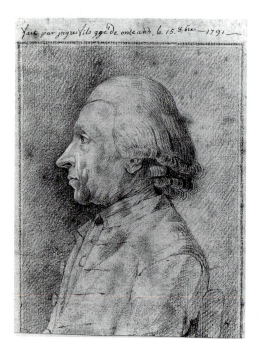

FIG. 1. Jean-Auguste-Dominique Ingres (1780–1867), *Portrait of Jean Moulet* (the artist's maternal grandfather), 1791. Red chalk on paper, 5⅜ x 4¼ in. (13.6 x 10.9 cm). Musée Ingres, Montauban

THE FIVE ARTISTS whom we will endeavor to serve call for an introduction. The earliest, Poussin, was born in 1594, and the one closest to our age, Ingres, less than two centuries later, in 1780. Ingres died in 1867 at the age of eighty-seven, 202 years after Poussin. Watteau lived a short life. Like Raphael and Vincent van Gogh, he died at the age of thirty-seven.

The five were born in France: Poussin in Les Andelys, Watteau in Valenciennes, Fragonard in Grasse, David in Paris, Ingres in Montauban. It should be noted that Valenciennes had been French territory for only a short period before Watteau's birth there in 1684 and that in the eighteenth century Grasse, where Fragonard was born in 1732, was barely a day's journey on foot from Savoie, which belonged to Italy. Two of the five artists died far from their native soil, both in more or less voluntary exile: David in Brussels in 1825 (not only had he voted in favor of putting Louis XVI to death when he was a deputy in the Convention nationale, but he also had supported Napoléon in 1815 after he returned from Elba) and Poussin in 1665 in Rome, which he considered his true home, openly preferring it to Paris (where Louis XIII and Richelieu, just before they died, tried to entice him). Watteau, Fragonard, and Ingres all died in Paris or its outskirts. Watteau, believing himself lost (it is likely that he suffered from tuberculosis or, according to old texts, an "ailment of the lungs"),[1] withdrew to Nogent-sur-Marne. None of these artists died in their place of birth and all, except Watteau, died between the ages of seventy-one (Poussin) and eighty-seven, a ripe old age for the period (very ripe, in Ingres's case).

France in 1867 did not have much in common with the country in 1594. It had been subject to a succession of different forms of government: royalty, several regencies, the Revolution, the Restoration, two more revolutions (1830 and 1848), two empires, two republics. In 1594 the country experienced a political crisis serious enough to put its future in jeopardy. In 1867 it could claim to be the foremost European power, rivaled only by England. Yet in 1594 Henri IV subdued Paris and soon ensured France the political stability that enabled it to replace Spain as the most powerful nation in Europe. In 1867 France stood at the brink

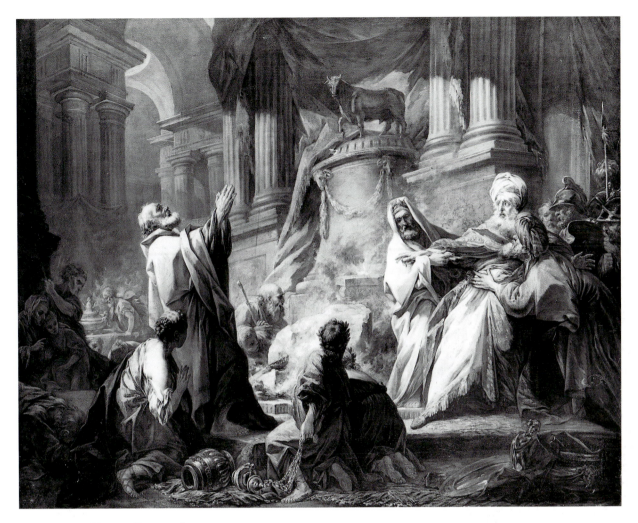

FIG. 2. Jean-Honoré Fragonard (1732–1806), *Jeroboam Sacrificing to the Idols,* 1752. Oil on canvas, 43⅞ x 56½ in. (111.5 x 143.5 cm). École Nationale Supérieure des Beaux-Arts, Paris

of the disastrous and humiliating Franco-Prussian War and the divisive Commune.

Poussin, Watteau, Fragonard, David, and Ingres all came from modest social backgrounds, an environment fairly well documented in the case of David and Ingres and poorly documented for Poussin, Watteau, and Fragonard. Little is known of their childhoods, except in the case of Ingres, whose precocity escaped no one (some drawings that he made at the age of eleven have been preserved; fig. 1).

A study of their training, on which there is either an abundance or a paucity of material, is essential. All five came to Paris while young and were molded in Paris and by Paris. The provinces they left behind—Normandy, Flanders, Provence—played only a secondary role. (Ingres's father, however, was a respectable artist who taught his son basic drawing skills.) The Académie royale de peinture et de sculpture loomed large in their artistic education. Fragonard, David, and Ingres all received what would later be called the Prix de Rome (figs. 2–4). Watteau, although not

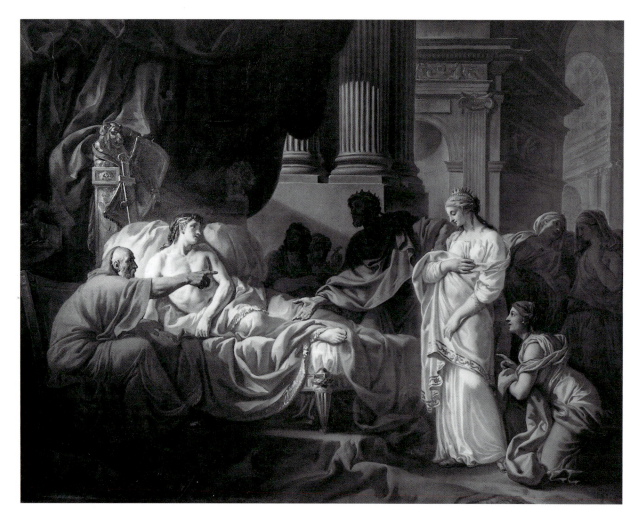

FIG. 3. Jacques-Louis David (1748–1825), *Antiochus and Stratonice,* 1774. Oil on canvas, 47¼ x 61 in. (120 x 155 cm). École Nationale Supérieure des Beaux-Arts, Paris

educated there, was accepted *(agréé),* and admitted *(reçu),* and, most important, recognized, as the Académie created an artistic category on his behalf, a new genre called the *fête galante* (fig. 5).[2]

The Académie royale de peinture et de sculpture was not established until 1648; Poussin could not have been a student there. The institution arose in the shadow of his tutelary spirit, and he remained the example and the symbol of an academy that he never knew. The teaching of drawing incontestably played a crucial role there.[3]

The second common element in their education is Italy: the Italy from which Poussin did not venture between 1624 and 1665, except for an unfortunate stay of nineteen months in Paris between 1640 and 1642; the Italy that Fragonard, David, and Ingres each visited twice. Fragonard lived in Rome between 1757 and 1761, as a *pensionnaire* of the Académie de France, located at the time in the Palazzo Mancini, then in 1773–74 as the guide for the fabulously wealthy *Fermier-général* Pierre-Jacques-Onésyme Bergeret de Grancourt (1715–1785). On his first journey, David stayed at the Académie de France from 1775 to 1780. In 1784–85 he

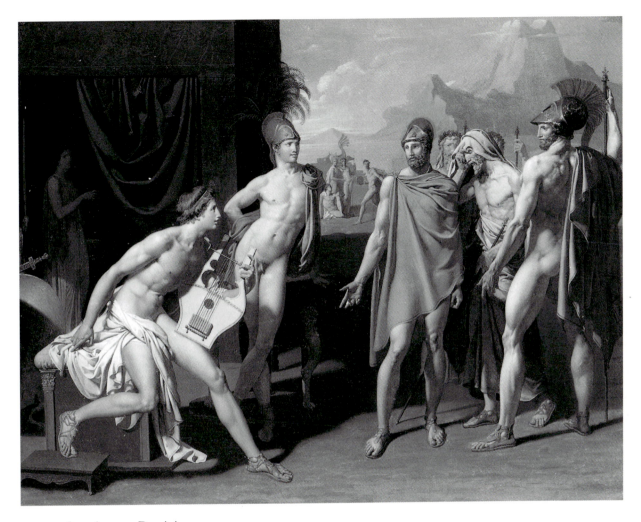

FIG. 4. Jean-Auguste-Dominique
Ingres, *The Ambassadors of
Agamemnon in the Tent of Achilles*,
1801. Oil on canvas, 43⅜ x 61 in.
(110 x 155 cm). École Nationale
Supérieure des Beaux-Arts, Paris

FIG. 5. Antoine Watteau
(1684–1721), *The Party of Four*, 1712.
Oil on canvas, 19½ x 24¾ in.
(49.5 x 63 cm). The Fine Arts
Museums of San Francisco,
Mildred Anna Williams Fund

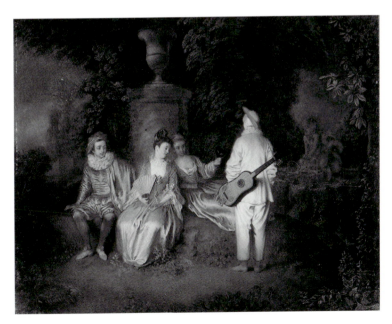

FIG. 6. Nicolas Poussin (1594–1665), *Self-Portrait,* 1650. Oil on canvas, 38⅝ x 29⅛ in. (98 x 74 cm). Musée du Louvre, Paris

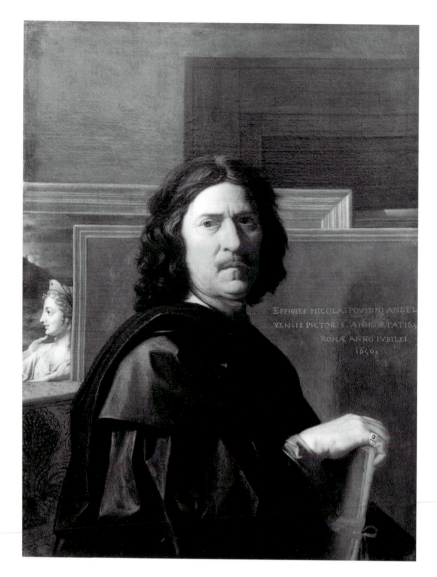

returned to Rome to paint his *Oath of the Horatii.* Ingres lived at the Académie, which had just been moved into the Villa Medici, from the end of 1806 to 1810. He extended his stay until 1824, in Rome and then Florence, as an "independent artist," making a living—with difficulty, after the fall of Napoléon—with his portrait drawings. He returned to Rome as director of this same villa, from 1835 to 1841, a sort of exile after the failure of his *Martyrdom of Saint Symphorian.* Only Watteau never made the journey to Italy, to his keen regret. His second place at the Prix de Rome of 1709 should have opened to him the doors of the Académie de France, but the country was in financial crisis during a politically difficult period, and Watteau was unable to go to Rome. Watteau knew Italy only through the paintings and drawings in the Crozat collection that he copied, demonstrating a preference for the artists of Venice over those of Rome.[4]

FIG. 7. Pierre-Nolasque Bergeret (1782–1863), *Poussin Accompanying Cardinal Massimi.* Graphite on paper, 4½ x 2⅞ in. (11.5 x 7.2 cm). Private collection

A physical description and a character sketch of each of the five artists are obligatory. Fortunately, they have helped us in this task by depicting themselves, not without a touch of narcissism (especially on the part of Ingres).

Giovanni Pietro Bellori left us a careful description of Poussin, to which we can compare the artist's self-portraits (figs. 6, 223): "A tall man, he had a well-proportioned body and a rare temperament. His complexion had a faintly olive cast, his black hair had largely turned white with age. His eyes harbored something of the celestial; his slender nose and large forehead ennobled his modest-looking face."[5] Bellori added the following well-known anecdote:

He took proper care of himself; his clothing wasn't magnificent, but severe and suitable. . . . He did not allow any sign of ostentation in his house, showing the same ease with his friends, even those of high station. One day he received a visit in his studio from Monsignor Camillo Massimi [for whom Poussin painted his last canvas], now a cardinal, whom he loved and admired for his fine qualities. The night wore on as they became engrossed in conversation, and when the time came for the cardinal to depart, Poussin accompanied him by the staircase to his carriage, holding a lantern. Seeing him undertaking the disagreeable task of carrying the light, Monsignor told him, "I pity you that you have no servant." "I pity even more," Nicolas answered, "Your Eminence, who has many" [fig. 7].[6]

We are not surprised by Bellori's further observation that "Poussin had a keen intelligence and a great deal of wisdom."[7]

From Bellori we move to Jean de Jullienne (1686–1766), a contemporary of Watteau, who described the artist as follows: "Watteau [figs. 8, 9] was of medium height and a sickly constitution; he had a lively and penetrating mind and lofty sentiments. He spoke little but well, and wrote the same. He was almost always meditative, a great admirer of nature and of all the masters who copied it. Constant work turned him somewhat melancholy [a word used repeatedly in Watteau's biographies], with a cold and embarrassed manner, which sometimes made him difficult for his friends, and often for himself; he had absolutely no other faults except indifference, and his love of change."[8] Edme-François Gersaint (1694–1750) noted, "He wanted to live as he liked, even in obscurity."[9] He added, "his face wasn't the least bit impressive";[10] "his eyes gave no indication of either his talent or the liveliness of his mind"[11]—this passage, little noted, is of some significance. He had "a sweet and kind disposition";[12] "a sad nature," a "delicate and worn-out temperament."[13] Pierre-Jean Mariette (1694–1774) observed his "completely shattered health."[14]

Fragonard's features are known through his self-portraits (fig. 10)

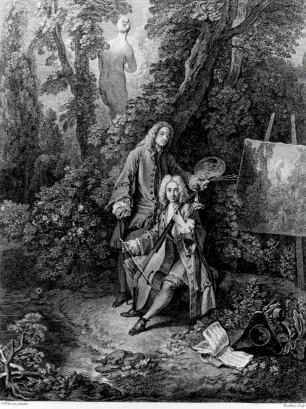

FIG. 8. François-Bernard Lépicié (1698–1755), after Antoine Watteau, *Portrait of Watteau.* Engraving. Département des Estampes et de la Photographie, Bibliothèque Nationale de France, Paris

FIG. 9. Nicolas-Henri Tardieu (1674–1749), *"Seated near You . . . ,"* portraits of Antoine Watteau and Jean de Jullienne, (From the Recueil Jullienne, 1731). Engraving. Département des Estampes et de la Photographie, Bibliothèque Nationale de France, Paris

and a certificate of good citizenship that he received on 25 Floréal Year II (14 May 1794): "Height four feet eleven inches, round face, high forehead, gray hair, gray eyes, gray eyebrows, ordinary nose, medium-size mouth, round chin, pitted [which indicates that his face carried traces of smallpox], living in Paris for fifty-six years."[15] Another, little-known, document describes the artist on the eve of his death, at the very beginning of the nineteenth century: "Round, fat, high spirited, always active, always cheerful, he had fine rosy cheeks, twinkling eyes, and very disheveled gray hair. He was always dressed in a long, loose-fitting, mottled cloak [then called a *roquelaure*], like the habit of gray nuns."[16] Bergeret de Grancourt draws a particularly severe portrait: "a painter of excellent talent, whom I need especially in Italy, and otherwise very easy for traveling, and always even-tempered," he wrote initially in his *Journal,* under the date 5 October 1773.[17] However, on his return from Italy, probably at the time of the lawsuit between them, Bergeret crossed out certain passages in his text, adding highly unfavorable commentaries: "Always even-tempered! Because he put on a pretense of evenness, and all the compliance he seemed to have turned out to be nothing more than

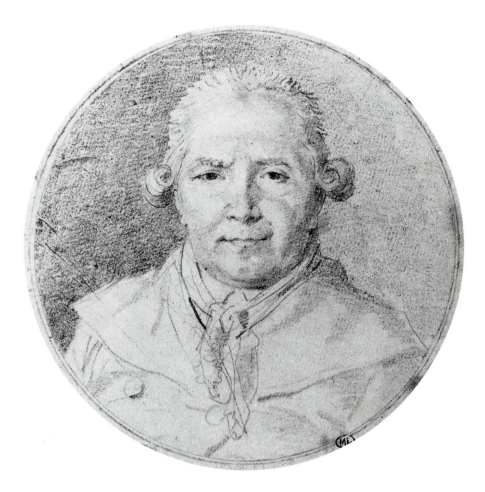

FIG. 10. Jean-Honoré Fragonard, *Self-Portrait,* c. 1788. Black chalk, heightened with colored pencil, on paper, diameter 5 in. (12.9 cm). Département des Arts Graphiques, Musée du Louvre, Paris

baseness, cowardice, fearing everyone and not daring to offer a forthright opinion, always saying things he does not believe. He admitted it himself."[18]

David, with his deformed left cheek, could easily be recognized (fig. 11). His royalist enemies called him "the fat cheek."[19] This tumor, which never stopped growing, resulted from a childhood accident, a wound from fencing that, not properly treated, probably led to an exostosis of the parotid gland, a salivary gland situated below the ear. Etienne-Jean Delécluze (1780–1863), who knew him well, composed a portrait:

His clothes had about them a studied elegance, a nattiness completely at odds with the habits of most of the revolutionaries. On top of that, despite the swelling of one of his cheeks, which disfigured him, and although his look had something rather hard about it [he had brown eyes according to his *Self-Portrait,* gray according to his request for a passport in 1815, which gave his height as 5 feet 7 inches],[20] on the whole he gave the impression of good breeding, which few people had managed to maintain during the stormy years of the Revolution. With the exception of the small tricolor cockade that

FIG. 11. Jacques-Louis David, *Self-Portrait,* 1794. Oil on canvas, 31⅞ x 29⅛ in. (81 x 64 cm). Musée du Louvre, Paris

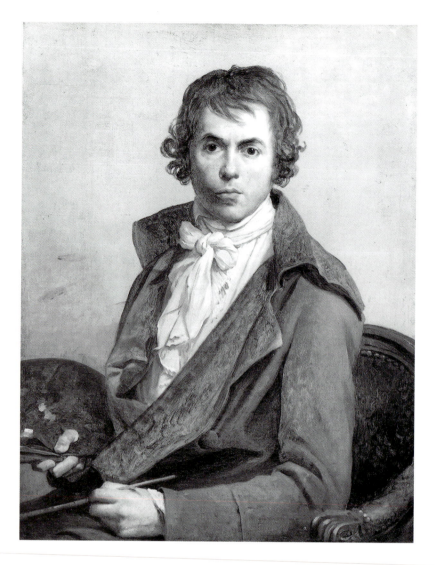

he wore in his round hat, the rest of his outfit, as well as his manner, gave him the appearance of a bygone gentleman in morning dress rather than one of the most fiery members of the Comité de sûreté générale.[21]

Walter Scott, in 1815, gave a much harsher description, calling his physiognomy "the most hideous he had ever seen," according to John Gibson Lockhart.[22]

Ingres (fig. 12) turns out to be small in stature (5 feet 2 inches), with an excitable temperament, and a testy nature. He was also said to be ugly.[23] In a little-known text, Rioux de Maillou tells us:

There was no way you could mistake him! That head must be his, shaped like a sugarloaf, with hair, still of a meridional blackness, parted in the middle, in the style of the angels in Italian Renaissance paintings. That is his receding forehead, his enormous ears, his intense eyes [they were brown, if

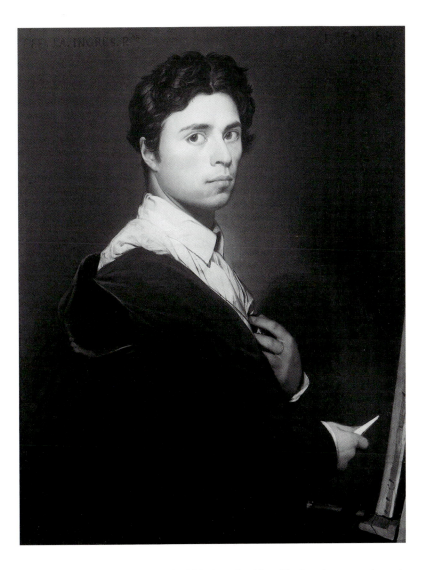

the self-portraits are accurate],[24] blazing, looking like luminous coals under
the thick arched eyebrows. That is his bilious complexion, his nose thrust
forward, disdainful even in his fury, his strong jaw, his obstinate chin,
solemnly tyrannical. That is also his stocky figure, vigorous despite the
deceptive resemblance to a balloon.[25]

The more familiar words of Louis Flandrin do not contradict Rioux de
Maillou's description: "Seeing this small, fat man, lacking in elegance, a
stranger would never suspect that the soul of an artist lay hidden beneath
this exterior, that is, unless he has caught a glimpse of his energetic
expression or the fire of his gaze."[26]

All except Watteau married, Ingres twice. Poussin seems to have
made a marriage of convenience, in 1630, with Anne Dughet (fig. 13),
the sister of the famous landscapist Gaspard Dughet (1615–1675), known
as le Guaspre.[27] They had no children, which led to some speculation:

FIG. 13. Gabriel de Saint-Aubin (1724–1780), *"Sketches after Objects from the Mariette Collection,"* 1775–76. Black chalk drawing after a bust of Nicolas Poussin's wife by François Duquesnoy (1597–1643), in the upper right margin of a catalogue from the Mariette sale. Museum of Fine Arts, Boston, bequest of William A. Sargent

Terres cuites. 9

36 Deux Enfants debout, les bras élevés, hauteur 6 pouces, non compris les pieds qui font de bois sculpté doré; l'un des deux a été restauré.

37 Deux autres idem à genoux, de même grandeur; un des deux a été aussi restauré.

38 Trois autres idem, assis & couchés, auxquels il manque quelques parties du corps.

39 Le Buste de la femme de N. Poussin, en corset & la gorge découverte, de 10 pouces & demi, y compris le piedestal qui est de marbre.

40 Le Buste d'un homme ayant le corps couvert d'une draperie qu'il tient de la main droite : ce morceau, qui est largement exécuté, est attribué au Cave. Bernin; il porte un pied de haut, y compris son pied qui est de bois noirci.

41 Saint Philippe de Néri, Figure debout lisant dans un Livre que lui soutient un Ange; morceau savamment fait par l'Algarde, de 18 pouces de haut, est connu en grand dans l'Eglise Neuve à Rome.

42 Le Buste d'un vieillard, d'un beau caractere, de 12 pouces, y compris le pied de bois noirci qui le porte.

Terres cuites de B O U C H A R D O N.

43 Un modele pour la figure de la Vierge de St. Sulpice, de 14 pouces de haut.

44 Deux autres pieces pareilles, avec différences dans l'attitude, de 11 à 12 pouces de haut.

did Poussin suffer impotence or sterility as a consequence of a serious venereal disease? There is as yet no confirming evidence.

Fragonard had two children: a beloved daughter, Henriette-Rosalie (fig. 14), who died at the age of nineteen, and Alexandre-Évariste (1780–1851; fig. 15), a painter who, unfortunately, remains obscure today. His private life before his union in 1769 with Marie-Anne Gérard (1745–1823; fig. 16) has been the subject of much investigation (Rosalie was born four or six months after the wedding; the date of the cere-

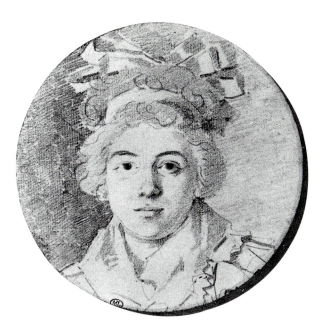

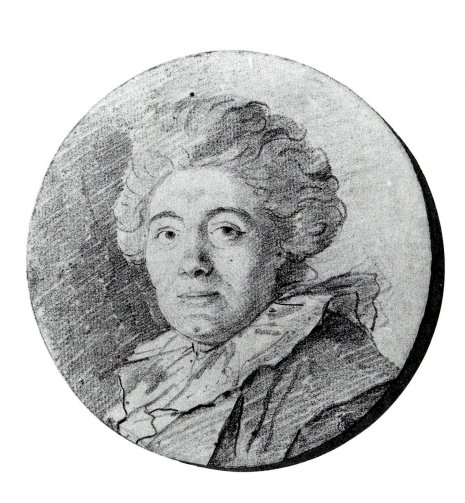

FIG. 14. Jean-Honoré Fragonard, *Portrait of Henriette-Rosalie Fragonard,* before 1788. Black chalk on paper, 5 x 5 in. (12.8 x 12.7 cm). Département des Arts Graphiques, Musée du Louvre, Paris

FIG. 15. Jean-Honoré Fragonard, *Portrait of Alexandre-Évariste Fragonard,* c. 1785. Black chalk on paper, 5⅛ x 5 in. (13 x 12.8 cm). Département des Arts Graphiques, Musée du Louvre, Paris

FIG. 16. Jean-Honoré Fragonard, *Portrait of Mme Fragonard, née Marie-Anne Gérard* (the artist's wife), c. 1785. Black chalk on paper, 5⅛ x 5 in. (12.9 x 12.6 cm). Département des Arts Graphiques, Musée du Louvre, Paris

FIG. 18. Marie-Anne Gérard (1745–1823), *Portrait of a Young Man.* Miniature, 3 1/8 x 2 1/2 in. (8 x 6.2 cm). Private collection

mony is in question),[28] as has his life after. What kind of relationship did he have with the well-known dancer Marie-Madeleine Guimard (1743–1816); did he have an affair with his sister-in-law, the beautiful Marguerite Gérard (1761–1837; fig. 17), who was herself a talented painter? Of the five wives of these four artists, only Marie-Anne Gérard wielded a brush, and she restricted herself to miniatures (fig. 18).[29]

David had four children by Marguerite-Charlotte Pécoul (1764–1826; fig. 19): two military officers, Eugène (1784–1830) and Jules (1783–1854)—who initialed their father's drawings at his death—and two daughters, whom he immortalized.[30] During the Revolution, in

1790, the couple separated. In 1794 they divorced, only to remarry in 1796. Was it a political or an emotional divorce? (Mme David, in a letter to her husband dated 11 August 1795, regretted her "thoughtlessness";[31] the painter, when arrested, was found living with Joséphine Tallard, probably a relative of the sitter for the portrait now in the Louvre.)[32] We do not know. There was little gossip about his private life, except—which should not surprise us today—to insist on his relationship, sometimes described as passionate, with his favorite student, Jean-Germain Drouais (1763–1788), who died young in Rome.

Ingres's marriages, with Madeleine Chapelle (1782–1849) and then Delphine Ramel (1808–1887; fig. 20) were both arranged by friends. They proved happy ones, nonetheless. A portrait drawing (fig. 21) shows the first Mme Ingres pregnant (it was a miscarriage; Ingres had no chil-

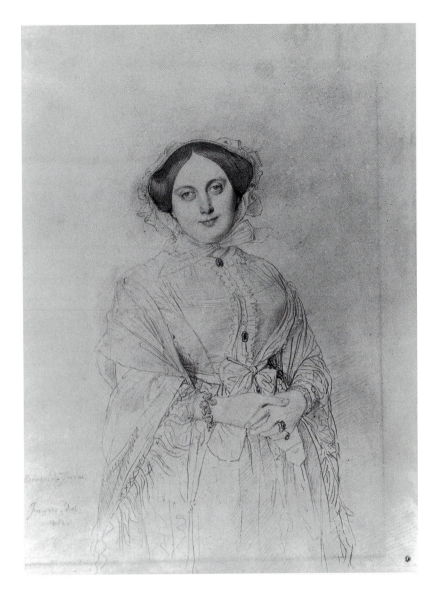

FIG. 20. Jean-Auguste-Dominique Ingres, *Portrait of Mme Ingres, née Delphine Ramel* (the artist's second wife), 1852. Graphite on paper, 13⅝ x 10⅜ in. (34.7 x 26.5 cm). Musée Bonnat, Bayonne

Opposite:

FIG. 21. Jean-Auguste-Dominique Ingres, *Portrait of Mme Ingres, née Madeleine Chapelle* (the artist's first wife), 1814. Graphite on paper, 8 x 5½ in. (20.4 x 13.9 cm). Musée Ingres, Montauban

dren). At her death in 1849, Ingres wrote the following in his own emphatic style:

[Cruel fate] had to carry off my wife! She is dead, she is taken from me forever, this wonderful woman, sublime in her cruel end. No, nothing can match my horrible despair, a man can truly die from too much anguish! . . . Ah, how I would have liked to follow her! I was prevented; I was pulled away from her. She is dead, my dear friends! She is dead and I will never see her again. It is hard to describe my unending grief. Innocent, admirable, heroic woman, I will see her no more, never again. Ah! I will die of sorrow."[33]

Ingres remarried three years later.

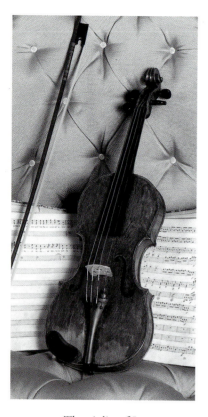

FIG. 22. The violin of Ingres.
Musée Ingres, Montauban

Next to nothing is known about the private life of Watteau, which has led to all manner of surmises: homosexuality, more or less open; impotence; and even (a surprising twist) heterosexuality.

In truth, the effort to construct a psychological portrait of these five artists must contend with extensive areas that remain shrouded in obscurity, especially in the cases of Watteau and Fragonard, opening the door to all manner of interpretations. Were they tireless workers or lazy? Did their talent need time to blossom and to make itself felt, or were these artists precocious? Were they demanding of themselves or easygoing, anxious or sure of their genius? First we can observe that they all experienced fame.

Poussin, after a difficult beginning, achieved a rank in 1627 that was never contested and that assured him an enviable situation in Rome and all of Europe. Watteau's appearance in French art history partakes of the miracle. He made a sensation, disturbing and even embarrassing his friends, such as Anne-Claude-Philippe, comte de Caylus (1692–1765), his most noted biographer of the eighteenth century. Fragonard dashed the hopes of those who saw him as able to inject new life into history painting. He enjoyed a few years of glory or, at least, a great reputation among connoisseurs, but he died in oblivion. In 1847, when the artist was on the verge of being rediscovered, his grandson Théophile made the cruel observation, "So after all the fuss, a silence fell around Fragonard; he and [Jean-Baptiste] Greuze looked at one another and asked themselves where and why it had vanished! For David and his new school had caught all the attention!"[34]

From 1781, with his *Belisarius,* David held center stage. He never actually left it, but his exile in Brussels was also the exile of a man who, because of Anne-Louis Girodet (1767–1824), of Jean-Antoine Gros (1771–1835), of Ingres, especially of Théodore Géricault, and already of Delacroix, would see the principles on which he based his work collapse, principles he had taught to an entire generation of artists. He died celebrated but isolated and "outdated." Finally, Ingres, also celebrated and venerated, was considered the guarantor of tradition and the bulwark of a sclerotic academicism (at the time of his death in 1867, Impressionism was in its ascendancy; Edouard Manet's *Le Déjeuner sur l'herbe* and *Olympia* date from 1863). The twentieth century would give him a brilliant comeback.

Ingres had many students, some who adored him, all of whom respected him. He taught, supervised in the studio, enjoyed his role as teacher, and asked his best students to "collaborate" on his paintings. In that he followed the example of his master, David. Neither Watteau nor Fragonard had students in the strict sense of the word, nor did they teach. Poussin, the model of so many artists and the obligatory academic reference for more than two centuries, worked alone in his studio. The failure

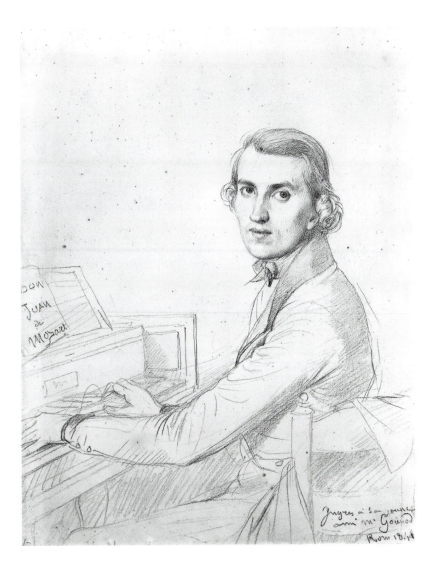

Overleaf:
Jacques-Louis David, *The Oath of the Tennis Court,* 1791 (detail of fig. 90).

of his stay in Paris from 1640 to 1642 was also the failure of a painter who did not know how (or had no desire) to direct a studio.

To varying degrees, all inaugurated a school and exercised considerable influence in France and abroad. These influences were felt immediately, with ups and downs that were more or less perceptible according to the artist and the country, as well as professional spheres. Watteau fascinated (and continues to attract) the worlds of theater and fashion, poets and musicians. Poussin, "the philosopher-painter," "the friend of the literati," is the painter of intellectuals, iconologists, and iconographers, as well as art historians and many painters. He is the painter of an elite, whereas Fragonard appeals to everyone. David, whose participation in the Revolution and whose role under the Empire has been the subject of many discussions, has exerted a special fascination for historians.

The violin of Ingres has become legendary (fig. 22). The artist especially adored Gluck, Rossini, Beethoven, Haydn, and Mozart and played

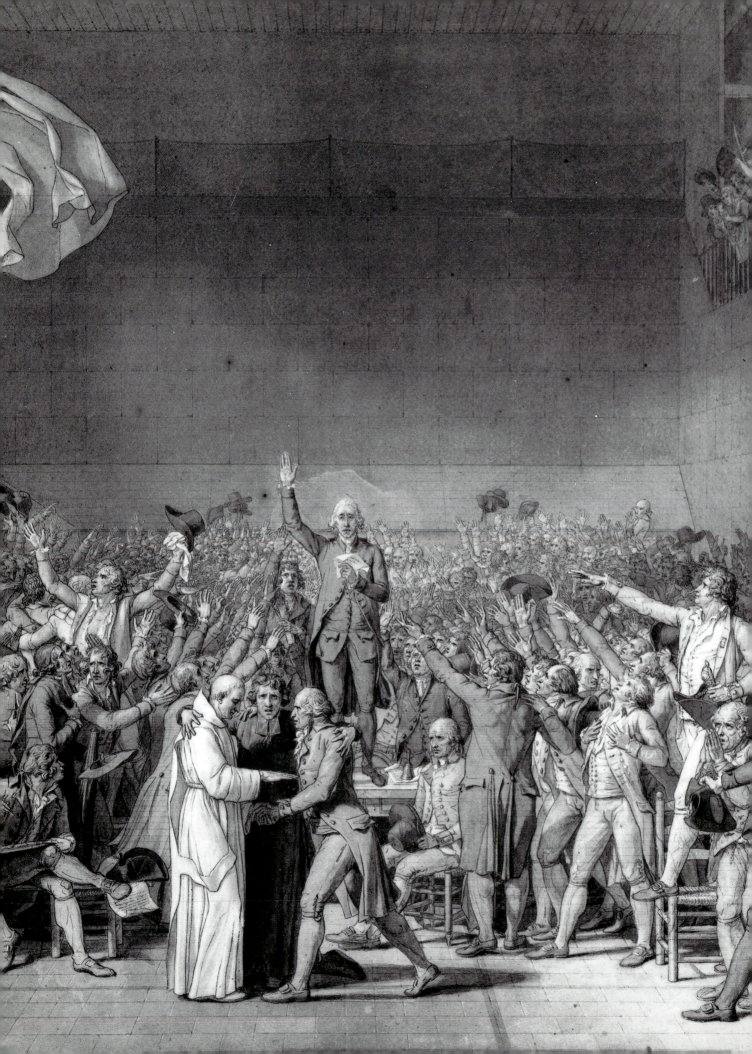

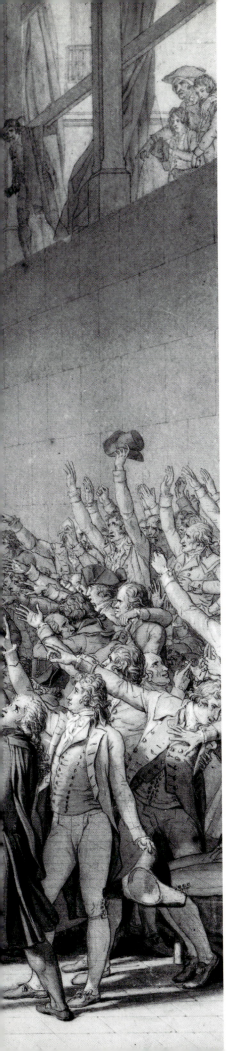

reasonably well. Music played a large part in the life of the Villa Medici during his tenure as its director (fig. 23). In 1840 Fanny Mendelssohn, the sister of the composer and an eminent pianist, played several pages of her brother's compositions there for Ingres.[35] In his will, he asked that the portraits of Haydn, Mozart, Gluck, Beethoven, and Grétry be hung beside that of Raphael in his museum in Montauban, above his desk, which held copies of the *Iliad* and the *Odyssey.*

Watteau "had an exquisite ear for music."[36] David loved the theater, like Watteau. The latter also enjoyed reading, probably primarily as distraction, unlike Poussin. A great reader, particularly of Montaigne, Poussin sought example and instruction, moral or philosophical lessons rather than pleasure.

The letters of Poussin and Ingres and accounts by contemporaries of Watteau, Fragonard, and David give us authoritative information on two essential matters: the religious convictions and the political ideas of all five artists.[37] Ingres was observant and, undoubtedly, a genuine believer. Even so, can his work be placed in the often denigrated category of religious painting? We have no knowledge of David's beliefs, although he assigned to "religion a significant part for his painting of the *Oath of the Tennis Court*" (see detail of fig. 90, opposite).[38] As to Poussin, this is not the place to reopen the heated debate occasioned by the celebration of Poussin's four-hundredth birthday in 1994.[39] Was Poussin a believer, or did he find moral comfort through his reading of Montaigne and the ancients' examples of virtue? His letters provide no more clues than his paintings—and his drawings even fewer. Watteau, in the days before he died, destroyed work he considered the most licentious:

He died with all the religious feeling one could hope for, and he spent the last days of his life painting a Christ on the Cross for Nogent's parish priest. . . . Watteau was the honest sort, so his submission had to be sincere. Otherwise, there was no passion that had gotten the better of him; no vice had taken hold [of him] and he never made an obscene work. His scruples pushed him to the point of wanting to see again, a few days before he died, some oil sketches that he thought not far enough removed from this genre, to have the satisfaction of burning them: which he did.[40]

As far as we know, such scruples never troubled Fragonard. Fragonard, who had served the *Fermiers-généraux* and their most celebrated mistresses, was a partisan of the Revolution.[41] He served the revolutionary government and served as curator in what would become the Louvre.[42] Does this point to opportunism on the part of a forgotten artist, anxious to ensure a way of making a living, or sincere conviction, rather surprising in a painter who worked so zealously for the ancien régime? We do not know.

Fragonard owed his position during the Revolution to David, whose political opinions have provoked bitter debates and always will. David painted for Louis XVI and for his brother, the comte d'Artois, then voted to put the king to death and was faithful to Napoléon. Yet he refrained from asking for the measure that had sent him into exile to be lifted and would not accept any intervention that would have made it possible for him to avoid his exile in Brussels, nor any that would have then allowed him to return to France. Of the five artists, David is incontestably the most "engaged," even if the depth of that engagement remains open to question. Was he truly a political being? We rather doubt it.

Poussin and Ingres would today be classified on the political right. Several phrases in Poussin's *Letters* show him anxious for France's fate during the Fronde and an attentive observer of the political evolution of his native land: "the poor state in which the affairs of our poor France was in and is in at present. . . . I would have started on the large version of your Virgin had it not been for the bad news arriving daily from Paris that these wicked Frenchmen had already begun to sack it as a result of their rabble-rousing speeches."[43] Some months earlier, he had noted, "Nevertheless, it is a great pleasure to live in a century in which such great things are happening, provided it is possible to take cover in some small corner from which to watch the Comedy at leisure."[44]

Ingres was a senator during the Second Empire, a "Grand Officier" of the Légion d'honneur, a member of the Institut (he took over the seat of Dominique-Vivant Denon [1747–1825], whom he heartily disliked), and a member of various foreign academies: he enjoyed honors. But his loyalty to Louis-Philippe and his son Ferdinand-Philippe, duc d'Orléans, the heir to the throne whose disappearance in 1842 deeply distressed him—a loyalty, it is true, more sentimental than political in nature— seemed to hold strong. Ingres has been seen as a reactionary, in politics as well as in painting. The former issue matters little; as to the latter, the twentieth century has taken a different point of view.

The political opinions of Watteau are unknown. There has been some debate about the portrait of Louis XIV (who died in 1715) that is placed in a box in the painting *Gersaint's Shop Sign,* which was completed in 1720–21. Was this a position favoring the regent, championing a new style, an art reacting against the Louis XIV style? With Watteau, painter of the ambiguous, all interpretations remain possible (and let me avoid any temptation to "overinterpret").

The least "cultivated" of the five is certainly Fragonard. Whether self-taught or educated at the Académie royale, Poussin as well as David, and Ingres in equal measure, valued the life of the mind. Could they be considered intellectuals? With the exception of Poussin—who nonetheless never put his ideas before his brushes—it is difficult to judge, as these artists gave so much to their work that it seems that left little room for

other intellectual curiosities. As to their level of intelligence, how could we tell? Ingres's contemporaries often made fun of his slowness or, at least, to cite Delécluze, lamented his "lack of a liveliness of thought," his want of "spirit," "his solemn character."[45] Clearly, Ingres was not "intelligent" except with pencil in hand. In this domain, however, he surpassed all his contemporaries. Paul Valéry's well-known observation that "drawing is an act of intelligence" applies to none better than to Ingres.[46]

Poussin, Watteau, Fragonard, David, and Ingres were, above all, painters. All worked prolifically; Poussin's paintings today number about 250.[47] He undoubtedly painted much more than this, especially in his early days, particularly landscapes. A standard catalogue on Watteau gives the approximate figure of 215 works, a respectable number for an artist who died at the age of thirty-seven.[48] A standard volume on Fragonard lists 451 paintings in his oeuvre.[49] David actually painted little—mostly portraits, plus several immense compositions and a number of oil sketches. Daniel Ternois's catalogue on Ingres enumerates 173 paintings (72 portraits, 2 of these self-portraits repeated in many versions), among which his detail studies for large compositions count for a large part.[50]

Did they paint regularly and throughout their lives? Fragonard probably abandoned his brushes around 1785, but Poussin—like Watteau, Ingres, and David—with more or less consistency, never stopped painting. All made large-format works: *The Coronation of Napoléon and Joséphine* by David, *Gersaint's Shop Sign* by Watteau, not to mention *Coresus Sacrifices Himself to Save Callirhoé* by Fragonard, *The Martyrdom of Saint Symphorian* by Ingres, or *The Miracle of Saint Francis Xavier* by Poussin. They drew their compositions from the secular and the religious, from ancient and contemporary history, from mythological subjects. They made portraits, official or personal, retrospective or contemporary, allegorical, inventive, or realistic; some landscapes; more or less dissolute genre scenes; and *"fêtes galantes."* None, however, seems to have left behind a still life.

Oil sketches exist for some of their paintings (David, Ingres, and, to a lesser extent, Fragonard). They rarely painted scenes of everyday life. They painted for the king, various popes, the nation, the Empire, and foreign courts as well as for the Church and for several important patrons, some of whom played a vital role: Paul Fréart de Chantelou (1609–1694) and Cassiano dal Pozzo (1588–1657), Gersaint and Jullienne, the abbé de Saint-Non (1727–1791) or the comtesse du Barry (1743–1793), Stanislas Potocki (1755–1821) or the marquis Douglas, Caroline Murat, James de Rothschild, or the duc de Luynes. They painted with pleasure—with great difficulty but with pleasure—rarely for pleasure alone.

"ON 19 NOVEMBER 1665, as noon struck, he [Poussin] gave up his soul to his Creator. . . . The next day, his body was brought to the church

of San Lorenzo in Lucina, his parish, for the viewing of the body. . . . He was buried amidst universal tears and grief."[51] A few weeks earlier, he had written to the abbé Nicaise, "I think only of dying, which is the only remedy for the ills that afflict me."[52] Accessible to all outward appearance, Poussin spoke little but well. Reserved, even secretive, he never flew into a passion. Was he really as austere, as "noble," as in control of himself as his letters and self-portraits would have us believe? Clearly, we will never know.

On 11 August 1721, Pierre Crozat (1665–1740) informed Rosalba Carriera (1675–1757), "We have lost poor Watteau, who ended with a brush in hand."[53] He had departed this world a month earlier, on 18 July.

Fragonard's expiration on 22 August 1806 went unnoticed: "He died at 5 o'clock in the morning, at the house of Véri,"[54] an important "restaurateur" of the period, "following a relatively short illness."[55]

Knocked down by a carriage while returning from the theater in February 1824, David died ten months later, on 29 December. Only ten days earlier, on 19 December, he had gone to the Théâtre de la Monnaie to see a performance of *Tartuffe*. His Belgian student François-Joseph Navez (1787–1869) reported that "he painted until the fifteenth of the month, but he could no longer hold a brush."[56]

David was reserved, restrained, regular in his habits. The "primitiveness of [his] manners did not predispose people toward him; but in his intimate relationships, he was simple and good-natured," wrote Antoine Thibaudeau.[57] The final image of Fragonard was of an old man, "round, stout, dapper, always alert, always merry."[58] Others, however, have noted a secretive man, insecure, touchy, capricious, sly, accommodating, indecisive, compliant, and anxious. "Late in his life" he experienced "sorrow, discouragement, and dismay."[59] Alexandre Lenoir claimed that "he no longer painted, and died miserable."[60] Watteau "was the honest sort"; "gentle and amiable," "he was not very demonstrative." "Anxious" and with an "embarrassed manner, which sometimes made him difficult for his friends," Watteau was "shy," "always unhappy with himself."[61]

On 8 January 1867 Ingres copied an engraving after Giotto's *Entombment* from the Arena Chapel, Padua, at the Bibliothèque Nationale (fig. 24). This was his last drawing. That evening he invited some friends for dinner, followed by a brief concert (Mozart, Cherubini, Haydn). During the night he opened a window to dissipate the "smoke filling the room from an ember that had just fallen from the fireplace onto the floor. An inflammation of the lungs ensued."[62] On 14 January Ingres quietly passed away. "Sensitive, overly nervous, and always irritated . . . happy, unhappy," as he described himself,[63] Ingres was badtempered. Intolerant, he still had a good heart.

Here we have five deaths, all with different circumstances, and five contrasting personalities. What bond unites these five artists except love

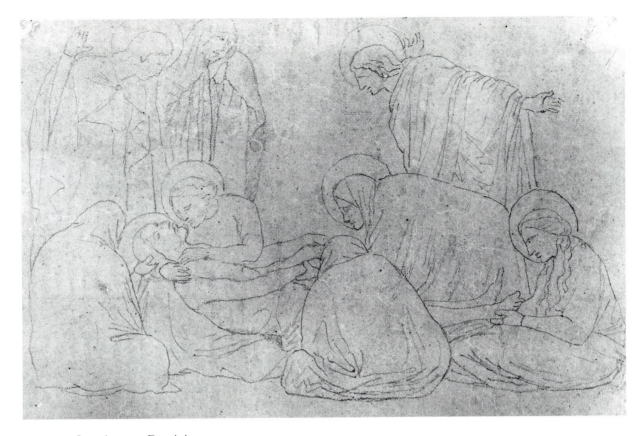

FIG. 24. Jean-Auguste-Dominique Ingres, after Giotto (c. 1266–1337), *The Entombment,* 1867. Graphite on tracing paper, 4 ¾ x 7 ⅜ in. (12 x 18.7 cm). Musée Ingres, Montauban

of art, an exalted notion of painting as an art in itself—the equal to music, literature, or architecture? Poussin, Watteau, Fragonard, David, and Ingres all shared a love for drawing. Nevertheless, their works bear little resemblance to one another. Whether they used black chalk or red chalk, favored line or color, gave evidence of a sense of humor or retained their seriousness at all times, were cruel or tender, driven by virtue or tempted by vice, contrasts are the rule, and examples of this variety can be multiplied at will. But all drew prolifically, drawing from need and drawing for pleasure, drawing to preserve memories, capture images, intercept elusive ideas, learn. And all prepared their paintings with drawings (albeit Fragonard less so).

Drawing is not an autonomous art, an independent discipline, an end in itself, isolated from all context, but a means, the favored medium of the artist to transform forms and lines as well as thoughts and ideas, concepts and ideals, into paintings. The problems of attribution in regard to the paintings of these artists, like their dating, are very different in nature. Sometimes their drawings, as we will see, can help to resolve these questions.

Chapter 2 The Drawings: Their Histories, Techniques, and Themes

TWO NAMES HAVE REMAINED LINKED to the study of Poussin's drawings even up to today: Sir Anthony Blunt (1907–1983) and Walter Friedlaender (1873–1966). Certainly, before them Poussin's drawings were zealously collected, and no one specializing in the artist could ignore them. It was, however, Friedlaender and Blunt who emphasized their importance and undertook the compilation of the mandatory catalogue raisonné. The first volume appeared in London, supported by the efforts of the Warburg and Courtauld Institutes, in 1939; the fifth and last appeared in 1974 (by which time Friedlaender had been dead for eight years). Soon after this volume came out, Blunt published two articles in *Master Drawings* that brought to light some unknown drawings by Poussin. He devoted another general book to Poussin as a draftsman, which was published in 1979.

The work by Blunt and Friedlaender is impressive and remains highly valuable, the more so as the two authors cited all the drawings that had ever carried the name Poussin, whether held in a private or a public collection. This extensive research has its limitations, however. The first is of a practical nature: each volume groups the drawings by theme.[1] Thus, the first volume is devoted to subjects from the Bible. Each time a new volume came out, Blunt and Friedlaender, and then Blunt alone, corrected, filled in, and brought up to date the preceding volumes. This practice made consultation of their work difficult, not to say impossible, for anyone who did not have a thorough grasp of Poussin's drawings.

The second limitation arises from the method adopted by the two authors. They put subject ahead of chronology, organizing the drawings into an iconographic order, which presents many disadvantages. Although they proposed a date for each sheet they catalogued and related it to Poussin's paintings of the same subject, their thematic classification inhibits any analysis of the artist's graphic development. As a result, it gives a warped conception of Poussin's ambitions as draftsman. Louis-Antoine Prat and I have taken the opposite tack, organizing (that is, attempting to organize) by date.[2] We were fully aware of the problems involved. It seemed to us, nevertheless, essential to follow this method.

FIG. 25. Nicolas Poussin, *Landscape*, c. 1635–40. Red chalk and pen and brown ink on paper, 4⅞ x 7¾ in. (12.3 x 19.6 cm). École Nationale Supérieure des Beaux-Arts, Paris

Dating drawings—especially those of Poussin—requires digging more deeply, making a greater effort to trace and understand the artist's creative process. Blunt and Friedlaender accepted 458 drawings as by Poussin (the backs, or versos, that carry a drawing have their own numbers). We have arrived at a comparable figure of 383 (382 numbers plus a *bis*). We have also catalogued (and reproduced, unlike Blunt and Friedlaender, for the most part) the 1,333 drawings we rejected.[3]

Since our catalogue appeared, we have discovered few new drawings by Poussin; to our great disappointment and regret, specialists and collectors have not called any to our attention.[4] There was, however, one that we should have known (fig. 25). It was offered for sale at Christie's, London, in 1985 as the work of Giuseppe Passeri and was bought by Mathias Polakovits (1921–1987). At his death he gave his collection of French drawings to the École des Beaux-Arts in Paris, where it is catalogued as the work of an obscure landscapist, Jacques Prou.[5]

Blunt and Friedlaender are to Poussin as Sir Karl Parker (1895–1992) and Jacques Mathey (1883–1973) are to Watteau. Their two volumes came out in Paris in 1957. Parker had long been interested in Watteau and had published in 1931 an authoritative book on his drawings.[6] Others before him had studied Watteau's graphic style, beginning with the

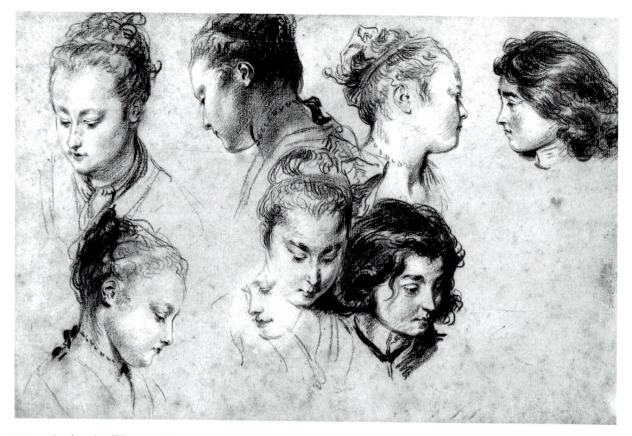

FIG. 26. Antoine Watteau, *Six Studies of Women's Heads and Two Heads of a Young Man,* c. 1717. Red, black, and white chalks, with touches of red wash and white gouache on paper, 8⅞ x 13¾ in. (22.5 x 34.8 cm). Département des Arts Graphiques, Musée du Louvre, Paris

Goncourt brothers, Edmond and Jules, whose title of "discoverers" of Watteau is perhaps a slight exaggeration, but the two volumes of 1957 (which, like those of Blunt and Friedlaender, became rarities sought by bibliophiles) summarized the issues involved and brought together everything that had already been published in a disorganized fashion.

Like Blunt and Friedlaender, Parker and Mathey chose to organize the drawings by theme, in nineteen chapters.[7] Unlike the English and German-American authors, they did not compile a list of drawings formerly attributed to Watteau. Our catalogue raisonné of Watteau's drawings was published in 1996. It contains 671 drawings accepted as authentic (see, for example, fig. 26) and about 860 rejected. Many of the sheets are reproduced in color, whereas the sepia-tinted photographs of Parker and Mathey make it difficult to judge the drawings.[8]

Fragonard's drawings are popular. They were already famous in the artist's day; Fragonard did a nice business with them. They were imitated, copied, and forged; perhaps they are even today. Between 1961 and 1970 Alexandre Ananoff (1910–1992) published the catalogue raisonné of Fragonard's drawings in four volumes. He noted 2,726 drawings, of which only a quarter were reproduced. Like his predecessors, he chose a thematic order, organizing the drawings by subject, in fourteen sections for the first three volumes and fifteen for the last volume.[9]

The work is useful but old and hardly trustworthy. Many experts have tried to revise it.[10] For our part, we have gathered (while preparing the Fragonard exhibition held at the Grand Palais and in New York in 1987–88) the greatest number of photographs of drawings attributed to Fragonard but have yet to begin the work of writing the new catalogue raisonné, a work anticipated by all eighteenth-century specialists. Fragonard produced prolifically, and his style was easily, often skillfully, faked. Moreover, the chronological order that we have decided on presents us with particularly thorny problems, which have yet to be resolved.

David's austere drawings have their defenders, and none of the specialists of the painter has neglected them, as their importance to the exciting and complex elaboration of the painter's masterpieces is obvious. Yet none of them, not even Arlette Sérullaz, who devoted her 1965 thesis (updated and published in 1991)[11] to David's drawings in the Louvre, has attempted to compile a complete catalogue. Such a catalogue, meanwhile, has become essential. It will be published in 2000.

Even today Ingres is more admired for his drawings than for his paintings; the artist would find this bitter truth highly irritating. Hans Naef published a catalogue raisonné of the portrait drawings of Ingres in five volumes between 1977 and 1980 (in German, which perhaps explains why his work did not receive the attention it deserves, as Naef's research is exemplary in all respects). Daniel Ternois's research and works and Georges Vigne's corpus of Ingres's drawings in the collection of the Musée Ingres in Montauban are also extremely useful.[12] Nonetheless, the catalogue raisonné that would reorder and reproduce the whole of the work, as considerable as it is marvelous, is still sadly lacking. We will work diligently to fill this deplorable gap (by the year 2002 at the earliest).

It would not be difficult to guess that each of these catalogues raisonnés would encounter problems related to the personalities of each artist, to his way of working, his artistic ideal, and so forth.[13] These complexities also arise from the very specific histories of their graphic work.

What importance did their creators assign to their drawings? How, and thanks to whom, did the drawings of Poussin, Watteau, Fragonard, David, and Ingres come down to us? Where are they located now? Were they always appreciated? What was their history from their creation to the present day? These questions are usually considered secondary, but to my mind they are paramount.

Returning to the first question, Poussin apparently had little interest in his drawings—which is not to say that he attached little importance to drawing. He does not seem to have made any effort to preserve them, although Jean Dughet (1618–1696), Poussin's brother-in-law and heir, in a memorandum of 1678 claimed to own "a book of drawings made by Monsieur Poussin *al'antico*" as well as a "book of drawing . . . of his invention," to which he added drawings "of landscapes," "of ani-

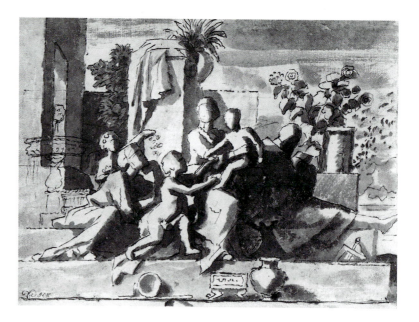

mals," and "some heads."[14] Nor did it occur to him to think of them as entirely independent works of art. He rarely mentions them in his letters. However, he left this illuminating phrase in reference to a painting commissioned by Lisle de la Sourdière in 1647: "found the thought in it. That is to say, the conception of the idea and the work of the mind is completed."[15] It should be emphasized that this noticeable disregard for drawings did not contradict the importance he gave to the daily exercise of drawing. For Poussin, drawing was a necessary tool, an indispensable intermediary, an obligatory passage leading from the idea to the painting.

While Poussin may have paid little attention to his drawings, some of his friends endeavored to assure their safety. At the time of his death, Jean Pointel, one of Poussin's main admirers and collectors, owned eighty drawings, most likely all authentic.[16] Chantelou, Gianlorenzo Bernini's cherished companion during his journey in France in 1665, who owned a few drawings (fig. 27)—and not all were by Poussin—noted his worries: "We had discussed those drawings [of the Jabach collection (1610–1695)], and I had told him [Bernini] that these were invaluable things, but as to me, who loved drawing, I had no desire whatsoever to embark on this kind of collection as it is so easy to be deceived. He answered that the same was true of painting. I agreed, but added that the danger was less."[17]

Such fears apparently did not affect Cassiano dal Pozzo nor Cardinal Camillo Massimi (1620–1676). A substantial number of the drawings by Poussin in Windsor, one of the major holdings of the artist's sheets, came from their collections.[18] These names, as well as Crozat and Mariette (we do not accept some of the works in Crozat's collection that the otherwise infallible Mariette considered autograph),[19] Sir Thomas

FIG. 28. François de Troy (1645–1730), *Portrait of Jean de Jullienne,* 1722. Oil on canvas, 36¼ x 28¾ in. (92 x 73 cm). Musée des Beaux-Arts, Valenciennes

FIG. 29. Antoine Watteau, *Double Portrait of Canon Haranger, His Left Hand Leaning on a Cane,* c. 1720. Red, black, and white chalks on paper, 10⅛ x 14⅜ in. (25.7 x 36.5 cm). Kupferstichkabinett, Sammlung der Zeichnungen und Druckgraphik, Staatliche Museen zu Berlin-Preussischer Kulturbesitz, Berlin

Lawrence, Frédéric Reiset (1815–1891), the duc d'Aumale, and Léon Bonnat, must be mentioned as among the principal admirers of Poussin. The Louvre, Windsor, Chantilly, and Bayonne are among the public repositories with major holdings of the drawings. Surprisingly, very few of Poussin's sheets today belong in private hands.[20]

Thanks to Gersaint, the man who commissioned *Gersaint's Shop Sign,* we know Watteau's opinion of his own drawings: "Besides, I can only be accused of having made a great draftsman, since I greatly prefer his drawings to his paintings. Watteau thought the same on that subject. He thought better of his drawings than of his paintings, and I can guarantee that in this respect he was not blinded to any of his shortcomings through pride. He derived greater pleasure from drawing than from painting. I often saw him upset with himself because he could not render in painting the spirit and the truth that he knew how to give to his crayon."[21]

"This painter drew continually," affirmed Antoine-Joseph Dezallier d'Argenville (1680–1765).[22] At Watteau's death in 1721, he saw to it that some of the more licentious ones were burned (unhappily for us).[23] Gersaint reported that at the end he desired that his drawings, "of which he made me the trustee, be divided equally between the four of us; which was carried out according to his wishes."[24]

The four beneficiaries were Gersaint, Jullienne (fig. 28), Nicolas Hénin (d. 1724), and the abbé Haranger, canon of Saint-Germain l'Auxerrois (fig. 29). The estate inventory of Haranger, dated 1735, was only recently rediscovered and published.[25] It included some 1,100 drawings by Watteau (unfortunately, too briefly described). Thus, if Gersaint acted scrupulously, and if Haranger's inventory is trustworthy, Watteau must

FIG. 30. Antoine Watteau, *Portrait Thought to Be of Antoine de La Roque,* c. 1715. Red chalk on paper, 9 x 6⅝ in. (22.8 x 16.9 cm). Fitzwilliam Museum, Cambridge

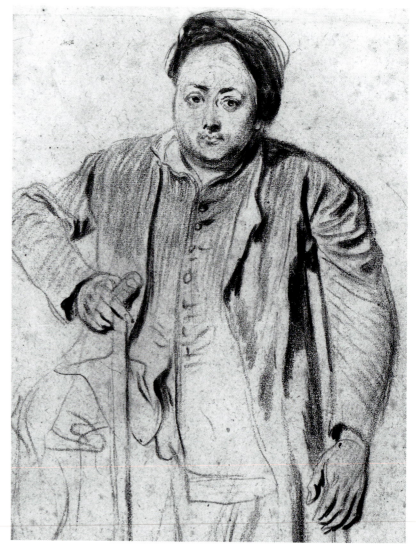

FIG. 31. Charles-Nicolas Cochin (1715–1790), *Portrait of Anne-Claude-Philippe, Comte de Caylus,* c. 1750. Graphite with stumping on paper, diameter 4¼ in. (11 cm). Fogg Art Museum, Harvard University, Cambridge, Massachusetts, gift of the Robert Lehman Foundation in honor of Paul J. Sachs' 80th birthday

have left more than 4,000 drawings at his death. However, another contemporary of Watteau's, as credible as Gersaint, the chevalier Antoine de La Roque (1672–1744)—"the man with the wooden leg" (fig. 30)—put forward a different version. In his obituary of Watteau, he specified that the artist "left his Drawings . . . to M. the Abbé Harancher [*sic*] his friend."[26] Was it 1,000 or 4,000 drawings? The issue—a crucial one—remains open.[27]

A document published in 1989 adds weight to the Gersaint thesis.[28] In a manuscript note in the margin of the sale catalogue for the auction held after Jullienne's death, Mariette—the greatest collector of his day—wrote: "All these drawings by Wateau [*sic*] are more or less all that the Painter made to serve as studies. He divided them on his death and left a quarter to the abbé Haranger, another quarter to Gersaint, a 3d to M. Hénin, died manager and administrator of the King's buildings, and

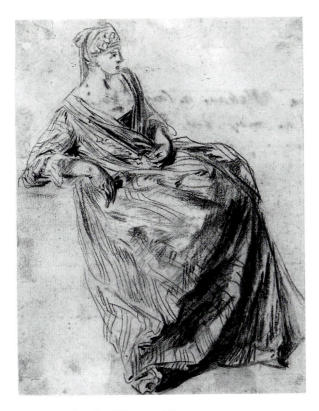

FIG. 32. Antoine Watteau, *Woman Seated, Leaning on Her Elbow and Turned to the Right*, c. 1715–16. Red and black chalks with graphite on paper, 5⅞ x 4½ in. (14.8 x 11.5 cm). The British Museum, London

FIG. 33. Verso of fig. 32

the 4th to M. de Julliene [*sic*] all his friends." Mariette added: "The last reunited almost all of them afterward since, with the exception of the share of the abbé Haranger that was sold on his death, all the others were bought by him. That is why such a great number are found here [with Jullienne]."[29] This indicates that Gersaint, who was an art dealer, and Hénin, who died in 1724, sold their allotments to Jullienne soon after Watteau's death.[30]

To the list of Watteau's heirs and friends should be added the comte de Caylus, one of Watteau's first biographers (fig. 31). The artist gave him some drawings, of which seven are known today, all annotated by his hand on the verso (figs. 32, 33). Watteau also offered some drawings to Crozat. The catalogue of Crozat's estate sale of 1741, written by Mariette (fig. 34), tells us he owned nine: "These are the Drawings that this Painter left at his death to M. Crozat, in acknowledgment of all the kind help he had received from him."[31]

Watteau's drawings continued to be sought during the course of the eighteenth century. Those that today belong to the Nationalmuseum in Stockholm were bought by Carl Gustav Tessin (1695–1770), either directly from the painter himself while he was living in Paris in 1715 or from the Crozat sale (see, for example, fig. 35).

In the nineteenth century, important collectors of Watteau included the mysterious Andrew James, who died before 1857 (he owned, for

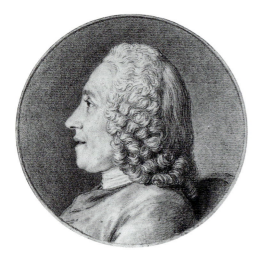

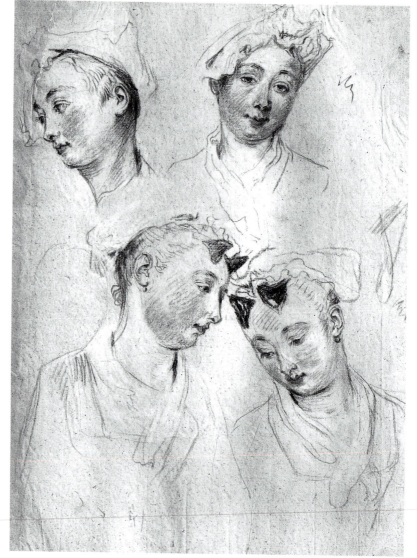

FIG. 34. Charles-Nicolas Cochin, *Portrait of Pierre-Jean Mariette.* Graphite on paper, diameter 4¼ in. (11 cm). Fondation Custodia, Institut Néerlandais, Paris

FIG. 35. Antoine Watteau, *Four Studies of Women's Heads Wearing a Bonnet,* c. 1720. Red, black, and white chalks on paper, 13⅜ x 9⅝ in. (34 x 24.5 cm). Nationalmuseum, Stockholm

instance, fig. 36),[32] and, closer to our day, the inspired grand couturier and collector Jacques Doucet (1853–1929) and Camille Groult (1837–1908), whose splendid collection of Watteau's drawings is today entirely dispersed.[33] All of these names are directly tied to Watteau's posthumous fate. It has not yet been sealed, as Watteau's drawings today have many admirers and collectors.

It is known that Fragonard drew copiously but was not concerned with saving his drawings. Already in the eighteenth century, some of them fetched very high prices. The finest collections of the time—those of artists or dealers like Mariette, Gros, or Pierre-Adrien Pâris (1745–1819), as well as of *Fermiers-généraux* and noblemen like Varan-chan de Saint-Geniès or Pierre-Antoine Auguste, comte de Rohan-Chabot—contained some, which can sometimes be identified by means

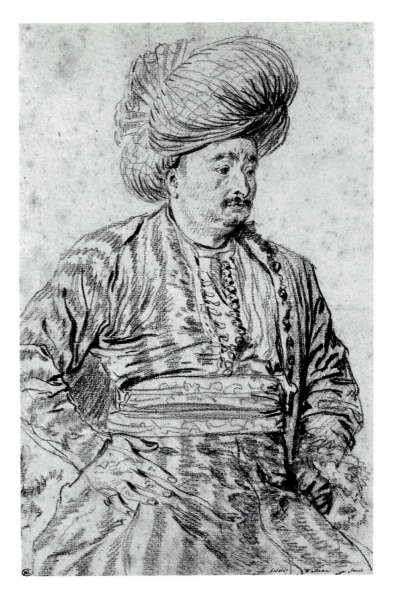

FIG. 36. Antoine Watteau, *Half-Length Seated "Persian" Wearing a Turban, Three-Quarter-Length View, Turned to the Right,* c. 1715. Red and black chalks on paper, 11⅞ x 7¾ in. (30.1 x 19.7 cm). Département des Arts Graphiques, Musée du Louvre, Paris

of the sketches that Gabriel de Saint-Aubin (1724–1780) drew in the margin of their sales catalogues.[34]

Some disputes swirled around these drawings. There is an account (very imperfect; unfortunately, the proceedings are lost) of a suit between Bergeret de Grancourt and Fragonard.[35] In 1773 the wealthy *Fermier-général* Bergeret (fig. 37) had asked Fragonard to accompany him to Italy and act as his guide, as the artist had already done, in 1760–61, for Saint-Non.[36] Fragonard made drawings throughout the journey (fig. 38). He copied certain paintings in churches and palaces (fig. 39), and sketched street scenes, picturesque views, and portraits.

During the course of his first Italian journey, Fragonard sketched almost exclusively with black chalk (rarely using red chalk, except for the wonderful landscapes of Tivoli and the Villa d'Este, today in Besançon;

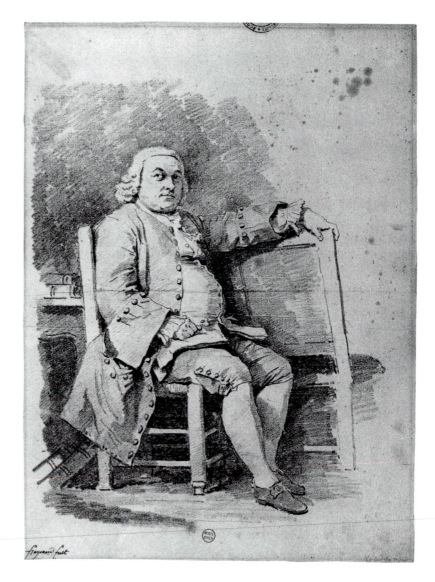

fig. 40), whereas during the second journey he tended to use bister wash. For Saint-Non he confined himself to copies of ancient masters, whereas he covered a great range of subjects while traveling with the Bergerets (the group included Bergeret's son by his first wife as well as his first wife's chambermaid, whom he would soon marry, and Fragonard's wife, the miniaturist Marie-Anne Gérard, whom Bergeret had authorized to come along—an exceptional grant, since very few artists' wives were permitted to take part in the Grand Tour in the eighteenth century). The journey proved a failure, as they ended up quarreling. On their return, Bergeret demanded the drawings made by Fragonard during their trip that he thought belonged to him—after all, he had paid for all the Fragonards' expenses—while Fragonard considered them his property.[37]

Even before the Revolution, Fragonard fell into oblivion. Not until the middle of the nineteenth century was Fragonard's painted and

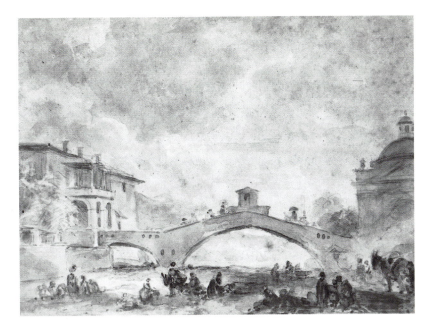

FIG. 38. Jean-Honoré Fragonard, *View of the Ponte di Santo Stefano in Sestri, near Genoa,* 1773. Bister wash over black chalk on paper, 6¼ x 8½ in. (16 x 21.5 cm). Musée des Beaux-Arts et d'Archéologie, Besançon

FIG. 39. Jean-Honoré Fragonard, after Mattia Preti (1613–1699), *The Deliverance of Saint Peter,* 1774. Bister wash on paper, 11¼ x 14½ in. (28.5 x 37 cm). Musée d'Art et d'Histoire, Narbonne

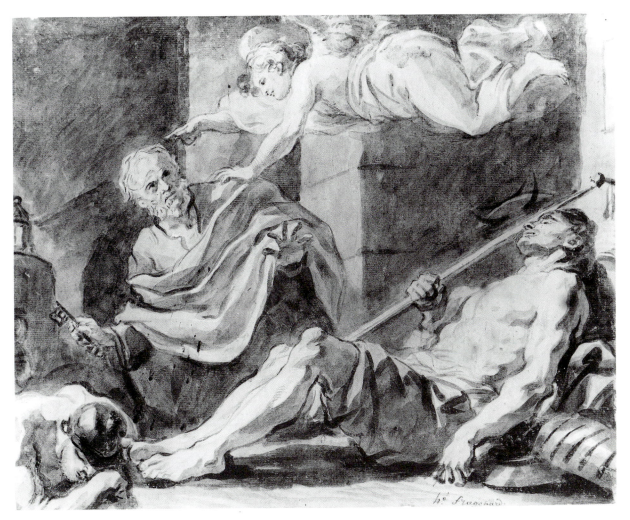

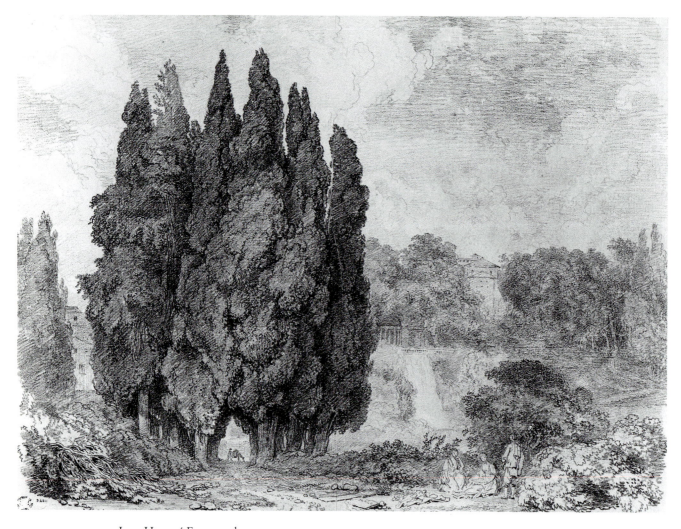

FIG. 40. Jean-Honoré Fragonard, *The Great Cypresses at the Villa d'Este with the Fontana dell'Organo,* 1760. Red chalk on paper, 14 x 18⅞ in. (35.6 x 48 cm). Musée des Beaux-Arts et d'Archéologie, Besançon

FIG. 41. Jacques-Louis David, *Old Horatius Defending His Son,* 1782. Black chalk, pen and brown ink, and gray wash on paper, 8½ x 11⅜ in. (21.8 x 28.9 cm). Département des Arts Graphiques, Musée du Louvre, Paris

FIG. 42. Jacques-Louis David, *Copies from the Antique* (page 4 of album 4), 1775–80. Black chalk on bluish paper; gray wash over black chalk on bluish paper, 19⅛ x 12⅞ in. (48.6 x 32.8 cm). National Gallery of Art, Washington, D.C., Patrons' Permanent Fund

graphic work rediscovered, thanks to connoisseurs, collectors, and critics. The name of Hippolyte Walferdin (1795–1880) must be mentioned, as he remains the greatest collector of Fragonard of all time.[38] He amassed a remarkable group of several hundred of the artist's drawings that no museum, not even the Louvre, could rival.

Like Watteau and unlike Fragonard, David carefully preserved the most important part of his graphic production. The drawings that belonged to him at his death in 1825 can be easily identified, as his two sons, Jules and Eugène, initialed each one (fig. 41). He made a great number of drawings ("a thousand drawings, perhaps more") during his

FIG. 43. Jacques-Louis David, *Studies for "The Sabine Women" and for "Homer Reciting His Poetry to the Greeks"* (fols. 1v and 2r of a sketchbook), 1794–99. *(Left)* graphite on paper; *(right)* graphite redrawn with pen and black ink on paper, 6 7/8 x 5 3/8 in. (17.6 x 13.6 cm) each sheet. Département des Arts Graphiques, Musée du Louvre, Paris

first Roman visit from 1775 to 1780.[39] After his death they were made up into a dozen "books," called "Roman albums" (fig. 42),[40] to which can be added the thirteen sketchbooks known today (eight in the Louvre [fig. 43], two in the Fogg, one in Versailles, one in Chicago, and one in a private collection, London).[41] There are many fewer individual drawings—portraits, works from the Brussels period (about seventy to date), the more finished studies for known commissions. At present, about a thousand drawings of David are known (four hundred individual ones and six hundred in the Roman albums), plus another five hundred sheets (recto and verso) of the thirteen sketchbooks.

Ingres was an indefatigable, especially prolific, draftsman. He made drawings to earn a living, for friends, and, most important, by necessity, driven by the creative impulse. Although he kept many of his drawings (he left 4,505 in his studio, now preserved in Montauban),[42] he sold some of them and was always ready to demonstrate his generosity with gifts. Admirers of Ingres's drawings, especially his portraits, have always been and continue to be legion. Among the most notable are Grenville Lindall Winthrop (1864–1943)[43] and Marianne Feilchenfeldt, to whom many American museums owe their drawings by Ingres.

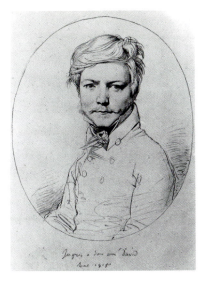

FIG. 44. Jean-Auguste-Dominique Ingres, *Portrait of Pierre-Jean David d'Angers,* 1815. Graphite on paper, 8 x 6¼ in. (20.3 x 15.8 cm). Musée des Beaux-Arts, Angers

FIG. 45. Jean-Auguste-Dominique Ingres, *Portrait of John Russell, Sixth Duke of Bedford,* 1815. Graphite on paper, 14⅞ x 11¼ in. (27.8 x 28.5 cm). The Saint Louis Art Museum

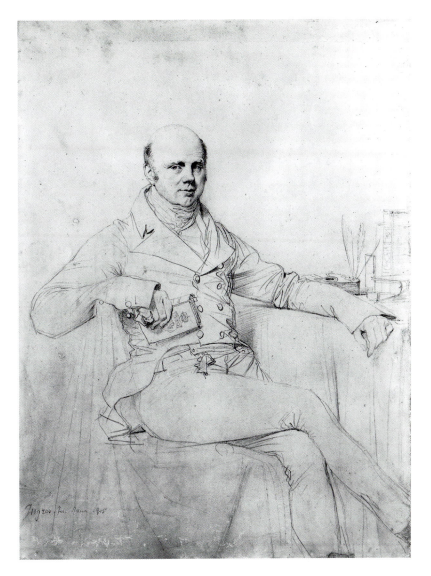

Ingres's exceptional virtuosity won recognition early on. The artist found himself in Rome and then Florence after Napoléon's fall, with no personal fortune or resources. In order to make a living, he drew portraits—very unwillingly, as he made clear—of English travelers who could once again resume the tradition of the Grand Tour. In 1818 Ingres wrote to his friend Jean-François Gilibert, "I was obliged to adopt a type of drawing (pencil drawings), from which I made my living in Rome for nearly two years."[44] These portraits proved so successful that David d'Angers (fig. 44) noted in 1816, "Many English people have invited Ingres to come to London, assuring him that in under five years he could make his fortune from his small portrait drawings alone." He added, "He is foolish enough to choose not to heed this advice."[45] Twenty-two portrait drawings dating from 1815 (see, for example, fig. 45) have been recorded, twenty-eight from 1816 and seventeen from 1817 (including fig.

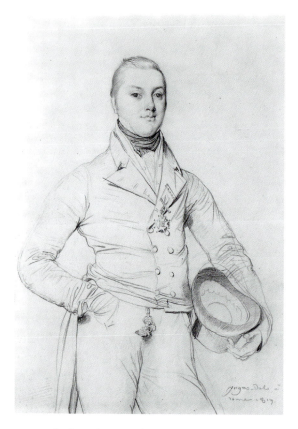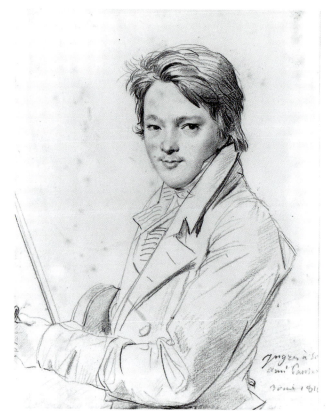

FIG. 46. Jean-Auguste-Dominique Ingres, *Portrait of Sir Fleetwood Broughton Reynolds Pellew,* 1817. Graphite on paper, 11¾ x 8⅜ in. (29.8 x 21.4 cm). Private collection

FIG. 47. Jean-Auguste-Dominique Ingres, *Portrait of the Musician Auguste-Mathieu Panseron,* 1816. Graphite on paper, 8 x 6 in. (20.3 x 15.2 cm). Musée Carnavalet, Paris

46).[46] These were difficult years for Ingres, years of "our greatest distress," affirmed Mme Ingres, who wrote, "Can you believe that in Florence, we often had no bread in the house and no more credit with the baker?"[47] In addition, throughout his life he drew portraits of his friends, to whom he dedicated these precious little gems and often presented them as gifts (fig. 47). He also made dozens of detailed preparatory drawings for each of his paintings. On his death he left his treasures to Montauban, his native town. Perhaps Ingres himself, the painter Armand Cambon (1819–1885), who can be considered the first curator of the Ingres museum, and the later curators, Jules Momméja and Daniel Ternois, wanted to organize the immense bequest, the irreplaceable evidence of a draftsman's tireless activity. However, the material remains inadequately displayed and difficult to use, for visitors as well as specialists. Do we owe this crude organization to Ingres himself? Is it possible today to distinguish in Montauban's collection the drawings by Ingres from those by his students, the visual documentation made by the master from that by one of his disciples? While Georges Vigne has enthusiastically applied himself to the task and has on many occasions explained the successive versions of the classification of the museum's collection for which he is responsible, there clearly remains a great deal more to accomplish.[48]

For Poussin we recorded 383 drawings. For Watteau, no more than

671. How many drawings by Fragonard are known today? Ananoff catalogued 2,726 sheets by the artist, undoubtedly an inflated figure, but the actual number is considerable. For David, the Louvre owns 223 sheets (including the two Roman albums, but not counting the versos) plus eight sketchbooks: in all 415 sheets. Multiplying this figure by three will probably give us the number of drawings (not including sketchbooks) by David that are extant. Naef inventoried 456 portrait drawings by Ingres, and, as mentioned, Vigne counted 4,505 sheets (some of them quite modest, many touching) at Montauban. In addition to these two figures are the drawings found in other museums and a substantial number in private collections, which we estimate at about 800.

These drawings came to us in a more or less sound state of preservation. Some of them, having been exposed to daylight in museums, notably in Montauban but also in the Louvre, have faded. Others have suffered the effects of harsh cleanings by art dealers and museums (for example, fig. 48). Some consist of fragments that were cut from larger sheets to make more individual "works," which garnered more money.

Why was Poussin's *Christ in the Garden of Olives* at Windsor cut in two horizontally (fig. 49)?[49] And what miracle brought the two fragments, which had belonged to Cassiano dal Pozzo and to Massimi, to Windsor? We will probably never know. Rarely have sketchbooks remained intact. Sometimes they were dismembered from the beginning, as we know was the case for Watteau (fig. 50), sometimes more recently, as for David's Roman albums known as the Seligman (fig. 51) and Prouté–de Bayser albums.[50] We will stop short of giving the entire list of indignities suffered by these drawings, which could be such to prevent us from judging them fairly (as, for example, in the case of some drawings

FIG. 50. Antoine Watteau, *Woman Seated; Fragment of a Man, Bust-Length, and Head of a Man Grimacing,* c. 1716. Red chalk on paper, with white heightening added by a later hand, *(left)* 8 ¾ x 5 ¼ in. (22.3 x 13.3 cm); *(right)* 5 ¼ x 6 ½ in. (13.2 x 16.5 cm). Private collection

Opposite:
FIG. 49. Nicolas Poussin, *Christ in the Garden of Olives,* c. 1628. Pen and brown ink with brown wash on blue paper, 11 ⅛ x 9 ½ in. (28.2 x 24.2 cm). Royal Library, Windsor Castle

FIG. 51. Jacques-Louis David, *View of a Pyramid* (from album 10, known as the Seligman Album), 1775–80. Pen and brown ink with brown wash over graphite on paper, 3 ⅝ x 6 in. (9.2 x 15.4 cm). The Metropolitan Museum of Art, New York, Edward Pearce Casey Fund, 1979

by Watteau in the collections of William Mayor and Paul Barroilhet, which the Goncourt brothers reported being "touched up . . . by their owners."[51]

What part of the production (to use an infelicitous term) of Poussin, Watteau, Fragonard, David, and Ingres has come down to us? How can we know the extent of what has been lost? We have already answered this question in part for Watteau. On his death, it is believed that he bequeathed to four intimates some 4,000 drawings. While alive, he gave away dozens. Today we have 671. This indicates that more than three-quarters of his graphic work has disappeared. However, a proof *a contrario* contradicts this figure. A good number of Watteau's drawings were magnificently engraved (by Boucher, among others; see, for example, fig. 52); he was the first artist to have benefited from this kind of recognition. The publication, organized by Jullienne, who probably owned the main portion of the engraved drawings, is known under the title *Figures de différents caractères.*[52] Of 351 drawings engraved in the *F.d.d.c.* (the abbreviation is widely used), we know two-thirds of them today.

Are such losses comparable for Poussin, Fragonard, David, or Ingres? We recently learned that only one of the twelve Roman albums of David has been lost.[53] Every year previously unknown drawings by Ingres or Fragonard come to light. Nothing prevents us from thinking that Poussin, as much through carelessness as through deliberate choice, destroyed a considerable portion of his drawings. He underestimated their interest, since only the completed work counted for Poussin, and he

FIG. 53. Nicolas Poussin, *Venus at the Fountain,* c. 1660. Pen, brown ink, and brown wash on paper, 10 x 9⅛ in. (25.6 x 23.2 cm). Département des Arts Graphiques, Musée du Louvre, Paris

FIG. 54. Letter from Antoine Bouzonnet-Stella to Nicolas Poussin, dated 1657 (verso of fig. 53)

would not have wished to leave them to posterity. We do not rule out, however, the possibility that new drawings by Poussin may surface. What are the odds of rediscovering some of these drawings? The answer lies in chance and the patience and labor of art historians.

INSTEAD OF AN IN-DEPTH DISCUSSION of the preferred techniques of Poussin, Watteau, Fragonard, David, and Ingres, several particulars will suffice. The paper they used has not been thoroughly studied. Poussin demonstrated a bent for economy with paper. He drew on the remaining white spaces of letters he received or on his own rough drafts, on the backs of sheets that he had previously used, sometimes years earlier (figs. 53, 54). Only Ingres took an interest in his choice of papers, paying particular attention to their quality.[54] A comparative study of the drawing practices of the five artists and those of their French or Italian contemporaries would prove instructive. Ingres frequently used tracing paper. For his portrait drawings, he employed a *tablette à tirant* (prepared tablet), which is rarely found today with the drawings.[55] A study of paper watermarks could prove extremely useful to the art historian, especially in Poussin's case, but this area has yet to be explored.[56] The practice that curators of drawings have followed in latter years of detaching drawings from their supports to reveal the versos has brought to light previously unknown compositions, especially for Poussin (figs. 55, 56) and Watteau (figs. 57, 58).[57]

Poussin favored pen and ink, usually associated with a more or less

Opposite:

FIG. 55. Nicolas Poussin, *The Confirmation*, 1644–45. Pen and brown ink, brown wash, and touches of white gouache on paper, 5⅛ x 10 in. (13 x 25.3 cm). Département des Arts Graphiques, Musée du Louvre, Paris

FIG. 56. Nicolas Poussin, *Studies for "The Confirmation"* (verso of fig. 55). Pen and brown ink with black chalk on paper, 5⅛ x 10 in. (13 x 25.3 cm). Département des Arts Graphiques, Musée du Louvre, Paris

FIG. 57. Antoine Watteau, *Head of a Black Man; Head of a Woman*, c. 1718–19. Red, black, and white chalks on paper, 6⅛ x 6⅞ in. (15.6 x 17.6 cm). Museum Boijmans van Beuningen, Rotterdam

FIG. 58. Antoine Watteau, *Study of a Lute Player* (verso of fig. 57). Red chalk on paper, 6⅛ x 6⅞ in. (15.6 x 17.6 cm). Museum Boijmans van Beuningen, Rotterdam

FIG. 59. Nicolas Poussin, *The Massacre of the Innocents,* c. 1628. Pen and brown ink with brown wash on paper, 5¾ x 6⅝ in. (14.7 x 16.9 cm). Musée des Beaux-Arts, Lille

FIG. 60. Nicolas Poussin, *Two Men Carrying a Corpse on a Stretcher (Study for "Phocion"),* 1748. Black chalk on paper, 4⅛ x 4⅞ in. (10.6 x 12.5 cm). Département des Arts Graphiques, Musée du Louvre, Paris

FIG. 61. Nicolas Poussin, *Nymph Riding on a Kneeling Satyr,* c. 1626–27. Red chalk on paper, 7¼ x 6 in. (18.5 x 15.2 cm). The British Museum, London

contrasting bister wash (fig. 59; his wash is sometimes gray). Some drawings in black chalk (fig. 60) and, more rarely, in red chalk (fig. 61; on these the specialists are divided) can be attributed to him. Watteau, by contrast, turned to red chalk first, frequently accompanied by black and white chalks (his famous "three-colored chalks"; fig. 62). Although Fragonard made many drawings simply using black chalk, red chalk, or bister wash, he also had a technique all his own. He would cast on his sheet (confusedly, it seems) several lines with black chalk, creating a sort of quasi-abstract interlaced effect, which he then covered entirely with wash (fig. 63). This wash obscured the underlying lines, rendering the initial chaos invisible. David favored black chalk, although he made many drawings with pen and ink, often with some wash as well (fig. 64), and in some more ambitious large compositions he combined all these techniques. Ingres's love of graphite, which became highly popular in the nineteenth century—for the "black lead" pencil, the "English pencil in

FIG. 62. Antoine Watteau, *Young Woman Seated, Turned to the Right, Her Right Leg Bent, Her Shoulders Bare,* 1716–17. Red, black, and white chalks on paper, 10 x 6¾ in. (25.4 x 17.1 cm). The Pierpont Morgan Library, New York

Opposite:

FIG. 63. Jean-Honoré Fragonard, *The Bedroom,* c. 1775. Bister wash over black chalk on paper, 9½ x 14½ in. (24 x 36.8 cm). National Gallery of Art, Washington, D.C., Samuel H. Kress Collection

FIG. 64. Jacques-Louis David, *Three Roman Landscapes; Copy after a Master* (page 21 of album 11), 1775–80. Pen and black ink with gray wash over black chalk on paper, 13 x 19 in. (33 x 48.5 cm) overall. The Getty Research Institute, Los Angeles

grade of hardness 3H," as Auguste-Jean Boyer d'Agen tells us—was famous.[58] Nevertheless, he also resorted at times to pen and, like Fragonard, watercolor, exploiting all these mediums in masterly fashion.

From whom or through what instincts did these artists learn which technique suited them better than another, which allowed them to get the best grasp on reality, to best communicate their intentions? It would be wonderful to know exactly how each groped his way, what problems, major or minor, he encountered, and the experiments he made before finding his path.

Poussin and Watteau, to our knowledge, never signed their drawings

FIG. 65. Jean-Honoré Fragonard,
*The Small Cascades at Tivoli with the
So-Called Temple of the Sibyl, the
Villa Mycenae, and the Grotto of
Neptune,* 1760. Red chalk over black
chalk on paper, 14¼ x 19 in. (36.3 x
48.3 cm). Musée des Beaux-Arts et
d'Archéologie, Besançon

FIG. 67. Jacques-Louis David,
*Portrait of Alexandre Lenoir and His
Wife,* 1809. *(Left)* Black chalk on
paper; *(right)* graphite on paper,
6⅛ x 8⅜ in. (15.5 x 21.4 cm) overall
on two attached sheets of paper.
Département des Arts Graphiques,
Musée du Louvre, Paris

(not to confuse signatures and inscriptions or more or less old annotations), whereas Fragonard did, for which he often adopted the form *frago* (fig. 65).[59] Ingres (fig. 66), like David (fig. 67), eschewed the use of his given names, abbreviating them to a single initial, and he sometimes dated his drawings. However (and unfortunately for the art historian), these dates are not always reliable. For example, he dated two of his drawings 1808 and 1810 (figs. 68–69), which were made after his *Romulus Victorious over Acron* in the Louvre, completed in 1812 (fig. 70). These dates, under the circumstances of the painting's commission for the Quirinal, are not possible. (These errors of dating confirm that these drawings are actually copies, undoubtedly autograph but late.)[60] In this, as elsewhere, the practice of the five artists varies, each responding to his own needs.

From Drawing to Painting

Opposite:

FIG. 68. Jean-Auguste-Dominique Ingres, *Romulus Victorious over Acron,* after 1812 (but dated 1808). Graphite and ink wash with touches of white heightening on paper, 13⅛ x 20⅞ in. (33.5 x 53 cm). Département des Arts Graphiques, Musée du Louvre, Paris

FIG. 69. Jean-Auguste-Dominique Ingres, *Romulus Victorious over Acron,* after 1812 (but dated 1810). Graphite and watercolor on paper, 12⅜ x 20 in. (31 x 50.7 cm). Département des Arts Graphiques, Musée du Louvre, Paris

FIG. 70. Anonymous, *Ingres Painting "Romulus Victorious over Acron" in Rome in the Church of the Trinità dei Monti,* 1812. Pen and brown ink with watercolor on paper, 18¼ x 22¼ in. (46.6 x 56.6 cm). Musée Bonnat, Bayonne

Has the role of counterproofs in the graphic work of Watteau or Fragonard been sufficiently investigated, or the importance of squaring and the meaning of *pentimenti* in the works of David or Ingres?

The role of the copy in the work of each of these artists also calls for discussion. The drawings of the *Museo cartaceo,* largely preserved in Windsor and the British Museum, still stimulate the interest of scholars today.[61] Cassiano dal Pozzo, Poussin's friend, wished to gather all the known evidence of the ancient world in a "paper museum." In order to carry out this enterprise, which in its universal nature foreshadowed the ambitions of Denis Diderot's *Encyclopédie,* he employed a crew of artists, among whom Pietro Testa seemed to play an important role amid other lesser-known artists such as Bernardo Capitelli and Vincenzo Leonardi. At dal Pozzo's behest, they copied statues and monuments of antiquity as well as plants, fossils, and so forth.

For a long time it was believed that Poussin had directly participated in this undertaking and that he had made copies for his friend. We believe, rather, that the *Museo cartaceo* served him as a constant source of inspiration (fig. 71).[62] When Poussin copied from antiquity—and we know his scrupulous care to describe faithfully the world of antiquity using reliable documents—he did so not from original works, which in Rome he had readily available, but from engravings of these works published in Antonio Bosio's *Roma sotterranea* (1632), from those by Francesco Villamena for Chacon's *Historia . . .* (1576; fig. 72), in du Choul's

De la religion des anciens Romains (1559), or from those of the collection of ancient works gathered in the *Galleria Giustiniani.* Interestingly, he rarely copied an entire engraving. He retained the motifs that particularly attracted him and arranged them harmoniously on his sheet, transcribing them meticulously.

Watteau also accorded the works of the ancient masters special attention. They proved all the more useful as he was unable to leave Paris—as mentioned previously—after winning second place for the Prix de Rome. Thus he had to make do with what the capital had to offer, copying works in Marie de Médicis's Rubens gallery in the Palais du Luxembourg as well as drawings in the collection of his friend Crozat. In this

FIG. 73. Antoine Watteau, after Domenico Campagnola (c. 1500-1564), *Two Young People Crouching in a Landscape,* c. 1715. Red chalk on paper, 9¼ x 9⅛ in. (23.5 x 23.2 cm). Département des Arts Graphiques, Musée du Louvre, Paris

FIG. 74. Jean-Honoré Fragonard, after Caravaggio *(left)* and Nicolas Poussin *(right), Saint Matthew and the Angel* (detail) and *The Holy Family,* 1761. Black chalk on paper, 13 x 17¾ in. (33 x 45.1 cm). Norton Simon Foundation, Pasadena, California

FIG. 75. Jacques-Louis David, partly after Jean-Auguste-Dominique Ingres, *Copies after Envoys from Rome*, 1809. Black chalk on paper, 9 x 7¼ in. (22.8 x 18.6 cm). École Nationale Supérieure des Beaux-Arts, Paris

immense collection, which for him somewhat replaced Italy, Watteau revealed his predilection for Venetian drawings (fig. 73).

Fragonard executed most of his copies during his two journeys to Italy, the first time for Saint-Non, then for the benefit of Bergeret. He copied the more or less famous paintings of churches and private galleries with an extraordinarily voracious eye. Did he himself choose the subjects, or were they due to his patrons' requests (fig. 74)? It is difficult to say. In copying paintings, he generally began with the entire work, but he might emphasize certain details, which he then transferred to his sheet with great mastery.

David was an ardent devotee of making copies, and he praised its virtues to his students (notably to his student Ingres, whom he copied in his turn; fig. 75). While he was in Rome he had formed himself a viaticum of copies, which he used throughout his career. He was primarily, but not exclusively, interested in antiquity. We owe to the indispensable Delécluze this fascinating testimony:

Among all the sketches of this period [Rome between 1775 and 1780], there is one given by David to Etienne [that is, Delécluze himself] and that Etienne preserves with even more care than the others because in handing it over, his master [David] added a rather strange verbal commentary. It is the design of two heads. One is of a young sacrificer wearing a crown of laurel. This latter, copied faithfully from antiquity, carries the air of calm that the ancients imparted to the faces of personages when they wanted to heighten their moral dignity. "You see, my friend," David said to Etienne, "here is what I used to call *antiquity in the raw*. When I had copied this head with great care and great pains, then back home, I made this one which you see drawn next to it. *I seasoned it with modern sauce,* as I put it back then. I knit the brow a touch, I brought out the cheekbones, I opened the mouth slightly, and finally I gave it what the moderns call *expression* and what today [this was in 1807] I call *grimace*."[63]

A reproduction of the drawing (which carries the date 1813, contradicting that of 1807 put forward by Delécluze) precludes the need for further commentary (fig. 76).

For David, copying had primarily a practical role. He brought back from Italy what he knew he would use and need throughout his career. Ingres, on the other hand, was driven by a curiosity that never waned until he died. He copied (and had his students make copies for him) everything that held his gaze: antiquity, Greek vases, the Middle Ages and the Renaissance (especially Raphael), John Flaxman (fig. 77), Poussin, of course, and even, surprising as it may seem, Watteau (fig. 78).[64]

Ingres, David, Watteau, and Poussin basically copied for their own use, while Fragonard worked on commission. They copied at specific moments in their careers, generally at the time of their journeys to Italy.

FIG. 77. Jean-Auguste-Dominique Ingres, after John Flaxman (1755–1826), *Seleuctos*, 1806–7. Graphite on tracing paper, 12⅛ x 13 in. (30.9 x 33 cm). Musée Ingres, Montauban

FIG. 78. Jean-Auguste-Dominique Ingres, after Antoine Watteau, *Italian Recreation*, before 1841. Pen and brown ink on paper, 5¾ x 6⅝ in. (14.7 x 16.7 cm). Musée Ingres, Montauban

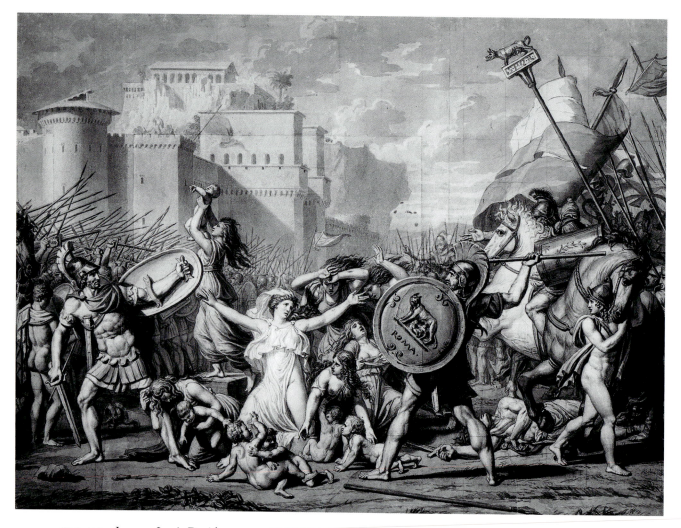

FIG. 79. Jacques-Louis David, *Study for "The Sabine Women,"* c. 1795. Pen and black and brown ink over black crayon, with gray wash and white heightening on three attached sheets of paper, 18¾ x 25 in. (47.6 x 63.6 cm) overall. Département des Arts Graphiques, Musée du Louvre, Paris

Why? Undoubtedly, in order to retain images, to recall compositions, or, if such should be the case, to earn money. For David, however, copying meant something different than it did for Ingres. Copying was strictly utilitarian for the former. For Ingres, often short on ideas, it provided a source of inspiration. Copying Raphael, however, meant trying to rise to his level, to vie with an absolute genius, to render homage to the greatest artist of all time, as well as to abase himself at his feet.

Ingres copied some engravings of Watteau from the *Recueil Jullienne*.[65] He admired him: "Watteau is a very great painter! Do you know his work? It is immense. . . . I have all of Watteau at home, myself, Monsieur, and I consult it," he declared to an unknown guest.[66] He also copied, not surprisingly, Poussin (who figures in his *Apotheosis of Homer;* fig. 91) and kept several drawings by his master, David, "the true restorer of French art and a very great master" (fig. 79).[67] While David seems to have tried to dissuade Denon from buying Watteau's *Gilles,*[68] he defended Fragonard in the Revolution and made him one of the curators

FIG. 80. Jean-Honoré Fragonard,
after Nicolas Poussin, *Theseus
Finding His Father's Arms,* 1761.
Black chalk on paper, 7 x 9⅞ in.
(17.9 x 25.3 cm). Norton Simon
Foundation, Pasadena, California

of what would become the Louvre. His well-turned phrase is well known: "He will dedicate his old age to the caretaking of masterpieces to which he contributed during his youth, enlarging their number."[69] And although very few copies by David after Poussin are known,[70] he admired him, "the immortal Poussin," and owned several engravings of his work, including *The Flood.*[71] Fragonard copied Poussin on many occasions (fig. 80).[72] Ingres and Watteau, David and Fragonard—these associations may seem surprising. They remind us to handle concepts of style and notions of influence with extreme caution.

One trait unites these five artists in their diversity of techniques, practices, and intentions. However respectful and faithful they wanted to be in respect to their models, their hand is unfailingly recognizable. Their faithfulness does not signal the renunciation of their identity. To the contrary, and each in his own way and style, they knew how to join a profound understanding of the intentions of the artist they copied to their own intentions to mark their copies with their own personalities.

Chapter 3 Practice and Idea

ANTOINE-JOSEPH DEZALLIER D'ARGENVILLE is not unknown (fig. 81). He is the author of the *Abrégé de la vie des peintres,* published in 1745 in two volumes and, in 1762, in a revised and more accessible edition in four volumes.[1] The Louvre recently published a book by Jacqueline Labbé and Lise Bicart-Sée dedicated to his collection of drawings and in 1997 devoted an exhibition to it.[2] Dezallier was himself an informed collector of drawings; while in the 1745 edition of his work he estimated his collection at "nine thousand original drawings," "arranged chronologically,"[3] by 1762 their number did not exceed "six thousand" (figs. 82, 83 were formerly in his collection).[4]

Few have read these volumes—a mistake for those interested in drawing. The qualifiers that Dezallier uses to define the style of the draftsmen he discusses (hundreds of artists, French, Italian, and northern European; we counted 254) are perfectly chosen and demonstrate his familiarity with drawing as well as a fine visual acuity. Even more, his "preliminary discussion" is among the oldest, and most pertinent, of those devoted to the knowledge and practice of drawing.

His books offer observations of great sensitivity. An example: "Drawings, infinitely superior to prints, occupy a level exactly between them and paintings; these are the first ideas of a painter, the first fire of his imagination, his style, his spirit, his way of thinking. . . . Drawings demonstrate the artist's fecundity, the liveliness of his genius, his nobility, the level of his sentiments, and the facility with which he expresses them."[5]

The volumes contain highly judicious remarks on the range of techniques, on the importance of "arranging [the drawings] in chronological order and by schools," on "the art of attributing the author" of a sheet.[6] In the phrase "the style of the country in which the drawing has been made tells us the school,"[7] we already hear the voice of Hippolyte Taine, who wrote over a century later. Instead of using the word *provenance,* he prefers the more felicitous term *filiation.*[8] He further notes: "Thus, there are two kinds of style for a painter, his own style, and that of his hand. His own style is his way of thinking, and of composing a subject; the style of his hand is the practice he has come to use in drawing in one style or

another."[9] Finally, he does not underestimate the educational gain that can be reaped from the study of drawings: "[T]hey provide the amateur with the best instruction. It is a wellspring from which can be drawn all the insights that he needs; he will converse, so to speak, he will learn in the company of these famous men; while examining a collection of their drawings, he will become familiar with them; their different styles will reveal themselves to his eyes."[10]

Of our five artists, Dezallier only knew, of course, Poussin and Watteau, and deeply admired them both. He writes about Watteau with an

FIG. 82. Antoine Watteau, *Sheet of Studies: A Standard-Bearer, Standing, Seen from Behind; Two Men Carrying Platters; Head of a Man Enclosed in a Yoke; Three Studies of Hands*, c. 1711–12. Red chalk on paper, 7¼ x 9⅜ in. (18.3 x 23.8 cm). The British Museum, London

FIG. 83. Antoine Watteau, *Studies of Ferns and Hart's Tongue with Buildings in the Center* (verso of fig. 82), c. 1714–15. Black chalk, gray wash, and traces of red chalk on paper, 7¼ x 9⅜ in. (18.3 x 23.8 cm). The British Museum, London

enviable assurance: "The taste [does he mean the style?] . . . of Watteau is extremely easy to discover."[11] But when it comes to the five artists who concern us, what will help us to advance in our knowledge of them is his proposition to separate and divide the drawings into five types: "thoughts" *(pensées),* "finished drawings" *(desseins arrêtés),* "studies" *(études),* "academies" *(académies),* and "cartoons" *(cartons).*[12]

"Thoughts," wrote Dezallier,

FIG. 84. Jean-Auguste-Dominique Ingres, *Study for "The Odalisque with a Slave,"* 1839. Pen and ink on paper, 6¼ x 7¼ in. (16 x 18.5 cm). Musée Ingres, Montauban

are the first ideas that the painter sets down on paper, for the execution of the work he has in mind; they are also called Sketches [*Esquisses*], or Preliminary Sketches [*Croquis*], because the hand has done no more than rough in the mass of and, so to speak, *sketch* the figures, the groups, the dispositions, and the other elements that compose them. These designs, uneven and executed very quickly, are often not done correctly, perhaps lacking in perspective and other elements of art; but these hardly count as faults in a sketch, whose entire purpose is to represent a thought executed with a great deal of spirit, or else isolated and imperfect figures who are intended to go into some composition to which they belong.[13]

By "uneven," he specifies in the notes that he means "depicted . . . with daring and unassertive strokes."[14]

Bellori states, "And the drawings that he [Poussin] made of his own invention were no more than spontaneous sketches, formed by rapid strokes and a simple chiaroscuro in colored wash, which nevertheless proved entirely effective for the movements and the expression."[15] The German painter Joachim von Sandrart, who knew Poussin in Rome between 1628 and 1635, mentioned "nimble sketches of general disposition."[16] Did these "thoughts" have to be made from the model, from life, from the motif, or were they pure invention, drawn from the artist's imagination? Dezallier does not specify, no doubt deliberately. It is easy to find in Poussin's work many examples of such drawings, as well as in that of Fragonard and Ingres (fig. 84), where they abound, but it is not so easy to

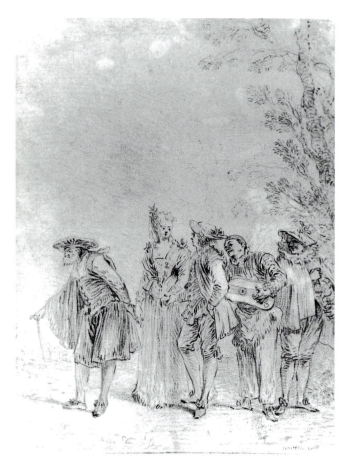

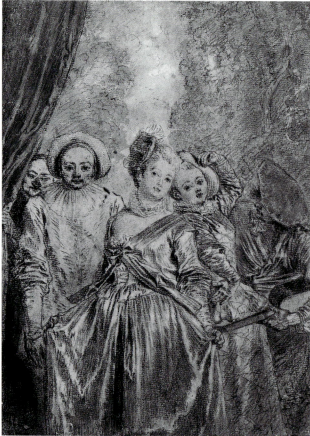

FIG. 85. Antoine Watteau, *The Badly Matched Couple*, c. 1709. Red chalk on paper (reworked counterproof), 8⅞ x 6¾ in. (22.5 x 17.2 cm). Curtis Baer collection, Atlanta

FIG. 86. Formerly attributed to Antoine Watteau, *The Italian Troupe*. Red and black chalks and gray and beige wash with stump on paper, 10¾ x 7⅜ in. (27.2 x 18.8 cm). Kupferstichkabinett, Sammlung der Zeichnungen und Druckgraphik, Staatliche Museen zu Berlin-Preussischer Kulturbesitz, Berlin

classify such sheets by Watteau or certain sketches by David in this category. For David, according to Delécluze, "it . . . was impossible to make the least mark, the simplest sketch of a figure, without a model," which he regretted, "recommending" to his students "not to fall into the same trap as he" and further advising them "to learn perspective," for, as he himself confessed, "he did not know its laws."[17]

What, according to Dezallier, characterizes "finished drawings," further qualified as "arrived, terminated, *principal*" (author's emphasis)? "More digested," these sheets "give a fair idea of the [painted] work; and it is usually by following these works, which are the last ones made, that the execution is determined." Later on, Dezallier, as a distinguished connoisseur, warns collectors, "Beware of designs that are too finished; they are rarely original; they are much easier to forge than the others."[18] He adds in his biography of Poussin, "We have almost no finished drawings from his hand."[19] (We would like to know if this "almost" is used as a rhetorical trope or if Dezallier knew some rare finished drawings that he accepted as genuine.)

Finished drawings are extremely rare in Watteau's work: "For never did he make either a sketch or a study, no matter how light or abbrevi-

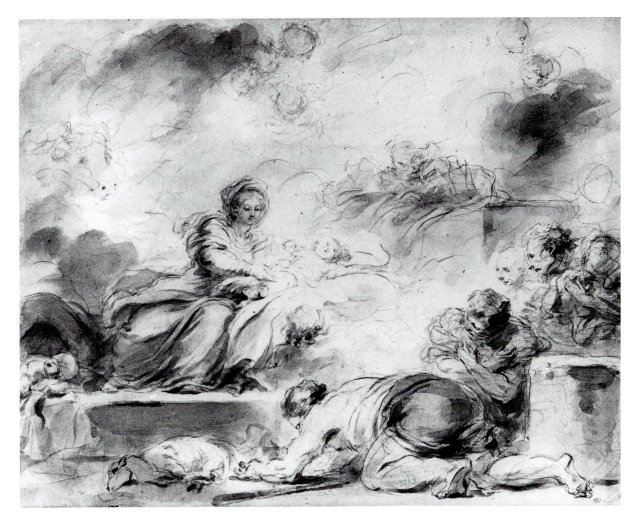

FIG. 87. Jean-Honoré Fragonard, *The Adoration of the Shepherds,* c. 1776. Bister wash over black chalk on paper, 14⅛ x 18⅜ in. (36 x 46.9 cm). Département des Arts Graphiques, Musée du Louvre, Paris

ated, for any of his paintings," Caylus wrote in an often quoted text.[20] This should lead us to reject a drawing like the one in the collection of Curtis Baer in Atlanta (fig. 85), which, to the contrary, we retain in our catalogue raisonné as authentic and instead refuse, not without a certain daring, the sheet recently acquired by Berlin, which until now the foremost specialists of Watteau's drawings have accepted as original (fig. 86).[21]

There are no known finished drawings, in the strict sense of the word, in Fragonard's oeuvre. The drawing for *The Adoration of the Shepherds* acquired by the Louvre in 1968 (fig. 87; the related painting was given to the same museum twenty years later by Roberto Polo) might qualify for this category. However, the few "finished drawings" by Fragonard that are directly related to his paintings were in fact made after the paintings for which they supposedly served as working drawings, as Eunice Williams has demonstrated.[22] Rather than preparatory works, they are *ricordi* (records). For Fragonard, his paintings are his sketches.

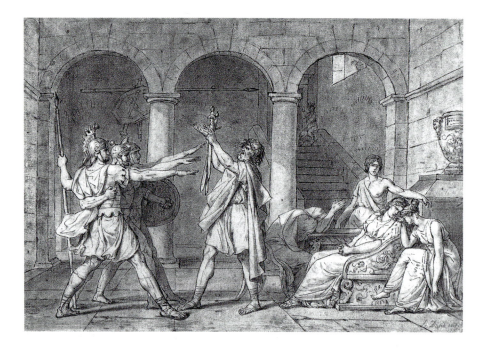

FIG. 88. Jacques-Louis David, *Composition Study for "The Oath of the Horatii,"* 1782? Pen and black ink, gray wash, and heightened with white gouache over black chalk on paper, 9 x 13⅛ in. (22.9 x 33.3 cm). Musée des Beaux-Arts, Lille

FIG. 89. Jacques-Louis David, *Composition Study for "Leonidas at the Battle of Thermopylae,"* 1813. Pen and black ink, gray wash, and heightened with white gouache over black chalk on paper, 8⅛ x 11 in. (20.9 x 28.1 cm). Département des Arts Graphiques, Musée du Louvre, Paris

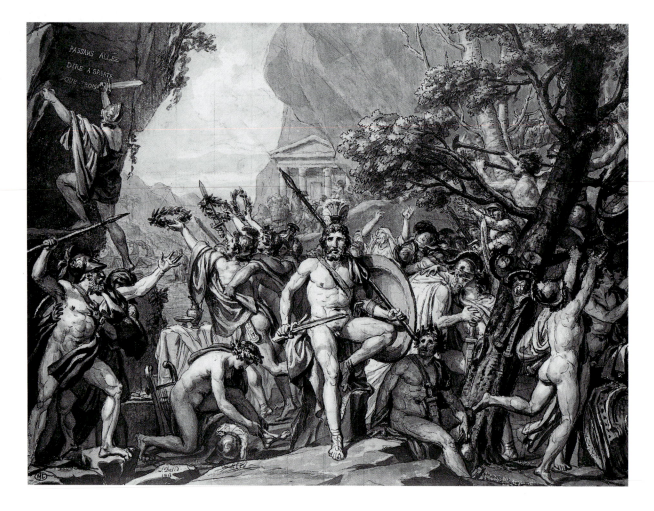

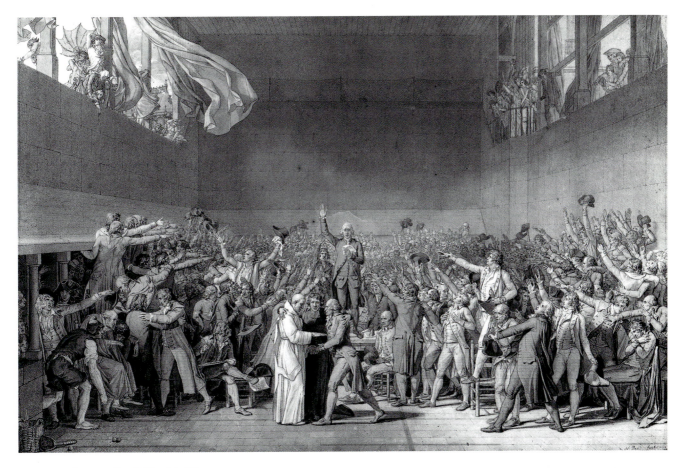

FIG. 90. Jacques-Louis David, *The Oath of the Tennis Court,* 1791. Pen and brown ink on paper, with later additions of black ink and brown wash, heightened with white, 26 x 39⅞ in. (66 x 101.2 cm). Musée National du Château, Versailles

David had his own special practice. For him, "thoughts," "finished drawings," "studies," "academies," and perhaps even "cartoons," in no particular order and in the confusion of creation, all participated at various stages of the painting's elaboration, from the initial phases to the extended developmental process. (The painting itself was subject to further transformations, sometimes substantial, in the course of its realization.)

Following Dezallier's classification, could the drawing in Lille for *The Oath of the Horatii* (fig. 88) or the one in the Louvre for *Leonidas at the Battle of Thermopylae* (fig. 89) be placed among the "finished drawings"? David, who did not care for "finished drawings," made further modifications to them before and during the execution of the painting. And is *The Oath of the Tennis Court* at Versailles a "finished drawing" or a "cartoon," as its size (more than three feet wide) would lead us to conclude (fig. 90)? Concerned with creating a contemporary history painting without having to find inspiration "in the history of ancient peoples" or, as he himself admitted, without the "need to invoke the gods of fable to excite my genius,"[23] was David overeager to commemorate an event to which he assigned its historic dimension in order to preserve the memory as he transformed it, following his vision, into a timeless image?

Practice and Idea 73

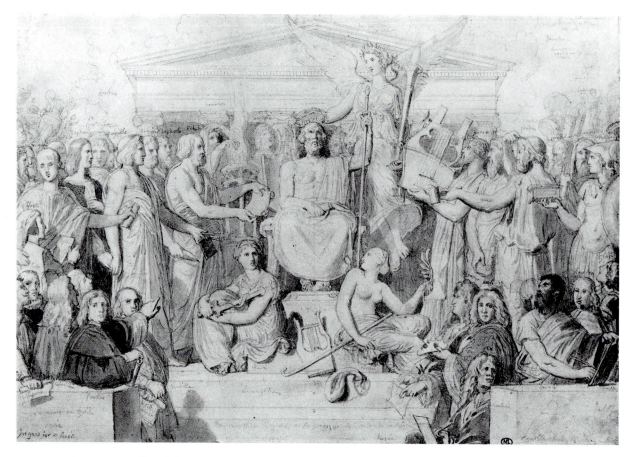

FIG. 91. Jean-Auguste-Dominique Ingres, *The Apotheosis of Homer,* 1864–65. Graphite and ink wash, heightened with white, on paper, 29⅞ x 33⅝ in. (76 x 85.5 cm). Département des Arts Graphiques, Musée du Louvre, Paris

Paradoxically, Ingres's method sometimes does not seem to be that far from Fragonard's. He liked to return to older works and copy his own paintings. Many of his "finished drawings" record painted compositions often realized at a much earlier date, such as *The Apotheosis of Homer* (1864–65, fig. 91) in the Louvre, which postdates the painting by thirty-seven years. There are exceptions, however, such as the various *modelli* for *The Golden Age* at the château de Dampierre.[24]

By "studies," Dezallier understood "portions of figures drawn from nature" (life drawing, from a "living model") or "in the round" (from cast), "such as heads, hands, feet, arms, sometimes even entire figures, those that are part of the total composition of a painting; drapery, animals, trees, plants, flowers, fruits, and landscapes are also studies that serve it immensely."[25] Here we see what, in the view of the author of the *Abrégé de la vie des peintres,* separates the "thought" from the "study." The former is intention, idea, invention; the latter is the capture of a motif, a detail, a fragment, a figure that might be used in the painted composition. Of the five artists, only David and Ingres proceeded in this manner, prolifically and throughout their careers. They even made it one of the bases of their teaching.

FIG. 92. Jacques-Louis David, *Nude Study of Napoléon Crowning Himself* (fol. 2r of a sketchbook), 1805? Black crayon on paper, 8¼ x 6½ in. (21 x 16.4 cm). Fogg Art Museum, Harvard University, Cambridge, Massachusetts, bequest of Grenville L. Winthrop

FIG. 93. Jacques-Louis David, *Napoléon Crowning Himself, the Pope Seated Behind Him,* 1805. Black crayon with touches of brown ink on paper, squared with graphite, 11½ x 9⅞ in. (29.3 x 25.2 cm). Département des Arts Graphiques, Musée du Louvre, Paris

It is easy to come up with examples. For David, the figures were alternatively studied nude and clothed (nude first, *then* clothed; figs. 92, 93). Sometimes these studies were squared off. Surprisingly, however, David frequently followed the same process as Watteau, although this method does not lend itself to direct comparison. When David painted, he might take up an old study that happened to serve his purpose. This practice has often disrupted art historians when they have attempted to assign his drawings precise dates. Antoine Schnapper, for one, judged that for the preparatory drawings for *Leonidas,* begun about 1798 and completed in 1814, "a precise and detailed chronological sequence . . . is not possible."[26]

Ingres's practice appears to resemble David's closely. Before he painted portraits, he made numerous preparatory studies. He used professional models for the portraits of the *Princesse de Broglie* and the *Baronne James de Rothschild* (figs. 94, 95), leaving behind surprising nude studies (it is surely inconceivable that these lofty ladies posed nude for the painter). In Ingres's paintings, the presence of a model always remains perceptible.[27]

This type of drawing is almost entirely absent in Poussin's work, a "situation without parallel among the painters active in Italy and France in the seventeenth century," as Ann Sutherland Harris has aptly noted.[28]

FIG. 94. Jean-Auguste-Dominique Ingres, *Study for the Portrait of the Baronne James de Rothschild,* before 1848. Graphite on paper, 8 x 5⅛ in. (20.4 x 13 cm). Musée Bonnat, Bayonne

Opposite:
FIG. 95. Jean-Auguste-Dominique Ingres, *Portrait of the Baronne James de Rothschild,* 1848. Oil on canvas, 55¾ x 40 in. (141.8 x 101.5 cm). Private collection

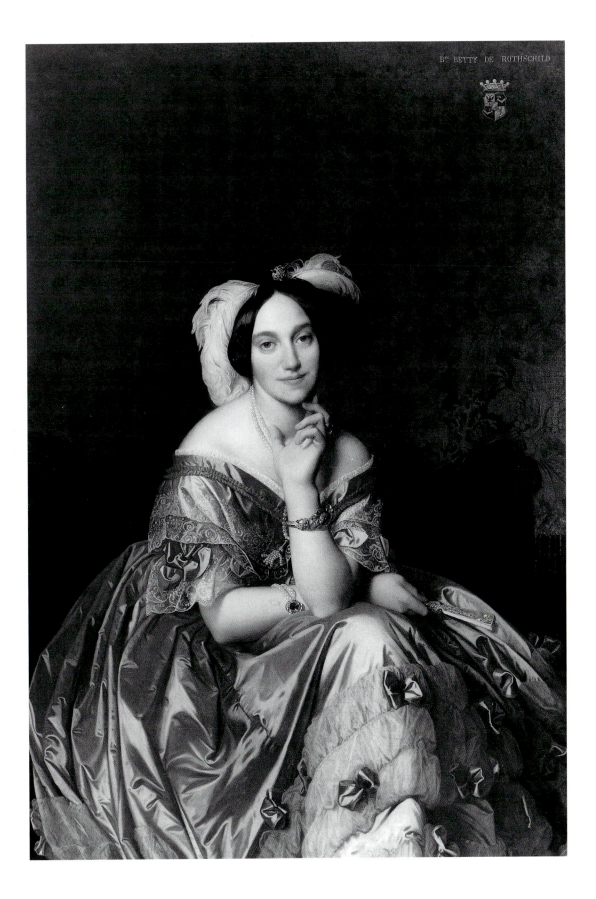

FIG. 96. Antoine Watteau, *Back View of a Woman Standing, Turned to the Right, and Leaning Forward; Study of Her Head,* c. 1716. Red, black, and white chalks on paper, 11¾ x 8 in. (29.9 x 20.2 cm without the later additions). Kupferstich-kabinett, Sammlung der Zeichnungen und Druckgraphik, Staatliche Museen zu Berlin-Preussischer Kulturbesitz, Berlin

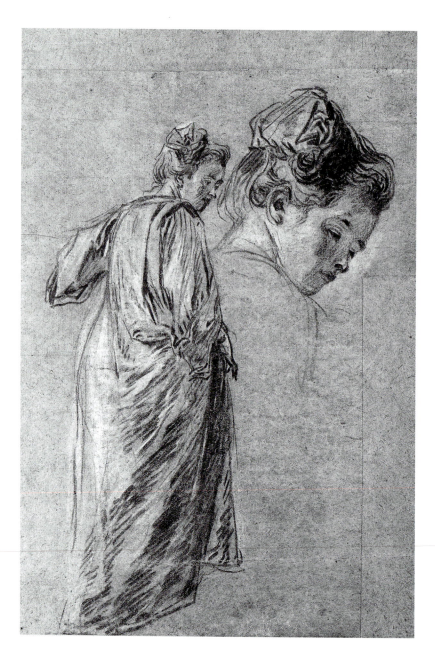

On the other hand, Watteau's work consists of nothing but studies, and we can only repeat Caylus's fundamental text:

His custom was to draw his studies in a bound book, so that he would always have a large number at hand. He had some gallant clothes, some of them comical, which he used to dress persons of the one sex or the other, depending on whom he could find willing to hold still, and he captured them in the poses that nature offered him, intentionally choosing the simplest over others. When he decided to execute a painting, he had recourse to his col-lection. From it he selected the figures that best suited him his needs of the

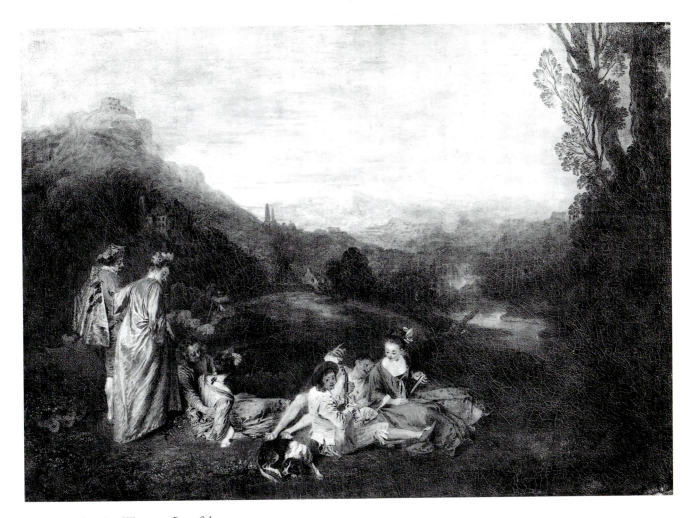

FIG. 97. Antoine Watteau, *Peaceful Love,* 1718. Oil on canvas, 22 x 31⅞ in. (56 x 81 cm). Stiftung Preussischer Schlösser und Gärten Berlin-Brandenburg, Schloss Charlottenburg

moment. He formed them into groups, usually according to a landscape background that he had conceived or prepared. He rarely departed from this practice [figs. 96, 97].[29]

What radically distinguishes Watteau from Ingres or even David is *the finality* of his drawings. The latter could understand them only in relation to a painting to come or already conceived. Nothing of the sort for Watteau. He drew with no other thought than his pleasure, with no other goal than his drawing. As for Fragonard, he had his habits, and rare are the drawings that can be classified as "studies" (unless all are considered as belonging to this group).

Moving on to the category of "academies," those "figures made from nature, in poses suitable to the composition of a painting, in order to catch exactly the nude, the shapes, the lights, and the shadows; then these figures are draped in imitation of the mannequin, in such a way as to *caress* this same nude, and to make it understandable. Nothing makes us more familiar with a master's accuracy, than these kinds of drawings;

at the same time, they reveal his ability in anatomy."[30] Such academies
still number in the hundreds today and are often surprisingly good. The
portfolios at the École des Beaux-Arts contain hundreds of them. But
none by Poussin that can be certified authentic is known. Dezallier
asserted, "There are no Academies by Poussin."[31] Passeri and Bellori,
whom we find more reliable, had the opposite opinion: "Nicolas also
practiced the study in the academies that customarily assembled in
different homes in the winter. The Academy of Domenichino, which he
eagerly frequented out of esteem for this great artist, closed following the
latter's departure for Naples. He went to Andrea Sacchi's, where Corpo-
ral Leone took off his clothes, one of the best models because he put such
spirit into the attitudes in which he was asked to pose."[32] "For the living
model, he [Poussin] frequented Domenichino's Academy, which was very
scholarly and accomplished."[33] Sutherland Harris made an effort to iden-
tify such academies (fig. 98),[34] but she has not made a convincing case.

No academies, in the narrow sense of the term, are mentioned for
Watteau either. Nonetheless, a text by Caylus allows us both to penetrate
the artist's inner nature and to gain a sense of the *function* of the academy
drawing in the eighteenth century:

He stayed mostly in several rooms that I had in different areas of Paris,
which we used only for posing the model, painting, and drawing. . . . Hav-
ing no knowledge whatsoever of anatomy, and having almost never drawn
the nude, he did not know how to understand it or express it; to the point
that the whole of an academy was painful to him and displeased him as a
result. He found the bodies of women demanding less articulation some-
what easier. This is related to what I already observed above, that the aversion
to his own work that he experienced so often arises from the situation of a

man whose thoughts surpass his abilities. In particular, this inadequacy in the practice of drawing placed painting or composing anything heroic or allegorical out of reach for him, much less rendering figures of a certain size.[35]

This is rather a harsh judgment of the creator of several magnificent nudes, mostly female (fig. 99), but it makes sense in light of the fact that Watteau never received that training or education in the Academy, without which, according to Caylus and many of his contemporaries, it was impossible to paint or compose "anything heroic or allegorical."[36]

On the other hand, Fragonard had learned from the Académie royale de peinture et de sculpture, then at the École royale, where he studied how to draw the academy and to "drape" correctly. Some examples date from his Roman years (fig. 100). Three illustrate Diderot's *Encyclopédie* (fig. 101). Others were in response to Charles Natoire (1700–1777), director of the Académie de France in Rome, who wished to fill the free time of its *pensionnaires* by having them draw "during the vacation periods . . . figures entirely draped, varied in all sorts of genres and with different clothing, especially the costume of the church which calls for very beautiful folds."[37] Nonetheless, we can say, not without

FIG. 100. Jean-Honoré Fragonard, *Man Stretched Out on the Ground, His Joined Hands Raised to the Sky,* c. 1758–59. Red chalk on paper, 12¾ x 20½ in. (32.5 x 52 cm). Musée de la Faculté de Médecine, Montpellier, Collection Atger

FIG. 101. A. J. de Fehrt (1723–1774), after Jean-Honoré Fragonard, *Kneeling Man Raising His Hands.* Engraving. Département des Estampes et de la Photographie, Bibliothèque Nationale de France, Paris

regret and some astonishment, that not a single female academy by Fragonard is known today.

Those of David—the male academies, that is—are few in number; two were acquired in 1826, at his estate sale, by the sculptor Théophile Bra, who gave them to the Douai museum in 1852 (fig. 102).[38] From Rome, where he was residing, he sent to the Académie the two superb painted academies now in Montpellier (1778) and Cherbourg (1780). And in the admirable drawings in Moscow of Hersilia and in Douai for a Sabine woman standing between Tatius and Hersilia (fig. 103) in *The Sabine Women,* we sense the artist's marked proclivity for the draped nude.

Delécluze confirms the full importance that the master accorded this exercise. In 1796, when the young Delécluze joined David's studio, then situated at the Louvre "in the eaves . . . facing the Pont des Arts," "*the model* was posed twice a week, or, rather, every *ten days,* at the time. For the first six days the model was posed nude; the last three days, a model for the head only, and the studio was closed on the tenth day."[39] David sometimes had his students pose nude. For his *Leonidas at the Battle of Thermopylae,* Delécluze tells us, he selected "a dozen of us" known for "the elegance of their stature and the agility of their movements rather than their facial features." "The exercise of swimming was highly popular in Paris then," as were "gymnastic and athletic exercises." "Among David's students, there were many that stood out in these exercises,"[40] which must have made his choices easier: "David took complete advantage both of that benefit and of their complaisance [of several of his most handsome students] to delineate, after a dozen of us, the group for the painting of the *Thermopylae,* which is composed of various figures combing their hair, fastening their shoes, or offering their floral crowns near the one who is writing on the rock. This remarkable sketch, made in the studio of the students, became the point of departure for the entire composition."[41] Delécluze also gave an account of the story concerning "the ladies of Bellegarde," one of whom posed for a figure in the *Sabines:* "It was claimed at the time, but I treated it as no more than a rumor from a painter's studio, that this person had carried her love of art to the point of posing her leg and a part of her thigh for a figure in the same painting."[42]

In truth, the academic study as David understood it broke with the practices of the Académie that he had fought so vigorously. At the Académie, the professor would give the model an acrobatic pose, which necessitated the use of "strings" and pulleys so that the model could "hold the pose."[43] David reacted against "these movements of convention," contorsions that he condemned. In his studio, David chose poses that he thought "natural" for his models.

In David's work, the female nude is exceptional (fig. 104), but it was the rule for Ingres. As we noted, he made nude drawings of the clothed

figures in his paintings, and he made this practice into a principle: "first draw the nude [fig. 105] that is to be enveloped in drapery and then the drapery that will envelop the nude."[44] It is difficult to distinguish "studies" from "academics" in the work of Ingres. With him the academy, in the highest sense of the term, attained a degree of perfection that could never be matched.

For Fragonard, the study of the academic model often meant only a draped model and the folds of the drapery. The tradition goes way back, to the stirring and grandiose precedent of Leonardo da Vinci. David, like Ingres, did not neglect this genre of study. One could almost go so far as to say that the artist's most accomplished drawings, and among the most beautiful, fall precisely into this category. Even as David adeptly molded the forms and studied, with a fine observation, each fold, as he lingered over the description of the fall, the least ridge, and, with a consummate virtuosity that is not customary with him, as he played on the contrasts of light and the effects of illumination, he did not suppress the human figure. Ingres, on the contrary, did not hesitate to study drapery as if it were a volume devoid of all content, giving it a strange form that some-

FIG. 105. Jean-Auguste-Dominique
Ingres, *Nude Study for "Joan of Arc,"*
1854. Graphite on paper, 16⅝ x 8¼
in. (42.3 x 21 cm). Musée Ingres,
Montauban

FIG. 106. Jean-Auguste-
Dominique Ingres, *Study for the
Skirt of Mme Moitessier,* 1856. Black
chalk, stump, heightened with
white, on blue paper, 8⅜ x 11 in.
(21.4 x 27.9 cm). Musée Ingres,
Montauban

times makes it unrecognizable, leading some to use (inappropriately) the
word *abstract* to describe them (fig. 106).

Let us return to Dezallier and his fifth "type" of drawing, "cartoons."
This drawing, intended to be "trac[ed] with a sharp end on the fresh
plaster of a ceiling,"[45] principally concerns fresco painters (or, in other
cases, weavers). It only rarely applies to our artists, especially since the
attribution to David of the cartoons in Lille representing Napoléon are
disputed by several specialists, and it is hard to consider as "cartoons," in
the sense understood by Dezallier, the admirable projects by Ingres for
the stained-glass windows for the chapels Saint-Ferdinand in Paris (1842)
and Saint-Louis in Dreux (1844).[46]

What should be retained of Dezallier's classification? What does it
leave out? Does it still have any relevance? It seems clear that while his
plan has certain conveniences, it also has its limitations. It does not take
into account whatever it is that often constitutes the originality of each
of these artists, the specificity of their talents, what distinguishes them
and their practice from those of their rivals, regardless of their national-
ity or period. Nevertheless, Dezallier has made it possible to cast a new
eye on the drawings of Poussin, Watteau, Fragonard, David, and Ingres
and to examine the particularities of their method.

For Poussin, everyone mentions "the box" without examining it very
closely. What did it actually consist of? Avigdor Arikha managed to
describe it precisely by seeking out the rare testimony of contempo-
raries.[47] First of all are some lines by Sandrart, whose interpretation is
problematic: "And for some 'Histories,' he would prepare a flat board, all
checkered *(Pflasterstein)* according to previous measurements on which

FIG. 107. Reconstruction of
Poussin's box (from Blunt 1967, 243)

he would display wax figures in the appropriate action, made to tell the
subtleties of the 'history,' which he clothed with wet paper, or fine
taffetas, or a material according to need, all held with threads, in such a
way that they were placed in the right distance in relation to the hori-
zon."[48] Bellori is hardly more explicit; he says nothing about the box (or
its implication) but indeed mentions "small wax models."[49] The essential
text remains that of Antoine Le Blond de Latour, a painter from Bordeaux
who has fallen into obscurity, from 1669. Poussin posed his draped "man-
nequins" on a board in "a Cube box."[50] He then made "holes" in his box,
"looking at it from there to draw his Painting on paper." Arikha notes that
the reconstruction of the box proposed by Blunt and Lawrence Gowing
in 1967 is certainly incorrect (fig. 107).[51] He aptly remarks that this prac-
tice, as well as the use of mannequins or wax figurines, could only have
been occasional. "It is conceivable," Arikha reasonably concludes, "that
Poussin used his box only to 'see' and 'verify.'"[52] It undoubtedly helped
him to resolve the shadows and the lights (figs. 108, 109). In fact, no one
saw the artist drawing—that is, no one left a record about it. Yet the
"box" made its mark; it has, so to speak, entered into Poussinian legend.

When David undertook the painting of *The Coronation of Napoléon
and Joséphine,* he had a wooden model made of the choir of Notre-Dame
"in which he placed little standing figures in the costume and pose that
the personages would have in the ceremony of the *Coronation.*"[53] The last
word belongs to Ingres, who wanted to "banish mannequins."[54] To exe-
cute *The Golden Age,* he told his longtime friend Gilibert, "I am waxing
a maquette, for the effect of the shadows."[55] And in his undated *Notes et
pensées,* as recounted by Henri Delaborde, he specified, "make a small
room like Poussin: indispensable for the effects."[56]

FIG. 110. Nicolas Poussin, *Old Woman, Seated,* c. 1630–32. Pen and brown ink on paper, 4½ x 3 in. (11.4 x 7.7 cm). Royal Library, Windsor Castle

Several firsthand accounts concerning the customs and practices of Watteau have come down to us, as mentioned above. Many fewer exist for Fragonard. Natoire, in Rome in 1759, reported his "lack of patience" and the inaccuracy of his copies but admired his "spirit." He had "high expectations" for his talent.[57] On 9 October 1773, Bergeret described him at work: "Uzerches: . . . as we arrived early in this most frightfully situated spot, on a knoll surrounded by mountains and bounded by a river dotted with dikes and mills that produce waterfalls, we have, as painters and devotees, ecstatically admired what no one admires and our doctor M. Fragonard always working and active planned and executed a drawing of this spot until dinnertime or suppertime which is just before 6 o'clock."[58] Who will identify and rediscover this picturesque view of an isolated village in Corrèze?

Bergeret's account can be compared with that of Eugène Emmanuel Amaury-Duval (1878) describing Ingres in action. He observed his quickness and the "facility" that aroused general admiration and which the artist himself distrusted ("Facility: it must be scorned even as it is used"[59]): "The pose was clearly that of a young man shooting an arrow, a Cupid, undoubtedly. Then, in front of us, in an instant and with several strokes of the pencil, while the child posed on one leg, he made a sketch of the whole; but, since the lifted leg naturally changed position with each movement the model made, M. Ingres drew another, so that, in the relatively brief time that the child could hold the pose, he had the marvelous skill to complete the whole and two legs more."[60] Does this drawing by Ingres still exist? Who will be able to connect it to this text?

Surprisingly, Dezallier neglected certain aspects of drawing that we consider essential. We will mention only one, and it is important. We can sum up in a few words a recurrent theme that comes from every pen: "to draw from nature."

There is every indication that the vast majority of Poussin's drawings were made in the studio and without recourse to a model. This would have us suppose that André Félibien's frequently cited text concerns only a minority of the artist's drawings:

He avoided society as much as possible, and escaped his friends, in order to retreat by himself to the country estates [les Vignes] and the most secluded spots in Rome, where he could at his liberty consider some ancient Statues, some pleasant views, and observe the most beautiful effects of Nature. It was in these retreats and these solitary walks that he made quick sketches of suitable things that he came upon, whether for the landscape, like terraces, trees, or some beautiful accidents of light; whether for historical compositions, like some felicitous arrangements of figures, some combinations of dress, or other special ornaments, from which he later was able to make such a fine choice and a proper use.[61]

FIG. III. Nicolas Poussin,
Landscape, c. 1645. Brown wash on
paper, 5¼ x 10⅛ in. (13.2 x 25.7
cm). Ashmolean Museum, Oxford

We believe that only a single sheet of a figure was realized "from life" (fig.
110), and the number of landscapes for which we have accepted the attri-
bution to Poussin (we will return to this) hardly amounts to many (fig.
III). We are inclined to reverse the oft-repeated phrase: Poussin only
rarely drew from nature. His drawings served to translate his ideas, to
make his thought concrete, to visualize it.

Dezallier himself tells us Watteau's approach: "Wateau [*sic*] is dis-
tinguished . . . by a greater study of nature, from which he has never
strayed."[62] Whether he drew in the studio, in those "rooms" that he fre-
quented with his friends Caylus and Hénin, at the Luxembourg, in the
gardens as well as in front of the Rubens in the gallery, at Crozat's, or in
the outskirts of Paris, Watteau always needed the support of reality, a real-
ity he sometimes disguised or clothed. He could not draw without a
model or a subject before his eyes.

Did Fragonard have a different practice? The answer seems obvious.
It is anything but clear: "Fragonard spoke often of the beauty that he
called the perfect health of nature."[63] Does this imply that the artist drew
from nature? Looking at the drawings, can we determine if he copied
faithfully what he saw? Certainly, in many cases, the answer is clear: these
oxen (fig. 112) and this man seated in an armchair (fig. 113) look as if they
were drawn from life, with the model right there, captured instanta-
neously. But is the same true for the famous representations of Tivoli and
the Villa d'Este executed during the summer of 1760? At first glance,
these ten red chalk drawings (rendering in red what is by nature green
smacks of a provocation) preserved in Besançon seem to reproduce the
sites illustrated with perfect fidelity (fig. 114). Should we trust the artist
or, as some contemporary documents indicate, did he freely interpret
reality? Fragonard naturally selected points of view that piqued his imag-

FIG. 112. Jean-Honoré Fragonard, *Two Oxen in a Shed,* c. 1770. Black chalk and bister wash on paper, 9⅝ x 15 in. (24.4 x 38.2 cm). Musée Fragonard, Grasse

FIG. 113. Jean-Honoré Fragonard, *Man Seated in an Armchair,* 1774. Bister wash over black chalk on paper, 14⅜ x 11⅛ in. (36.5 x 28.4 cm). Département des Arts Graphiques, Musée du Louvre, Paris

FIG. 114. Jean-Honoré Fragonard, *L'Escalier de la Gerbe at the Villa d'Este, Tivoli,* 1760. Red chalk on paper, 13 ¾ x 19 ⅛ in. (35 x 48.7 cm). Musée des Beaux-Arts et d'Archéologie, Besançon

ination; favoring nature over architecture, he magnified it, taking liberties with the scene offered to him. This should not surprise us, given Fragonard's technique, the confusion of chaotic lines recomposed by his brush. Fragonard does not describe, he recreates. The poet took precedence over the topographer—and who can blame him?

David declared himself incapable of drawing without having a model in front of him. As a young man, he thanked Joseph-Marie Vien for having "recommended always studying nature (and antiquity)."[64] From then on David appeared to be consistent with himself in seeming to make light of ideas: "An idea is only an intention, a vague project, such that without a confident and skillful means of execution, the artist could not give it a body and render it both comprehensible and perceptible. There are people who have *ideas* that could not be more auspicious, but they cannot render them."[65] Was David alluding to many of his students who, with the best intentions, did not know how to transform their ideas into readable, coherent, convincing, affecting images?

While Ingres is the epitome of the zealot of drawing from life, he is also among those artists who know how to deviate from what they see, a position one would expect from this defender of the "beau idéal." Citations abound: "When one knows one's craft well and has learned to imitate nature, a good painter spends most of his time *thinking* through his painting." "Drawing is not simply a matter of reproducing the shapes, the drawing does not consist simply in the line: drawing is also expression, internal form." "To express character, a certain exaggeration is allowed, it is sometimes even necessary, especially in the attempt to tease out and highlight an element of the beautiful."[66]

Ingres was not unaware "that exactitude of detail is a hindrance to

the truth of the whole." He realized how to take liberties with anatomy, noting that he "knew to put aside" the science of anatomy; he wished to simplify, and he was not afraid of distortions (fig. 115). This tendency could provoke criticism even from someone like Amaury-Duval, one of his unconditional admirers: "He made for himself a kind of drawing all his own, bizarre and of doubtful accuracy."[67] Is this not the greatest compliment one could pay to this virtuoso, this incomparable draftsman who quickly learned that drawing is also, if not above all, interpretation?

TO CONCLUDE THIS CHAPTER, we offer a citation from Honoré de Balzac's *Chef-d'oeuvre inconnu:* "You others [the old painter addresses the young 'Porbus'], you think you are finished when you have correctly drawn a figure and put every element in its place following the laws of anatomy! . . . and because you look at a nude woman standing on a table from time to time, you think you have copied nature. . . . The mission of art is not to copy nature but to express it."[68]

Chapter 4 On the Attribution and Dating
of the Drawings

EACH OF OUR FIVE ARTISTS was interested in landscape, especially views of Rome's environs. These landscapes, whether painted or drawn, present problems of attribution, some knotty and difficult to solve, yet all highly stimulating and full of information.

The painted landscapes of Poussin generally contain figures, placed very discreetly (fig. 116). Need we look for a subject in his paintings or were these pure landscapes?[1] Critical opinion is divided on this point. Nor is there any more agreement about the attribution of these works. Many formerly attributed to Poussin were actually done by his brother-in-law Gaspard Dughet. The reverse is not necessarily ruled out.[2] The confusion between the two artists is long-standing, going back to the seventeeth century.[3]

FIG. 116. Nicolas Poussin, *Landscape with Three Men*, 1648. Oil on canvas, 47¼ x 75⅝ in. (120 x 187 cm). Museo Nacional del Prado, Madrid

FIG. 117. Nicolas Poussin,
*Landscape with a Large Tree and a
Belvedere on a Hill,* c. 1645–47?
Pen and brown ink, brown wash,
and touches of black chalk on paper,
8 ¾ x 15 ¼ in. (22.2 x 38.9 cm).
Musée Condé, Chantilly

FIG. 118. Nicolas Poussin, *Saint
Zozime Giving Communion to Saint
Mary the Egyptian in a Landscape,*
c. 1635–38. Pen and brown ink with
brown wash on paper, 8 ⅞ x 12 ¼ in.
(22.5 x 31 cm). Royal Library,
Windsor Castle

The issue of Poussin's landscape drawings is particularly thorny. To
this day, no one has questioned the attribution of certain drawings that
offer no "spectacular" features and could easily be passed over (fig. 117).
Why are these accepted by the specialists, for once unanimous in
opinion?

One point strikes us as essential: the execution and technique of
these drawings must resemble the landscapes seen in the backgrounds of
composition drawings, drawings with figures by the artist (fig. 118). Cer-
tain of these sheets show landscapes sufficiently large to form a fairly clear
idea of Poussin's graphic style. To this first category, the largest in num-
ber, can be added three groups of landscape drawings that would seem
hard to separate from the work of the master. These are the preparatory

FIG. 119. Nicolas Poussin,
*Landscape with a Man Carrying a
Bird Net and a Cane*, c. 1648. Pen
and brown ink, brown and gray
washes, and black chalk on paper,
10⅜ x 15⅜ in. (26.3 x 39 cm).
Musée des Beaux-Arts, Dijon

FIG. 121. Nicolas Poussin, *Apollo
Sauroctonos*, 1660–64. Pen and
brown ink with gray wash on paper,
7⅜ x 10⅛ in. (18.8 x 25.6 cm).
Département des Arts Graphiques,
Musée du Louvre, Paris

drawings for undisputed paintings by the artist (fig. 119); those that carry fragments of Poussin's actual handwriting (fig. 120); and, finally, those whose figures are unequivocally by Poussin (fig. 121).

How can we characterize this "unyielding core?" How can we define it? The pen stroke plays a major role; the planes are clearly defined and cleanly differentiated; the leaves and trunks of trees are precisely drawn. Bister washes, generally used sparingly, have a secondary role. No virtuosity is deployed, just a quiet and measured vision suited to the drafts-

FIG. 122. Nicolas Poussin, *Path in a Glade*, 1635–40. Pen and brown ink with brown wash on paper, 15¼ x 9¾ in. (38.6 x 24.9 cm). The J. Paul Getty Museum, Los Angeles

man's means, which consists of conveying an optimum of emotion using limited technical resources.

In our catalogue raisonné of Poussin's drawings, Louis-Antoine Prat and I have held to this restrictive, limiting concept (the drawing standard, you might say; fig. 122). It must seem sacrilegious,[4] excessive in comparison with the approach adopted by Blunt and Friedlaender and especially with that of Konrad Oberhuber in his exhibition catalogue *Poussin* for Fort Worth in 1988.[5] We excluded all 29 landscapes that Oberhuber catalogued as made before 1630. We are not the first to apply

FIG. 123. Formerly attributed to Nicolas Poussin, *A Fountain in a Wood*. Pen and brown ink with brown wash over black and red chalks on paper, 10 x 7⅜ in. (25.5 x 18.9 cm). The British Museum, London

a strict standard. Two of the landscapes displayed at Oxford's exhibition of Poussin's drawings from British collections[6] that were accepted by Oberhuber[7] were attributed by Larissa Haskell and Sutherland Harris to little-known Italian contemporaries of Poussin, Bartolomeo Torregiani (d. 1675) and Giovanni Domenico Desiderii (1623–1667; fig. 123).[8] And in 1990, Sutherland Harris observed that of the 192 drawings listed by Oberhuber, only 28 had been accepted by Blunt and Friedlaender.[9]

Our exclusionary policy has been brought to bear in particular on a group of landscapes the experts of all periods have admired, and which we also admire unreservedly. These drawings had belonged to Crozat and were dispersed at his estate sale in 1741. The infallible Mariette wrote the sale catalogue. They were sold in lots with the numbers 974 to 985, 169 drawings in all: "Landscapes by Poussin, the majority made from

FIG. 124. Formerly attributed to Nicolas Poussin, *Two Trees.* Pen and brown ink with gray wash over black chalk on paper, 9⅜ x 7 in. (23.9 x 18 cm). Département des Arts Graphiques, Musée du Louvre, Paris

Nature in the country estates [les Vignes] of Rome, or in the environs of this City." Mariette cast some doubt on the attribution of the last two lots, of respectively twenty-three and twenty drawings "among which are many copies of Landscapes of the Carracci, which are said to have been done by Poussin." He gives a moving description of lot 983, consisting of six landscapes, "one executed with a trembling hand, but in which one can recognize the same idea, sublime as in all the other works of this great Master."[10] The names of some of the buyers, including Caylus and Tessin, and dealers, including Huquier, Nourri, and Mariette himself, are known to us, as well as the prices the lots brought, good but lower than Poussin's drawings for compositions in the same sale. A large number of these sheets are today preserved at the Albertina and the Louvre (fig. 124).[11]

Mariette ended his presentation of the lots of landscape drawings with a long, highly interesting, and especially vivid note, which merits a full citation:

There are very few finished Drawings by Poussin. When he drew, his only aim was to put his ideas down on paper, and they flowed in such abundance that a single theme provided him with an infinity of different sketches. A simple line, sometimes accompanied by a few strokes of wash, was enough for him to express clearly what his imagination had conceived. He did not strive for perfection of line, nor truth of expressions, nor the effect of chiaroscuro. It was with brush in hand that he studied the different elements of his painting on the canvas. He was convinced that all other methods would only obstruct inspiration, and make the work flat. His reasoning proved sound for small pictures, and Poussin made very few large ones; but if we do not find any of his Academies, nor Studies of heads and other parts of the body, we should not conclude that he scorned the Study of Nature. On the contrary, no one has consulted it more often, and he cannot even be accused of ever having worked from memory: this is why he followed a different method for the Landscape from that for the figure. The indispensable need to go and study the subject in place led him to make a great number of very careful Landscape drawings from Nature. He not only observed forms religiously, but he devoted extreme attention to capturing the lively effects of light, which he transposed to his paintings with great success. Furnished with these Studies, he next composed in his Studio these beautiful Landscapes, in which the viewer could think himself transported to ancient Greece, and in the enchanted Valleys described by the Poets. For M. Poussin's genius was entirely poetic. In his hands, the simplest and most barren subjects became interesting.[12] In the last days of his life, with a trembling and leaden hand refusing to work for him, the fire of his imagination was in no way extinguished, and this skillful Painter managed to bring forth magnificent ideas, which commanded admiration, at the same time that they caused a kind of pain to see them so badly executed.[13]

This text contains a significant phrase: "he followed a different method for the Landscape from that for the figure." Is this remark explained by the marked difference in style between the landscape drawings in the Crozat sale and those definitely by Poussin that we mentioned and reproduced above? Did Mariette hope to justify attributions he knew to be debatable by means of this observation, attributions on which he himself, in the case of at least two lots, had already cast doubt? We do not know. In any case, we are convinced of Mariette's good faith and do not suspect him of acting from commercial considerations.

As mentioned above, the Crozat landscapes are arguably among the most beautiful of the seventeenth century. Still, we do not consider them the work of Poussin for several reasons. John Shearman has already made the observation that the Crozat drawings could not be by the same hand.[14] Under the letter G (for Gaspard Dughet), this scholar isolated a group of forty-two superb drawings (fig. 125), eighteen of them display-

FIG. 125. Attributed to Gaspard Dughet (1615–1675), *Landscape.* Brown wash over red chalk on paper, 10 x 7⅜ in. (25.5 x 18.6 cm). Département des Arts Graphiques, Musée du Louvre, Paris

FIG. 126. Formerly attributed to Nicolas Poussin, *Five Trees in a Landscape.* Pen and brown ink with brown wash on paper, 9¼ x 7⅛ in. (23.7 x 18 cm). Département des Arts Graphiques, Musée du Louvre, Paris

ing comparable technique and dimensions.[15] The others were related to this group by their style.[16] It is worth noting, however, that Marco Chiarini, Eckhard Knab, Clovis Whitfield, Doris Wild, Hugh Brigstocke, and Ann Sutherland Harris did not consider the "G group" homogeneous.[17]

Two "survivors," which the most experienced Poussinists, along with Shearman, continued to consider from Poussin's hand, were worth a closer look. The first of these drawings, entitled *Five Trees in a Landscape,* belongs to the Louvre (fig. 126). For a long time it was thought to match one mentioned in the estate inventory of Claudine Bouzonnet-Stella,[18] niece and heir of a close friend of Poussin, the painter Jacques Stella (1596–1657): "At folio 44, a drawing by Poussin: five tree [*sic*] in ink."[19] In 1965 we pointed out, in *Master Drawings,* that the attribution of the Louvre drawing rested on a shaky identification: it does not actually show "five trees," and even more significant, the "ink" drawing mentioned in the Bouzonnet-Stella inventory gains in the Louvre drawing a generous bister wash not listed by the inventory writer.[20] To our mind, this disqualified the Louvre drawing from being seen as the sheet in the Stella collection. In the following issue of the same periodical, Per Bjurström illustrated a previously unpublished sheet whose subject and technique

FIG. 127. Nicolas Poussin,
*Landscape with Five Trees Lining a
Pool,* 1652–54. Pen and brown ink
over black chalk on paper, 10 x 11⅞
in. (25.4 x 30 cm). Formerly in the
University Library, Uppsala

corresponds perfectly with the description in the Bouzonnet-Stella inventory (fig. 127).[21] Preserved in the library of the University of Uppsala but stolen in 1971 or 1972 and since lost, this drawing, in ink and without wash, represents five trees. From that time it has been unanimously accepted as a work by Poussin—a conclusion that seems inevitable when it is compared with landscapes of uncontested attribution. Moreover, it very likely had been acquired by Tessin at the Crozat sale (which confirms that some authentic sheets had found their way among the 169 drawings in the Crozat collection).

The second drawing (or survivor), also unanimously accepted by specialists, is in the Musée Condé in Chantilly (fig. 128).[22] It supposedly represents a view of the Roman Campagna (Shearman called it "An arch in the campagna"). Roseline Bacou in 1967,[23] and before her Reiset, the owner of the drawing until 1861,[24] identified the site: Fort Saint-André in Villeneuve-lès-Avignon, seen from the celebrated Pont d'Avignon. Poussin might have stopped at the city of the popes on three occasions:

FIG. 128. Formerly attributed to Nicolas Poussin, *View of Villeneuve-lès-Avignon.* Brown wash with traces of brown ink on paper, 8½ x 10⅞ in. (21.8 x 27.7 cm). Musée Condé, Chantilly

in 1624 when he left for Rome or in 1640 or 1642 on his way to and back from Paris. However, from a stylistic point of view, the drawing in Chantilly could not possibly date from 1642, as Poussin's drawings from that period have a radically different conception. Only Oberhuber saw it as a drawing made in 1624, but this dating is even less convincing when compared with Poussin's earliest efforts.

If the Louvre's *Five Trees* and Chantilly's *View of Villeneuve-lès-Avignon* are not by Poussin, logic would entail eliminating the great majority of the drawings of the Crozat group from his oeuvre.[25] In any case, it is hard to imagine the artist using wash in such a pictorial manner, so freely and decoratively at the same time. Too anecdotal, too picturesque, too artful, the Crozat sheets are more in keeping with the style of Jacques Callot, Dughet, Bartholomeus Breenbergh, Filippo Napoletano, or of Claude Lorrain in particular. There is nothing in their style that suggests an attribution to a single artist, or to a French artist.

But the complexities of the problems linked to Poussin's landscape drawings call for modesty: the *View of the Aventine* in the Uffizi (fig. 129)

FIG. 129. Nicolas Poussin, *View of the Aventine,* c. 1640. Brown wash over traces of black chalk on paper, 5¼ x 12¼ in. (13.5 x 31 cm). Gabinetto Disegni e Stampe, Galleria degli Uffizi, Florence

FIG. 130. Antoine Watteau, *Landscape with a Cottage on the Right and a Well on the Left,* c. 1714. Red chalk on paper, 3⅜ x 5½ in. (8.7 x 14.2 cm). The Metropolitan Museum of Art, New York, gift of Cornelius Vanderbilt, 1880

is among the most famous drawings of the seventeenth century, one of the most spectacular and beautiful for the quality of its light. But is it by Poussin? We believe so, but Louis-Antoine Prat, our Poussin colleague, thinks not.[26]

Are all the landscape drawings attributed to Watteau beyond question? A simple look at his paintings, especially *Pilgrimage to the Island of Cythera,* shows us the artist's genius in this domain. As for his drawings, it is helpful to make a distinction between landscapes made from nature (fig. 130) from those executed after the masters, primarily Venetian. Some sheets attributed to Watteau by Parker and Mathey have been given back by Denys Sutton, Bernard Hercenberg, and ourselves to Nicolas Vleughels (1668–1737), a friend and model of the painter (fig. 131).[27] As easy as it is to separate from the work of Watteau landscapes

FIG. 131. Nicolas Vleughels (1668–1737), *The Gate*, 1723. Pen and ink and watercolor on paper, 8⅛ x 5⅞ in. (20.7 x 14.9 cm). Location unknown

Opposite:

FIG. 132. Nicolas Delobel (1693–1763), *View of the Emperor's Palace on the Palatino in Rome,* 1724. Pen and brown ink, brown wash, and watercolor, 9¾ x 15⅞ in. (25 x 40.3 cm) overall. Département des Arts Graphiques, Musée du Louvre, Paris

FIG. 133. François Boucher, *Village in a Hilly Landscape.* Red chalk on paper, 8¾ x 13¾ in. (22.2 x 34.9 cm). Fitzwilliam Museum, Cambridge

too mediocre in execution or too different in style (to this day, not a single pen and ink drawing by Watteau is known), it is much harder to offer convincing substitutions of attribution.[28] We can only wonder under which names the drawings of Nicolas Delobel (1693–1763) are kept; one of his works recently acquired by the Louvre bears a strong resemblance to the Watteau-Vleughels group (fig. 132).[29] On the other hand, a landscape that Parker and Mathey had assigned to Watteau has rediscovered its glorious paternity, as it has been restored to Boucher (fig. 133);[30] its nervous line should have alerted us. Others had to be reattributed to Jean-Baptiste Pater (1695–1736) or Louis de Silvestre (1675–1760) and, more recently, François Lemoine (1688–1737; fig. 134).[31] A thorough study of landscape painting and drawing in France in the first half of the eighteenth century remains to be carried out. Only this will permit us to distinguish Watteau's genius from the many talented specialists in the genre of the time.

FIG. 134. François Lemoine
(1688–1737), *Buildings beside a
Stream.* Red chalk on paper, 8½ x
13 in. (21.5 x 33 cm). The Pierpont
Morgan Library, New York

Opposite:
FIG. 135. Jean-Honoré Fragonard,
The Wagon Stuck in the Mud, 1759.
Pen and ink, bister, gray, and red
washes on paper, 8⅜ x 15½ in.
(21.5 x 39.5 cm). The Art Institute
of Chicago, gift of the Print and
Drawing Club

FIG. 136. Hubert Robert
(1733–1808), *Ruins next to the Sea
near Naples,* 1760. Red chalk on
paper, 13⅛ x 17⅞ in. (33.5 x 45.6
cm). Yale University Art Gallery,
New Haven, Connecticut, Everett V.
Meeks, B.A. 1901, Fund

Fragonard, without a doubt, belongs among the greatest land-scapists of his century. His drawings in this genre, which flowered during his first Italian journey (December 1756–April 1761), equal his paintings in beauty. Still, they face us with many unanswered questions. In the catalogue for the *Fragonard* exhibition of 1987–88, we regretted that it was too easy to confuse drawings by Fragonard and Hubert Robert (1733–1808). We thought that an exhibition placing the two artists side by side would be our only chance to resolve the problem. This exhibition took place in Rome during 1990–91.³² It aimed, through the comparison of their work, not only to clearly separate works by Fragonard from those by Robert but also to study their respective stylistic evolutions. Above all, it tried to determine whether it was Fragonard or Robert who had invented the genre of the landscape of the environs of Rome, the view of the Roman Campagna, a formula destined to be followed by many artists by the second half of the eighteenth century.

As early as January 1759, Natoire was encouraging his students at the Palazzo Mancini to draw "views of the environs of Rome," "teaching by example."³³ Robert had settled in the Eternal City in 1754. Fragonard arrived two years later, and his first years proved extremely difficult, forcing him to reconsider what he had learned in Paris from Boucher and the Académie. *The Hermit's Courtyard in the Coliseum* dates from 1758 (drawings by Fragonard before 1760 are rare), *The Wagon Stuck in the Mud* (fig. 135) and *Ruins of the Imperial Palaces of Rome* from 1759, and the ten views of the Villa d'Este and Tivoli, as mentioned previously, from 1760 (figs. 40, 65, 114). There are a fair number of sheets by Robert, many signed with the Italian name "Roberti," dated 1759 and 1760 (fig. 136), but we know of very few (beyond question) that carry an earlier date.

Some visual comparisons will help us to distinguish between the two

FIG. 137. Hubert Robert, *The Hermit's Courtyard in the Coliseum,* 1758. Red chalk on paper, 15⅜ x 10¾ in. (39.2 x 27.5 cm). Musée des Beaux-Arts et d'Archéologie, Besançon

FIG. 138. Jean-Honoré Fragonard, *The Hermit's Courtyard in the Coliseum,* 1758. Red chalk on paper, 14½ x 10½ in. (36.8 x 26.7 cm). Private collection, United States

artists. *The Hermit's Courtyard in the Coliseum* exists in two closely related versions; the first, today in Besançon, comes from the collection of Pâris and carries an indisputably old inscription, "Premier dessin de Robert après nature" (First drawing by Robert from nature) (fig. 137). The second, in the United States, is signed and dated "fragonard Rome 1758" (fig. 138). The two drawings, comparable in size, both executed in red chalk, were undoubtedly made "from life." Everything leads us to think that Robert and Fragonard realized them sitting side by side. Fragonard's sheet is cautious, still a bit timid. That of Robert, notably more vigorous, depicts the vegetation with spirit. This energetic execution also characterizes Robert's *Waterfall at Tivoli* (fig. 139), which can be dated 1758, while Fragonard (fig. 140), meanwhile, has taken on an elegance, a sense of space (it could be called a respiration or, following Giuliano Briganti, a dilatation),[34] a poetry lacking in Robert. From this point on, Fragonard displays a preference for nature over the ruins favored by Robert. A comparison of Fragonard's *View of Ronciglione* of 1761 (fig. 141) with Robert's *Washerwomen of Ronciglione* (fig. 142), no doubt also realized at the same time, seems to confirm this analysis.

It appears almost certain that in 1758 and 1759 Fragonard and

FIG. 139. Hubert Robert, *Waterfall at Tivoli,* 1758. Red chalk on paper, 21⅜ x 16¾ in. (54.5 x 42.5 cm). Private collection

FIG. 140. Jean-Honoré Fragonard, *Waterfall at Tivoli,* 1760. Red chalk on paper, 19¼ x 14¼ in. (48.8 x 36.1 cm). Musée des Beaux-Arts et d'Archéologie, Besançon

Robert had a relationship based on emulation or rivalry. That Robert invented the formula while Fragonard was still proceeding tentatively also seems clear. In 1758 the former gave evidence of authority and power while the latter was still finding his way. Subsequently, Robert tended to fill his entire sheet with a close view, while Fragonard opened his to light and a harmonious organization of space. But let us beware of making a premature judgment; two red chalk drawings, one in Chicago (fig. 143) and one in Lille, cause us considerable worry. They carry the inscription "Napoli 1760": do they belong to Fragonard, to Robert, or to a third artist, and if so—to whom?[35]

David is not considered to have accorded landscape with an important place in his work, at least not in his painted work. Following the fall of Robespierre, whom he ardently supported, the artist was put in prison, at first from September to December 1794 in the Palais du Luxembourg (*The Life of Marie de Medici* by Rubens, copied by Watteau, did not leave the palace until 1790). In a letter to her husband dated 14 August 1795, Mme David referred to the "landscape painting that you made in the Luxembourg."[36] "From the bars of his prison, he painted the trees in the garden, and made the only landscape he ever executed," wrote

FIG. 141. Jean-Honoré Fragonard, *View of Ronciglione,* 1761. Black chalk on paper, 8⅛ x 11½ in. (20.8 x 29.2 cm). The British Museum, London

FIG. 142. Hubert Robert, *The Washerwomen of Ronciglione,* 1761. Red chalk on paper, 12¾ x 17½ in. (32.5 x 44.5 cm). Musée des Beaux-Arts, Valence

FIG. 143. Anonymous, *Italian Landscape,* known as *"The Love Nest,"* 1760. Red chalk on paper, 14¼ x 19 in. (36 x 48.5 cm). The Art Institute of Chicago, Helen Regenstein Collection

Delécluze.[37] (Pierre-Maximilien Delafontaine, 1774–1860, another student of David's but less reliable than Delécluze, claims that in prison David painted "on canvas, from his window, two landscapes.")[38]

Since Jules David's monograph on his grandfather appeared in 1880, the painting made in prison has been identified as the work then part of the collection of Sosthène Moreau, which entered the Louvre in 1912 (fig. 144). But is this work actually by David, and does it truly represent the Luxembourg Gardens? Few dared to question this work before Anna Ottani Cavina and Emilia Calbi mustered the arguments that made it impossible to accept not only the attribution but also the identification of the site represented,[39] although their substitute for David, Louis Gauffier (1762–1801), is not wholly satisfactory. In any case, David's Luxembourg landscape has yet to be found.

During his two Roman visits, David drew profusely, including a number of landscapes, most of which were urban views "with white facades." An example from the first visit (1775–80; fig. 145) and one from the second journey of 1784–85 (fig. 146) show that from the first visit to the next, David's vision had "radicalized," to borrow Ottani Cavina's apt

FIG. 144. Formerly attributed to
Jacques-Louis David, *Landscape
Formerly Thought to be of the
Luxembourg Gardens.* Oil on canvas,
21⅝ x 25⅝ in. (55 x 65 cm). Musée
du Louvre, Paris

expression. Initially descriptive and narrative, David's conception had become stripped down, more geometric, "quasi abstract." Fortunately, these drawings bear the initials of David's two sons, which carry the weight of his own signature. Some sheets in Gauffier's Wildenstein album (today in the Getty Research Institute; fig. 147), published by Ottani Cavina,[40] like some landscapes (among close to a hundred) from the album by Drouais, astutely acquired by the Rennes museum in 1974,[41] are so close to David's style that such an attribution could easily be conferred. Master and students demonstrate the same syntax, use the same grammar, the famous "Neoclassical grammar."[42] The similarity between the work of David and that of some of his followers is such that it excuses errors of attribution. Thus, the sketchbook acquired by Berlin in 1966 as by David that contains some beautiful urban views (fig. 148) is the work of Drouais, as first suggested by Prat and as confirmed by comparing it with certain pages in the Rennes album.[43]

FIG. 145. Jacques-Louis David, *View of the Tiber near the Ponte and Castel Sant'Angelo,* 1775–80. Gray wash over black chalk on paper, 6 ½ x 8 ⅝ in. (16.6 x 22 cm). Département des Arts Graphiques, Musée du Louvre, Paris

FIG. 146. Jacques-Louis David, *View of the Church of the Trinità dei Monti in Rome* (fol. 73r of a sketchbook), 1784–85. Black crayon and gray wash on paper, 5 ¼ x 7 ⅜ in. (13.5 x 18.8 cm). Département des Arts Graphiques, Musée du Louvre, Paris

It may come as a surprise to find that several of the most uncompromising Neoclassicists, unconditional defenders of historic painting and its supremacy, should devote such perseverance and zeal to the study of landscape, a minor genre in the official classification. It is true, however, that these consist mostly of austere urban views. A grim and unrelenting gray has replaced the warm bisters dear to Poussin and the deep reds of Watteau's and Fragonard's chalk drawings. Nonetheless, for David and his disciples, these representations of Rome—a timeless Rome, emptied of its inhabitants, the ancient Rome as well as Poussin's

FIG. 147. Louis Gauffier (1762–1801), *View of Saint John Lateran* (fol. 40r of a sketchbook), c. 1785. Pen and black ink with gray and brown washes on paper, 6¼ x 8⅞ in. (16 x 22.7 cm). The Getty Research Institute, Los Angeles

FIG. 148. Jean-Germain Drouais (1763–1788), *Landscape with Santa Agnese Fuori le Muri* (fol. 47r of a sketchbook), c. 1788. Graphite and bister wash on paper, 5¾ x 8 in. (14.6 x 20.3 cm). Kupferstich-kabinett, Sammlung der Zeichnungen und Druckgraphik, Staatliche Museen zu Berlin-Preussischer Kulturbesitz, Berlin

Rome—found their place quite naturally beside the history paintings, whose philosophical, ideological, or moral content held such importance for their authors.

David painted a single landscape; it is lost. Did Ingres paint any? Hélène Toussaint, wielding convincing arguments, reattributed those in Montauban to Alexandre Desgoffe (1805–1882).[44] For the most beautiful landscape, *The Casino of Raphael at the Villa Borghese* (fig. 149), she has shared her doubts. Otherwise, she has emphasized the importance of a drawing in the Fogg Art Museum that shows the Villa Medici (fig. 150), Ingres's future residence, which from 1801 served as the seat of the Académie de France in Rome.[45] This view, which Ingres sent, along with a second drawing now lost, in January 1807 to his fiancée Julie Forestier, carries an annotation in Ingres's hand: "vue de la villa médicis depuis ma

FIG. 149. Jean-Auguste-Dominique Ingres (?), *The Casino of Raphael at the Villa Borghese,* 1807? Oil on panel, diameter 6⅜ in. (16 cm). Musée des Arts Décoratifs, Paris

FIG. 150. Jean-Auguste-Dominique Ingres, *View of the Villa Medici,* 1807. Graphite on paper, 4¾ x 8 in. (12 x 20 cm). Fogg Art Museum, Harvard University, Cambridge, Massachusetts, gift of John S. Newberry in memory of Meta P. Sachs

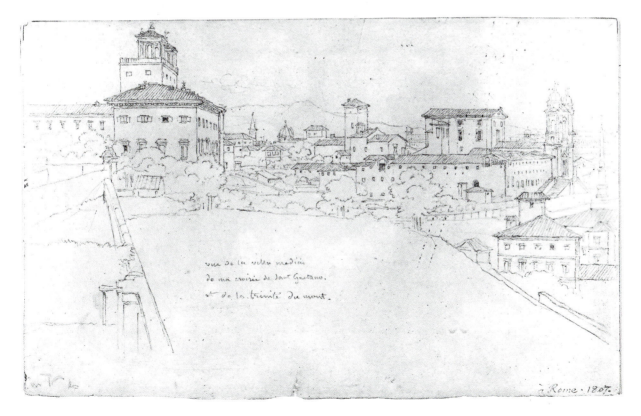

FIG. 151. Jean-Auguste-Dominique Ingres, *Portrait of Jean-Louis Robin,* c. 1810. Crayon and stump on paper, 11⅛ x 8¾ in. (28.4 x 22.3 cm). The Art Institute of Chicago, gift of Mrs. Emily Crane Chadbourne

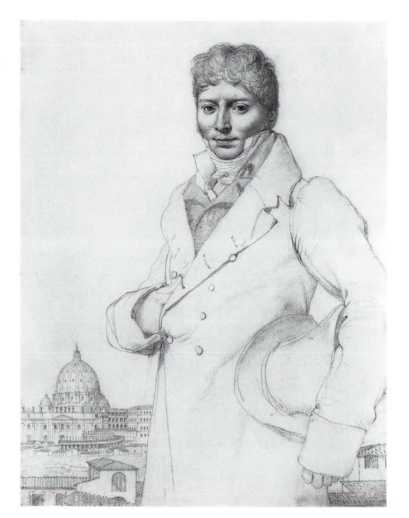

croisée de Saint Gaetano et de la trinité du mont" (view of the Villa Medici from my window at Saint Gaetano and the Trinità dei Monti).[46] Toussaint believes this to be the only landscape drawing by Ingres of unimpeachable attribution outside the Montauban museum, making it a kind of "touchstone."

Naef, the author of the catalogue raisonné of Ingres's portrait drawings,[47] published a book in 1960 entitled *Rome vue par Ingres.*[48] He illustrated it with 140 drawings from the Montauban museum, which came from Ingres's bequest, and considered them all by Ingres. But are they? In 1987 Daniel Ternois, a former curator of the Montauban collection, inspired by a little-noted article by Henry Lapauze from 1911,[49] investigated a portrait of the doctor Jean-Louis Robin (fig. 151) shown in front of the dome of Saint Peter's in Rome. He ascertained that "if Ingres had not signed it" (and he cited a certificate that accompanied the drawing) it was "due to the drawing of the architectural background, which is, it seems, the work of a colleague of Ingres, a winner of the grand prix for

FIG. 152. Jean-Auguste-Dominique Ingres, *Portrait of François-Marius Granet,* 1807? Oil on canvas, 29¼ x 24⅞ in. (74.5 x 63.2 cm). Musée Granet, Aix-en-Provence

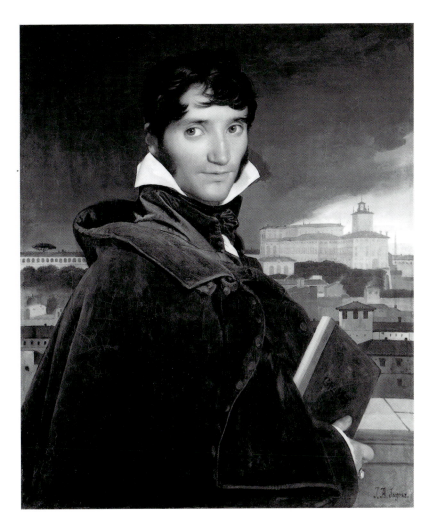

architecture." "This information is invaluable," Ternois asserts, as "it brings into question the attribution of all the architectural backgrounds in the portrait drawings by Ingres during his first Roman visit."[50]

Two authors, Toussaint and Vigne, have been working for several years to "reconsider" not only the attribution of the architectural backgrounds but also that of the landscapes in the portrait drawings and paintings of Ingres. We will not venture into the details of this complex and sensitive problem. The landscapes that embellish the portraits of François-Marius Granet (fig. 152) and Charles Cordier (1811, Louvre) appear to be the work of Granet,[51] as do those in the portraits of Moltedo in the Metropolitan Museum of Art, New York (c. 1810) and Count Gouriev in the Hermitage (1821).[52] Jean Briant, Desgoffe, Paul Flandrin (1811–1902), Cambon, and Michel Dumas prove responsible for various landscape backgrounds in some portrait paintings. The names of other fellow *pensionnaires* and friends of Ingres, such as Nicolas Didier Boguet, Pierre-Athanase Chauvin, and Pierre-Henri Valenciennes, the latter for

FIG. 153. Attributed to François Mazois (1783–1826), *Panorama of Rome from the Villa Medici,* 1816. Graphite and brown wash on bluish paper, 5⅛ x 19⅜ in. (13 x 49.3 cm). Musée Ingres, Montauban

Opposite:
FIG. 154. Master of Small Dots, *View of the Villa Medici and Its Kitchen Garden,* before 1811. Graphite on paper, 7⅛ x 9¼ in. (18.2 x 23.5 cm). Musée Ingres, Montauban

the *Portrait of Mlle Rivière,* have also been mentioned, which adds further confusion to an already perplexing issue.

Returning to the landscape drawings at Montauban, Toussaint made a case for assigning some of them to François Mazois (1783–1826; fig. 153).[53] Vigne, currently the curator of the museum, has reorganized what he views as doubtful drawings under names of convenience: "Master of Small Dots" (forty sheets; fig. 154); "Master of the Gardens of the Villa Medici" (seventeen sheets; fig. 155); or "Master of the Vivid Walls."[54] In order to enrich some of his portrait drawings with landscapes, Ingres apparently did not hesitate to use, and sometimes copy, landscapes drawn by his friends, which he bought or received as gifts. These drawings quite naturally found their way to the Ingres museum, where they quite naturally lost their authorship.

Nevertheless, an attribution to Ingres of a landscape drawing cannot always be ruled out. Almost one hundred works from Montauban's collection are indisputably by his hand. Such views as *The Stairway of Santa Maria d'Aracoeli in Rome* (fig. 156) or *The Villa Medici* (from 1817, according to Vigne) are without any doubt by Ingres. Another is *View of Vesuvius* (fig. 157), which Ingres used for his wonderful, recently rediscovered *Portrait of Caroline Murat* (fig. 158).[55] Incomparable draftsman that he was, Ingres was much more comfortable facing a model than nature. And he was surely aware of it.

FIG. 155. Master of the Gardens of the Villa Medici, *San Gaetano Pavilion in the Villa Medici,* c. 1807. Graphite and brown wash on paper, 4¼ x 5⅜ in. (10.9 x 13.6 cm). Musée Ingres, Montauban

FIG. 156. Jean-Auguste-Dominique Ingres, *The Stairway of Santa Maria d'Aracoeli in Rome,* 1806–20. Graphite and brown wash on three attached sheets of paper, 7⅛ x 13¾ in. (18 x 34.9 cm) overall. Musée Ingres, Montauban

124 *From Drawing to Painting*

FIG. 157. Jean-Auguste-Dominique Ingres, *View of Vesuvius,* before 1814. Graphite on paper, 7⅛ x 10¼ in. (18.3 x 26.1 cm). Musée Ingres, Montauban

FIG. 158. Jean-Auguste-Dominique Ingres, *Portrait of Caroline Murat,* 1814. Oil on canvas, 36¼ x 23⅝ in. (92 x 68 cm). Private collection

FIG. 159. Charles Mellin (after 1600–1649), *The Presentation in the Temple.* Pen and brown ink with brown wash on paper, 5⅞ x 4¼ in. (14.9 x 10.9 cm). New York art market

FIG. 160. Charles-Alphonse Dufresnoy (1611–1668), *The Triumph of Galatea.* Brown wash over black chalk on paper, 5½ x 8 in. (14.2 x 20.2 cm). Nationalmuseum, Stockholm

The landscape drawings of Poussin, Watteau, Fragonard, David, and Ingres, as we have seen, present interesting problems of attribution. Let me point to some other areas of concern. We have set apart several hundreds of drawings from Poussin's oeuvre that had formerly been attributed to him. In some cases the reasons are well established; for example, no one today would confuse Poussin and Charles Mellin (after 1600–1649). This was not true only thirty years ago: the works of Doris Wild,[56] Jacques Thuillier,[57] Philippe Malgouyres,[58] and our own[59] have given us the means to restore to Carlo Lorenese—to use his Italian name—his identity and his works. Many of the artist's drawings carry the inscription "Posino," but some, like the one formerly in the Getty, which was thought to be by Poussin and was acquired as such in 1984 (it came from the collection of Dezallier d'Argenville; fig. 159)[60] are more misleading. Mellin is a recent conquest of art history.

For other drawings previously attributed to Poussin, the research is less advanced. Prat and I have placed under the name of convenience "Master of Stockholm" a group of sheets characterized by certain common features of graphic style: soft forms, undefined hands and feet; empty faces; (too) elegant wash; unstructured composition, without a framework.[61] A drawing of *The Triumph of Galatea* in the Nationalmuseum, Stockholm (fig. 160) presents this artist at his most typical, undoubtedly a Frenchman working in Rome during the first half of the seventeenth century. But who is this artist? Several names, besides that of Poussin, have been given. That of Mellin should be set aside, as also that of Charles Errard (1606/1609–1689), today better known through the

FIG. 161. Jacques Blanchard (1600–1638), *Charity,* c. 1637. Red and white chalks on paper, 4⅜ x 6⅛ in. (11.2 x 15.4 cm). École Nationale Supérieure des Beaux-Arts, Paris

FIG. 162. Jacques Blanchard, *Charity,* 1637. Oil on canvas, 42⅝ x 33 in. (106.8 x 83.8 cm). Courtauld Institute Galleries, London

work of Thuillier.[62] In 1994 we hesitated between Jacques Blanchard (1600–1638) and Charles-Alphonse Dufresnoy (1611–1668).[63] We had hoped to find a sheet that Blunt (1979) tied to drawings that we have attributed to our "Master of Stockholm."[64] However, he did not reproduce it, and it was not until after our work on Poussin's drawings had come out that we were able to locate the drawing (fig. 161).[65] Comparing it with Blanchard's *Charity* in the Courtauld Institute (fig. 162), a painting that, while reduced to a fragment, is indisputable, as it exists in engraved form, its attribution to Blanchard appears convincing. By elimination, therefore, we can now identify the "Master of Stockholm" as Dufresnoy, further confirmed by a recent article by Sylvain Laveissière.[66]

Great care must be taken to avoid confusing the drawings of Watteau with those of his most successsful imitators, many of them little studied: Nicolas Lancret (1690–1743), Pater, François Octavien (1682–1740), Bonaventure de Bar (1700–1729), Peter Angillis (1685–1720), Philippe Mercier (1689–1760), or the skillful Pierre-Antoine Quillard

FIG. 163. Charles de La Fosse (1636–1716), *Head of a Negro,* c. 1715. Red and black chalks with touches of rose-colored pastel on paper, 7⅛ x 5¾ in. (18.1 x 14.5 cm). The British Museum, London

FIG. 164. Charles de La Fosse, *The Adoration of the Magi*, 1715. Oil on canvas, 168⅛ x 176 in. (427 x 447 cm). Musée du Louvre, Paris

(c. 1704–1733), who disappeared in Lisbon while still very young, to whom Martin Eidelberg has dedicated some studies.[67] In addition, there are Claude Gillot (1673–1722), one of Watteau's teachers (we are still waiting for a monograph on this first-rate artist), and the architect Gilles-Marie Oppenordt (1672–1742).[68] Two splendid drawings in the British Museum, London, had long been admired as among Watteau's masterpieces, until Jean-Pierre Cuzin restored the attribution to Charles de La Fosse (1636–1716), who influenced Watteau.[69] These two drawings of a *Head of a Negro* (fig. 163) can be recognized in *The Adoration of the Magi* (fig. 164) painted in 1715 for the choir of Notre-Dame in Paris, today housed in the Louvre.

je certiffie moi fragonard peintre
duRoy que les deux dessins que
monsieur mercier a achité a la vente
de Mr Varenchan nommé Le verou
et Larmoir sont originaux ce 7 juillet
1789

le present certificat ecrit de la main de Mr fragonard ma
été remis pour servir à Mr fiquet proprietaire des dits dessein
paris 7 juillet 1789 H Meter

Opposite:

FIG. 165. Certificate of authenticity signed by Jean-Honoré Fragonard (verso of fig. 166)

FIG. 166. Jean-Honoré Fragonard, *The Bolt,* c. 1776–79. Bister wash on paper, approx. 9⅞ x 14⅞ in. (25.2 x 37.8 cm). Location unknown

FIG. 167. Jean-Robert Ango (d. 1773), *View of a Stairway in a Roman Garden,* 1759. Red chalk on paper, 8¾ x 12⅜ in. (22.3 x 31.5 cm). Fitzwilliam Museum, Cambridge

Fragonard also had his imitators, enough to make a long list. Some of them simulated his style so cleverly that their drawings remain hidden—even today—among those by Fragonard. It is regrettable that the signatures carried on the drawings of these minor masters (Maréchal, Berthélemy, Suvée, Chaix, Jombert, Le Bouteux, Pâris, Lemonnier, the abbé de Saint-Non, to name only a few) have so often been cut off, for the greater profit of commerce, but to the detriment of art history and, of course, the reputation of these artists. Even in his own lifetime, Fragonard had to take steps to protect himself; in a certificate dated 7 July 1789 (a week before the storming of the Bastille; fig. 165),[70] he guaranteed the authenticity of *The Bolt* (fig. 166) and *The Cupboard,* two drawings realized about fifteen years earlier.

Two particularly dangerous imitators are worth mentioning: Jean-Robert Ango, who died a pauper in Rome in 1773, and François-André Vincent (1746–1816). The very existence of the former was even questioned by scholars: was not *Ango* simply *Frago* playing with some letters of his name? However, there is evidence to restore Ango's place in history; he was mentioned by Mariette and Julien de Parme.[71] He had accompanied Fragonard to Naples to make copies for Saint-Non and he made copious drawings, from the antique, after Michelangelo.[72] He skillfully imitated the drawings of Robert, not hesitating to sign them (fig. 167) as well as those of Fragonard. Today it is believed that his style is recognizable and that his work can be distinguished from that of his victims; his line, which he repeated and seemed to double, is emphatic, monotonous. What is Ango still hiding and what surprises does he still have in store for us?

FIG. 168. Jean-Honoré Fragonard, *Woman of Santa Lucia in Naples,* 1774. Bister wash over black chalk on paper, 14⅜ x 11⅛ in. (36.4 x 28.1 cm). Graphische Sammlung, Städelsches Kunstinstitut, Frankfurt

Opposite:
FIG. 169. François-André Vincent (1746–1816), *Neapolitan Woman,* 1774. Oil on canvas, 32 x 19⅝ in. (81.5 x 50 cm). Private collection

Vincent was a fine painter and an exceptional draftsman. His work is as varied as it is prolific. A resident at the Académie de France in Rome between 1771 and 1775, from October 1773 to July 1774 he belonged to the small circle that formed around Bergeret and Fragonard. Sometimes Vincent and Fragonard painted or made drawings from the same model, which makes it possible to distinguish their work (figs. 168, 169).

But who is the author of the four celebrated studies of young girls in the Besançon museum? Should we stand behind Cuzin, who accorded two to Vincent (fig. 171) and two to Fragonard (fig. 170)?[73] On the other hand, are the two heads of a man, one wearing a fur hat (fig. 172), the other a white turban (fig. 173), by the same artist? Or could one perhaps be attributed to Fragonard and the other to Vincent? All of this remains open to question.[74]

Let us tackle the sensitive issue of forgeries. On 8 and 9 March 1978, Geraldine Norman of the *Times* (London) wrote: "More than 30 'Frago-

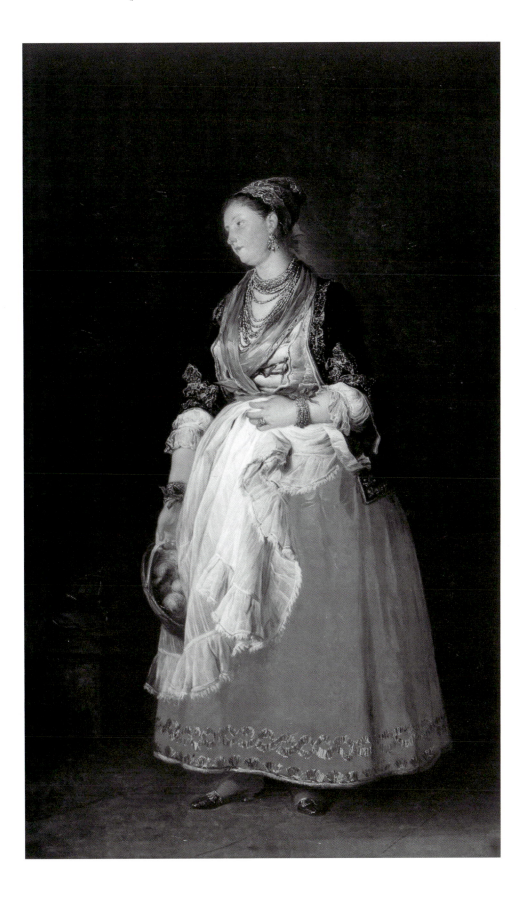

FIG. 170. Jean-Honoré Fragonard,
Little Girl Sitting on Her Heels, 1774.
Red chalk on paper, 15⅛ x 11⅜ in.
(38.4 x 28.9 cm). Musée des Beaux-
Arts et d'Archéologie, Besançon

FIG. 171. François-André Vincent,
Little Girl Sitting on Her Heels, 1774.
Red chalk on paper, 13⅛ x 9⅞ in.
(33.5 x 25.1 cm). Musée des Beaux-
Arts et d'Archéologie, Besançon

134 *From Drawing to Painting*

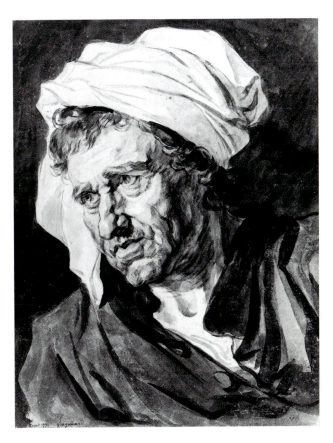

FIG. 172. François-André Vincent
or Jean-Honoré Fragonard (?), *Head
of a Man with a Fur Hat*, 1774.
Bister wash on paper, 14⅜ x 11⅜ in.
(36.5 x 29 cm). Fitzwilliam Museum,
Cambridge

FIG. 173. François-André Vincent
or Jean-Honoré Fragonard (?), *Head
of a Man with a White Turban*, 1774?
Bister wash on paper, 14½ x 11 in.
(36.8 x 28 cm). Graphische
Sammlung, Städelsches
Kunstinstitut, Frankfurt

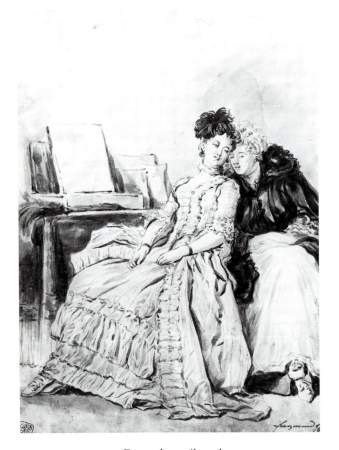

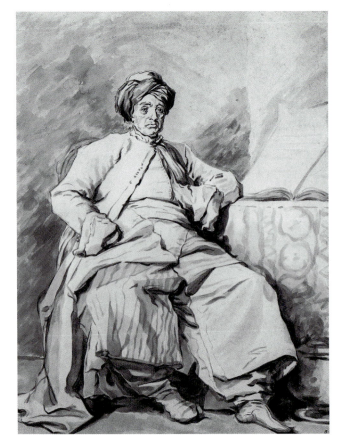

FIG. 174. Formerly attributed to Jean-Honoré Fragonard, *The Secret.* Brown wash over black crayon on paper, 12 x 8¾ in. (30.4 x 22.3 cm). The National Gallery of Canada, Ottawa

FIG. 175. Formerly attributed to Jean-Honoré Fragonard, *The Sultan.* Bister wash on paper, 14¼ x 11¼ in. (36.2 x 28.5 cm). The Metropolitan Museum of Art, New York, bequest of Walter C. Baker, 1971

nard' drawings may be fakes. Copies of eighteenth-century works believed to have been marketed in Paris." The well-documented article reproduced two of these "fakes," *The Secret* (fig. 174), which had just been acquired by the National Gallery of Canada, and *Young Woman Stretched Out in a Garden,* which was on the New York art market. Norman cited Ananoff, who compiled the catalogue raisonné of Fragonard's drawings.[75] In his preface to the first volume, he had noted that Fragonard repeated and copied his own work. "Thus he quite naturally resorted to the 'copie à la vitre' (copy at the windowpane) if he wanted to reproduce a work in its original dimensions, or with a pantograph if he wanted to change the dimensions." (Ananoff later gave a precise description of the device used for making a "copie à la vitre.")[76]

Could not this practice have guided the "forger" alluded to in the *Times* article? The answer comes by way of a drawing at the Metropolitan Museum of Art. *The Sultan* (fig. 175) had been acquired by Walter C. Baker between 1957 and 1960.[77] It carries at lower right the stamp of the collection of Denon,[78] the director of the Louvre under the Empire, and figured in his estate sale of 1–19 May 1826 (no. 729): "Dessin au lavis, au bistre représentant un turc assis" (wash drawing, bister, representing a seated Turk). The entry in the sale catalogue bore an asterisk, which indi-

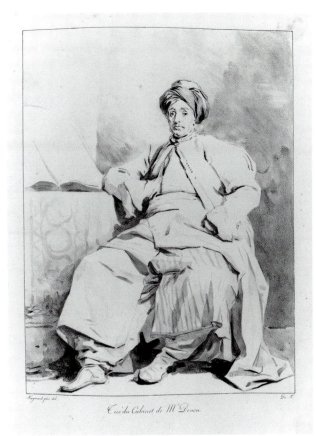

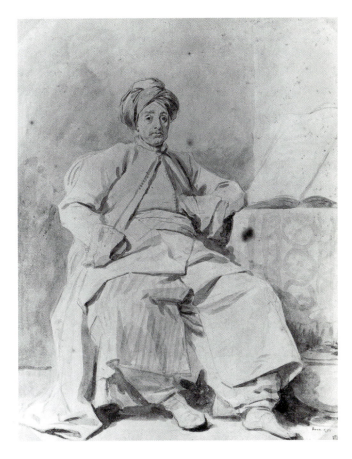

FIG. 176. Dominique-Vivant Denon (1747–1825), after Jean-Honoré Fragonard, *The Sultan.* Lithograph. Private collection, Paris

FIG. 177. Jean-Honoré Fragonard, *The Sultan,* 1774? Brown wash and black chalk on paper, 14⅛ x 11¼ in. (36 x 28.5 cm). Location unknown

cated, and Ananoff mentions, that the drawing had been lithographed (undoubtedly for its publication in *Monuments des arts du dessin;* fig. 176). Ananoff added, "We were able to examine the lithograph." It is exceedingly rare.[79] The original drawing (fig. 177) came up at auction in London in 1962.[80] It was signed and dated "Rome 1774" and carries the stamp of Denon. Unfortunately, it has been lost from view, and it is known from only a mediocre reproduction.[81] The "forger" knew about the lithograph and was aware of its rarity. He copied it "à la vitre" and affixed on the copy an imitation of Denon's stamp. He could hardly have imagined that the original would resurface. The drawing in the Metropolitan Museum is a forgery of exceptional skill.

Today we know, owing to the work of Virginia Lee, Marie-Dominique de La Patellière, and Philippe Bordes, that a group of drawings at the Fogg Art Museum (fig. 178) and the Art Institute of Chicago attributed to David and related to his *Oath of the Tennis Court* were actually executed by Jean-Pierre Norblin de La Gourdaine (1745–1830), a French artist who worked in Poland for thirty years.[82] Dare we also cast doubt on the authorship of a famous drawing in the Louvre? It supposedly represents Jeanne-Suzanne Sedaine, one of the two daughters of Jean-Michel Sedaine, who helped David in his early days.[83] The signature

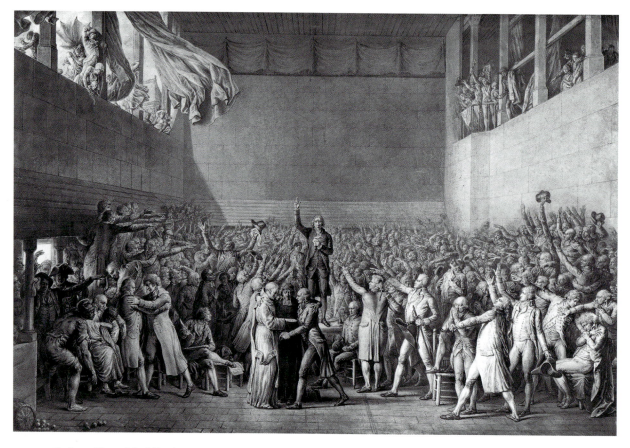

FIG. 178. Jean-Pierre Norblin de
La Gourdaine (1745–1830), *The
Oath of the Tennis Court*, 1805,
reworked in 1814. Pen, black and
brown ink, brown and gray wash,
and white gouache over black chalk
on tracing paper, 20⅝ x 30¼ in.
(52.4 x 76.8 cm). Fogg Art Museum,
Harvard University, Cambridge,
Massachusetts, bequest of Grenville
L. Winthrop

is strange, the model's identity uncertain, the provenance hardly convincing, and the style seems too elegant, too graceful. In comparison with the splendid portrait drawings that David made during the Revolution, the sheet in the Louvre shows a surprising reversion to the style of the eighteenth century, especially Henri-Pierre Danloux.

Would we not hesitate more often with David's drawings if they did not carry his sons' initials? These initials reassure us, but they may also blind us. If a drawing carries these initials, we tend to accept it with "closed eyes," that is, without examining it critically. Do we know how to "look" at a drawing by David? The fact that his students vied to better one another at imitating their teacher and were formed in the mold of his style makes such an exercise even more complex.

Neoclassical drawing in general is particularly difficult to attribute. To return to Delécluze:

One day, going through the portfolios, David came upon two drawings by Etienne [Delécluze]. One depicted Cimon shepherding the women and children onto ships at Piraeus, to defend Athens; and the other Leonidas with his Spartans preparing for battle. These two compositions, which David had honored in the contests established in his teaching studio, had

FIG. 179. Nicolas Poussin, *Battle between the Romans and the Sabines,* 1622–23. Graphite underdrawing, pen and brown ink with brown wash on paper, 7⅛ x 12½ in. (18 x 31.8 cm). Royal Library, Windsor Castle

FIG. 180. Nicolas Poussin, *The Death of Germanicus,* 1636–40. Pen and brown ink with brown wash on paper, 6⅜ x 9½ in. (16.3 x 24.1 cm). Musée Condé, Chantilly

been ceremoniously placed by him in his portfolios. The master . . . repeated the praises he had earlier bestowed on these efforts; then, suddenly pulling the drawing of Leonidas from the portfolio, "Wait, my dear Etienne," he said, "I will return to you this drawing that you lent me and which gave me the idea of two groups that I put in my painting of the *Thermopylae.* Hold on to it, it will be a reminder both of your studies and of your master's manner of working. As to the one of Cimon, I like it and as you gave it to me, I will keep it.[84]

In all likelihood, Delécluze's drawing never left David's portfolios. Could it have been pasted into one of his albums on his death? Did his

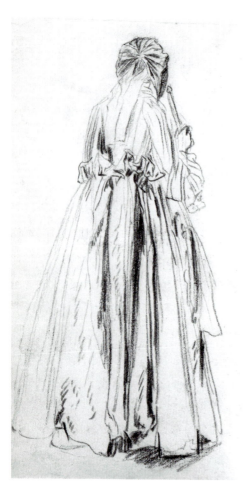

FIG. 181. Antoine Watteau, *Woman seen from the Back, Wearing a Bonnet with Ribbons, a Lorgnette in Her Hand,* c. 1713–14. Red chalk on paper, 7 x 3⅞ in. (18 x 10 cm). Private collection

sons add their initials to it? And if it is still in existence, who will know to look at it carefully and attribute it to its actual author?

We will not linger over the drawings of Ingres. Several copies have passed as originals, and several drawings by his students have sometimes been attributed to him. But his exceptional virtuosity puts all his imitators in the shade.

HOW ARE ATTRIBUTIONS MADE? Are paintings and drawings attributed in a comparable way? Is there a method? Can it be taught, can some elementary rules be specified for the benefit of the curious and connoisseurs? Can it be turned into theory? It is impossible to overemphasize the importance of provenances and histories. Beyond that, the most incisive critical judgments come from the familiarity born of the daily handling of originals as well as photographic reproductions, in drawing collections in museums as well as galleries and auction houses.

Knowing how to attribute a drawing involves knowing how to date it, as demonstrated in the following examples. In his *Poussin* catalogue for Fort Worth, Oberhuber rejected Windsor's fifteen drawings, most of them illustrating Ovid's *Metamorphoses,* supposedly made in Paris for the poet Giambattista Marino about 1622–23. He judged these as copies made after Poussin in Italy about midcentury.[85] However, in 1991 Martin Clayton discovered on one of these drawings, the *Battle between the Romans and the Sabines* (fig. 179), the watermark of a papermaker in the area of Troyes, Jean Nivelle, who it seems did not produce any paper after 1621.[86] This information leads to the near certain conclusion that the Windsor drawings had indeed been created in France by Poussin, before he left for Italy in 1624.

For a drawing in the Musée Condé, Chantilly, representing *The Death of Germanicus* (fig. 180),[87] everything pointed to a date of 1627, the date of the famous painting in the Minneapolis Institute of Arts—everything, that is, except the style. Comparing it with drawings from the years between 1632 and 1640, such as those for the first series of the *Seven Sacraments* in Belvoir Castle, it becomes clear that the sheet in Chantilly was executed well after the painting. Why, and for whom? Had Poussin received a commission for a second version, or did Chantelou, who owned the drawing, want a reminder of the painting? It remains a mystery.

The problems involved in dating Watteau's drawings are particularly difficult. They arise from the artist's singular way of working. A sheet executed in 1713–14 might not be used in a painting until 1720. That is the case for the drawing that shows a back view of a woman holding a lorgnette, or opera glasses (fig. 181).[88] The same figure, for the most part unaltered, appears in *Gersaint's Shop Sign,* an absolute masterpiece of European painting. If we compare it with one of the rare preparatory

FIG. 182. Antoine Watteau, *Two Men Handling Frames, One for a Painting, the Other for a Mirror,* c. 1720. Red, black, and white chalks on paper, 6 ⅝ x 8 ⅞ in. (16.8 x 22.7 cm). Musée Cognacq-Jay, Paris

FIG. 183. Antoine Watteau, *The Shipwreck,* c. 1712. Red chalk on paper, 8 ¾ x 13 ¼ in. (22.3 x 33.9 cm). Ashmolean Museum, Oxford

drawings today connected with that painting, *Two Men Handling Frames, One for a Painting, the Other for a Mirror* (fig. 182), it becomes evident that the former drawing is considerably earlier than the latter.[89]

The date of *The Shipwreck* at the Ashmolean Museum, Oxford (fig. 183),[90] causes no less embarrassment. This drawing has been seen as an allusion to Watteau's voyage to England (from 1719 to 1720) and his own financial wreck that had been one of his reasons for going there. (The

FIG. 184. Antoine Watteau, *Woman Spinning Thread, Standing,* c. 1714; *Right Profile of a Female Head,* 1717–18. Red chalk on paper, 6⅜ x 4¾ in. (16.4 x 12.2 cm). The Metropolitan Museum of Art, New York, bequest of Anne D. Thomson, 1923

FIG. 185. Jacques-Louis David, *The Queen of Naples,* 1817–20. Black crayon on paper, 7¾ x 5⅝ in. (19.7 x 14.3 cm). Musée des Beaux-Arts et d'Archéologie, Besançon

bankruptcy of John Law's "Compagnie des Indes" [Company of the Indies] had swallowed a portion of the artist's modest fortune, and he hoped to make some profits in London. The other reason he made the voyage was to consult the celebrated Dr. Richard Mead [1673–1754] about his shattered health.) Yet the technique of the drawing prevents a dating of 1720, inviting instead a date of about 1712. Its mysterious subject is still to be identified.

To complicate matters further, Watteau's career was very short, and the evolution and development of his style were particularly rapid. Watteau also was known to draw in bound sketchbooks, as mentioned earlier. He opened them at random and, on a page previously used and already carrying a drawing, would add a new study or several studies. A good number of such sheets by Watteau, bearing works executed at considerable intervals of time, are known (fig. 184).[91] Distinguishing Watteau's successive additions to a sheet calls for great familiarity with his work.

We will not go into the issue of dating Fragonard's drawings; the solid examples to anchor dates are rare, too rare, and the artist frequently made drawings after the paintings they supposedly helped to prepare.

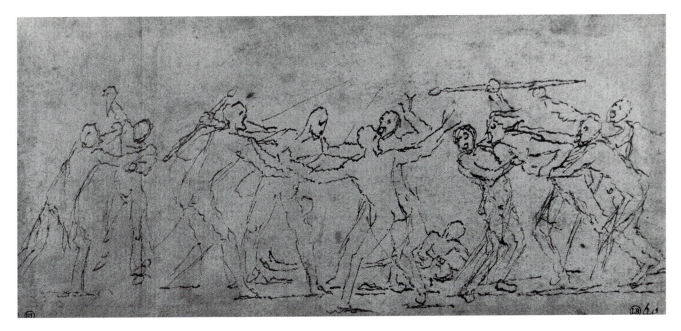

FIG. 186. Nicolas Poussin, *Ten Men Fighting, Two Others on the Ground,* c. 1650. Pen and brown ink on paper, 4 x 8⅞ in. (10.1 x 22.5 cm). Musée Bonnat, Bayonne

Ingres, on the other hand, provided many dates, but they are not always reliable. Let us pause, however, to question a group of drawings by David. The Besançon museum contains a group of studies of heads presumed to be studies for *The Coronation of Napoléon and Joséphine* (fig. 185).[92] The style, however, rules out a dating of 1805–7. Like Schnapper,[93] we believe that these sheets are actually autograph replicas made by David "from memory" (these words ["de souvenir"], in David's hand, can be read on many of the Besançon sheets), in preparation for the second version of the work, completed in 1822 and now preserved in Versailles.

We have often used the terms *style, graphic style,* and *stylistic evolution* in this chapter. These are useful but do not explain everything. Why does an artist change his style? What are the reasons behind these developments, these transformations, these changes? What forces are they obeying? It is, of course, impossible to say. There are material imperatives, declining health, age, the trembling hand of an aged Poussin (fig. 186). There are also the encounters of youth and the revelations of maturity, as well as what we bundle, for the sake of convenience, under the word "influences" (a word that demands its own thorough study someday). There is concern to adapt to the taste of the time (as seen with Fragonard). There are events in public or private life that can make their impressions on a style (such is the case with David).

These changes are rarely fortuitous. They have their logic, although difficult to pin down, and it is on this that the accurate dating of a drawing finds its footing. Dating a drawing involves, above all, understanding—understanding the painting for which it serves as a study, understanding the artist who conceived it.

Chapter 5 Drawing and Money

FIG. 187. Jean-Auguste-Dominique Ingres, *Portrait of Hippolyte Flandrin*, 1855. Graphite on paper, 12⅝ x 10 in. (32.2 x 25.3 cm). Musée des Beaux-Arts, Lyons

POUSSIN, WATTEAU, FRAGONARD, DAVID, AND INGRES all made thousands of drawings. What did they do with them? Some drawings were destroyed. As noted previously, Poussin did not save his drawings—not because he did not value drawing, but because only the finished work mattered to him. Others were carefully saved, even the simplest rough sketches. Sometimes the artists bequeathed drawings to friends (Watteau), to heirs (David), or to museums (Ingres). In their lifetime they made gifts of them. Ingres proved especially generous, thanking friends for hospitality by offering and dedicating drawings to them. On occasion he drew their portraits and gave them with dedications of friendship, admiration, affection, or gratitude. Some of these messages are touching ("to his friend and great artist"; fig. 187), while others display a touch of obsequiousness ("most sincere devotion and respects"; fig. 188).

Fragonard, David, and Ingres exhibited their drawings. This action is of additional interest, as it both confirms the official recognition of drawing as an independent work of art and affirms the artists' desire to become known and appreciated for their drawing as well as their painting. It is notable that while Poussin and Watteau did not exhibit their drawings, neither did they exhibit their paintings. The Salon did not become firmly established until about the mid-eighteenth century.[1] Fragonard participated only twice, in 1765 and 1767. In 1765 his *Coresus Sacrifices Himself to Save Callirhoé,* which had won him entry to the Académie, also brought him acclaim. Fragonard also displayed a *Landscape* that belonged to Bergeret de Grancourt as well as "Two Drawings. Views of the Villa d'Este in Tivoli. They belong to M. Abbé de Saint Non" (fig. 189).[2] Although critics, foremost among them Diderot, devoted pages to their enthusiastic discussions of *Coresus,* they did not entirely neglect mention of the red chalk drawings made by Fragonard in the summer of 1760, toward the end of his residency in Rome. Fragonard's decision to exhibit them reveals the importance he already accorded his drawings, which he maintained throughout his career. As confirmation, he presented "several drawings" at the Salon of 1767, whose subjects are known thanks to Diderot: a "Landscape, A man leaning on

FIG. 188. Jean-Auguste-Dominique Ingres, *Portrait of the Comte de Nieuwerkerke,* 1856. Graphite on paper, 13½ x 10½ in. (34.3 x 26.8 cm). Fogg Art Museum, Harvard University, Cambridge, Massachusetts, bequest of Grenville L. Winthrop

his spade," and a "sort of dealer in second-hand goods, seated in front of his table in an armchair."[3] Subsequently, Fragonard bypassed the Salon ("he is content to confine his brilliance to ladies' boudoirs and dressing rooms these days," derided Bachaumont in 1769)[4] and made his reputation through more private pathways (fig. 190).[5]

David's attitude toward the Salon is ambiguous. Although it brought him notoriety and recognition, he evinced hostility toward it by presenting some of his paintings outside its auspices. In the English manner, he charged admission for the right to see such works as *The Sabine Women.* David showed no interest in exhibiting his drawings, the one exception being a work of unusually large dimensions, his *Oath of the Tennis Court* now in Versailles (fig. 90), which he presented at the Salon of 1791.

Ingres faithfully displayed his most important paintings at the

FIG. 189. Jean-Honoré Fragonard, *The Great Cypresses at the Villa d'Este,* 1760. Red chalk over black chalk on paper, 19 ½ x 14 ⅜ in. (49.5 x 36.5 cm). Musée des Beaux-Arts et d'Archéologie, Besançon

Salon. He won recognition at the Exposition Universelle of 1855, where he exhibited his principal masterpieces. On the other hand, at the Salon des Arts-Unis in 1861 he showed only drawings, from every stage of his career, not only portraits but also "compositions and sketches," to borrow Emile Galichon's terminology.[6] The organizers of that show had attempted to persuade the artist to lend his drawings in 1855. Amaury-Duval recorded his response: "'No,' he answered me, 'they will be the only things looked at.'"[7] Amaury-Duval observed, "I believe that M. Ingres, in his answer, fully realized the worth of his sketches, which I find superior to everything he's done in the field of painting, or at any rate, which set him apart from all artists past and present; there is nothing to match them in any period, and his marvelous and innumerable drawings in large part constitute his originality."[8]

FIG. 190. Jean-Honoré Fragonard, *The Island of Love*, c. 1775. Oil on canvas, 27⅞ x 35⅜ in. (71 x 90 cm). Fundação Calouste Gulbenkian, Lisbon

Did Ingres truly fear, as Amaury-Duval leads us to think, that a comparison between his drawings and his paintings would put the latter in the shade? Did he prefer to be judged only for his paintings, the fruit of so much labor? In any case, he was aware that his drawings attracted universal admiration, while his paintings were sometimes met with reservations.

To make their works known, Poussin, Watteau, Fragonard, David, and Ingres turned to the print, each in his own way. Of the five only Watteau, Ingres, and Fragonard practiced printmaking, the first two only on occasion, the last more regularly. All three made prints of a few of their drawings, although Fragonard, David, and Ingres saw their works popularized by means of the print during their lifetimes.

Poussin did not make engravings himself. Almost all of his paintings were widely reproduced through prints, guaranteeing his compositions a wide audience. But the great majority of these prints, which contributed significantly to his renown, were executed after the artist's

Opposite:

FIG. 191. Nicolas Poussin, *Mars and Venus,* c. 1627. Pen and brown ink with brown wash on paper, 7⅝ x 10¼ in. (19.4 x 26 cm). Musée du Louvre, Paris, Département des Arts Graphiques

FIG. 192. Fabrizio Chiari (c. 1615–1695), after Nicolas Poussin, *Mars and Venus,* 1635. Engraving. Département des Estampes et de la Photographie, Bibliothèque Nationale de France, Paris

FIG. 193. Antoine Watteau, *Woman Walking,* c. 1710. Etching. Département des Estampes et de la Photographie, Bibliothèque Nationale de France, Paris

death.[9] In his lifetime, curiously, it was only some of his drawings that had this distinction. From 1635 to 1636 Fabrizio Chiari engraved two (see figs. 191, 192). In addition, Poussin provided drawings for the illustrations for Leonardo da Vinci's *Treatise on Painting*; certain books produced by the Imprimerie Royale during his visit to Paris; frontispieces for the writings of Virgil and Horace; and a plate for Father Giovanni Battista Ferrari's *Hesperides.*[10] Poussin considered such commissioned drawings of only minor importance.

Watteau became interested in printmaking in 1710, when his talent began to gain recognition but while he was still finding his way. These initial efforts consisted of etchings, described by the Goncourt brothers as "free improvisations" and "scrawls," of which only two or three copies of each are known. They were immediately "touched up with the burin" by Simon Thomassin fils and Simonneau l'aîné, specialists in printmaking. Their number is limited, probably only nine altogether, including the seven *Figures de mode* (fig. 193), *"Recruë Going to Join the Regiment,"* and the last in date (1716?), *"The Clothes Are Italian."*[11] Watteau made

Drawing and Money 149

FIG. 194. Jean-Honoré Fragonard, after Annibale Carracci (1560–1609), *Moses and a Prophet,* 1764. Etching. Edmond de Rothschild Collection, Département des Arts Graphiques, Musée du Louvre, Paris

them all from his own drawings, transmitting their nervous line and spontaneity; it is possible that he drew directly on the copperplate, which would explain certain clumsy passages.

The reproduction print did more for Watteau than for any other artist before him. Soon after he died, Jullienne oversaw the publication of his entire drawn and painted oeuvre, admirably and faithfully reproduced.[12] Already Jullienne believed that "the slightest works he [Watteau] produced are precious and too much care cannot be taken in their study."[13] The *Recueil Jullienne* can be considered one of the oldest illustrated catalogues raisonnés in art history.

Fragonard took to printmaking at two very different moments in his career (not counting a youthful effort after Boucher): on his return from Italy, he made etchings of sixteen of his numerous drawings after the masters that he had realized for the abbé de Saint-Non. Two of these etchings are dated 1764 (fig. 194).[14] In his turn, the abbott (fig. 195) secured these sheets and copied them "à la maniere du lavis" (in the style of a wash), or, as it is known today, as an aquatint. The very rare *Fragments* and better-known (but rather mediocre) *Griffonis,* we believe, were made with a view to their publication. Saint-Non wanted to use them to illustrate his *Journal de voyage en Italie,* which went unpublished for a

FIG. 195. Jean-Honoré Fragonard, *Portrait of the Abbé de Saint-Non,* c. 1769. Oil on canvas, 31½ x 25⅝ in. (80 x 65 cm). Musée du Louvre, Paris

long time.[15] It is worth noting the artists Fragonard chose for his etchings: Lodovico and Annibale Carracci, Giovanni Benedetto Castiglione, Giovanni Lanfranco, Pietro Liberi, Johann Liss, Livio Mehus, Mattia Preti, Sebastiano Ricci, Giovanni Battista Tiepolo (fig. 196), and Jacopo Tintoretto—surely not an arbitrary selection. Of these painters, Tiepolo was the only one still alive; Fragonard devoted three etchings to his work, more than for any other artist—evidence of his admiration.

In 1778 Fragonard returned to the etching, for unknown reasons. This time he chose his own creations as the subject, rather than drawings after the masters. Some of these etchings—hardly more than a half dozen—are attributed to Marguerite Gérard, the younger sister of Marie-Anne Fragonard (it has long been asserted that she was the artist's lover, despite the lack of concrete evidence). However, as Georges Wildenstein observed, "a close examination of the technique of this work composed in close collaboration [reveals that] the hand of the teacher predominated over the delicate work of his young student."[16] Still in

FIG. 196. Jean-Honoré Fragonard, after Giovanni Battista Tiepolo (1696–1770), *The Banquet of Antony and Cleopatra,* 1761–64. Etching. Département des Estampes et de la Photographie, Bibliothèque Nationale de France, Paris

1778 (the year Marguerite Gérard was to turn seventeen) the two artists, with Fragonard's contribution essential, created *To the Genius of Franklin,* an allegorical composition in honor of that "good fellow Franklin," who had just been triumphantly received in Paris (figs. 197, 198). Pahin de La Blancherie gave a description of this ambitious undertaking of Fragonard: "The painter represented him [Benjamin Franklin] simultaneously holding up Minerva's shield against the lightning, which he had tamed with his conductors and with the other hand ordering Mars to do battle with avarice and tyranny; meanwhile, America, nobly leaning on him and holding a fasces, to symbolize the United Provinces, tranquilly contemplates her vanquished enemies."[17]

Had Fragonard met Franklin? It is likely, although no proof exists.

FIG. 197. Marguerite Gérard (1761–1837), after Jean-Honoré Fragonard, *To the Genius of Franklin*, 1778. Etching. Département des Estampes et de la Photographie, Bibliothèque Nationale de France, Paris

FIG. 198. Jean-Honoré Fragonard, *To the Genius of Franklin*, c. 1778. Black chalk and sepia wash on paper, 21⅝ x 17⅛ in. (54.9 x 43.5 cm). The White House, Washington, D.C.

However, Franklin certainly met Saint-Non; his account of the visit was reported by Gabriel Brizard in 1792:

Francklin [*sic*], stranger to no art, desired to talk about it with SAINT-NON. He was curious to know the ingenious and so expeditious process that he used for his wash engraving [the technique of aquatint, which Saint-Non had claimed as his invention]. The date was accordingly prepared. Francklin went to have lunch with him; and, while the tea was being made [Paris was then seized by Anglomania], the plate was prepared. Everything was ready; SAINT-NON went to work: he had provided himself with a press; the plate was pulled, and out came a charming print, on which was seen the genius of Francklin hovering over the hemisphere of the New World, and crowned by Liberty's hands. What a pleasant surprise for the Brutus of America![18]

Fragonard's drawing of *The Bust of Franklin Crowned by Liberty* has not been located, whereas Saint-Non's aquatint has been reproduced often.

In his lifetime Fragonard saw not only his paintings but also a number of his drawings, notably those for La Fontaine's *Contes* (fig. 199), made into prints. These reproductions, such as those by Maurice Blot

FIG. 199. Jean-Honoré Fragonard, *A Gallant Swindler for a Miserly Woman,* c. 1780? Pen and brown ink with bister wash on paper, 8¼ x 5½ in. (20.9 x 14.1 cm). Fondation Custodia, Institut Néerlandais, Paris

after *The Bolt* (fig. 166), undoubtedly bolstered his reputation and assured him, for a while, of a clientele and considerable profits.

Saint-Non could not or did not know how to publish his *Journal de Voyage en Italie.* Some years later, he devoted all his efforts to another work, his *Voyage pittoresque de Naples et de Sicile,* perhaps the most beautiful illustrated book of the eighteenth century, which he claimed as his own work despite considerable assistance from Denon. The latter owned Fragonard's drawings for a *Don Quixote* (fig. 200) that he "had himself saved to print as etchings" (fig. 201). The artist had made these drawings at the time he experienced the "end of his fashion." "David and his school" had given "a very different direction to the taste of artists and connoisseurs."[19]

FIG. 200. Jean-Honoré Fragonard, *Don Quixote Attacking the Biscayan,* c. 1780. Brown and gray washes over black chalk on paper, 16 ⅞ x 11 ⅜ in. (42.8 x 28.8 cm). Private collection, Gift promised to the National Gallery of Art, Washington, D.C.

FIG. 201. Dominique-Vivant Denon, after Jean-Honoré Fragonard, *Don Quixote Attacking the Biscayan.* Engraving. Département des Estampes et de la Photographie, Bibliothèque Nationale de France, Paris

In 1794 Denon—soon to assume the highest responsibilities of France's artistic life—made a print of David's drawing *Head of Le Pelletier de Saint-Fargeau on His Deathbed,* today lost (fig. 202). David himself did not make prints, but he examined closely those made after his historic compositions. These brought him wide recognition and a good profit.

Ingres turned to printmaking only sporadically. In 1959 Heinrich Schwarz accepted four prints by him, three lithographs and an etching, including the undisputed *Portrait of Monseigneur Gabriel Cortois de Pressigny* (fig. 203), made after his drawing of 1816, of which two versions exist.[20] But the artist made drawings for prints only in order to make a living, whereas after he became well known he took a great interest in the

From Drawing to Painting

FIG. 202. Dominique-Vivant Denon, after Jacques-Louis David, *Head of Le Pelletier de Saint-Fargeau on His Deathbed.* Engraving. Département des Estampes et de la Photographie, Bibliothèque Nationale de France, Paris

FIG. 203. Jean-Auguste-Dominique Ingres, *Portrait of Monseigneur Gabriel Cortois de Pressigny,* 1816. Etching. Bibliothèque Municipale, Versailles

reproduction of his works. At the age of seventy-six, on 26 February 1856, the artist wrote in a letter to a friend: "Nevertheless, I must tell you that my lethargy has been sufficiently awakened by all the cares over the past month that I have passionately devoted myself to the drawing of my painting *Homer* [fig. 91], which I am doing myself to be made into a print. This drawing is very big; it's the same composition, but with new figures added and all the perfections I can muster."[21] Ingres here offered a magnificent example of a reflection pursued with perseverance throughout an entire career, of a close and permanent interconnection among painting, drawing, and printmaking. "I want this composition to be the work of my artistic life," he concluded, "the most beautiful and the most important."

Money, not mentioned in the quote above, nevertheless played a prominent role. Poussin, somewhat of a penny-pincher, became wealthy, and today the extent of his fortune is well documented.[22] At the beginning of his career, however, he experienced hardships. Félibien, who estimated his worth at 50,000 livres at his death, recalled that he had to struggle to obtain the "equivalent of eight livres" for a *Prophet,* and that he sold two *Battles* for seven écus apiece (that is, twenty-one livres). By 1628 he had received 180 livres for the *Death of Germanicus,* and the following year the altarpiece for Saint Peter's in Rome fetched 900. Bellori

noted: "With him [Cardinal Massimi], as with his other friends, he never discussed the prices of his paintings. When he delivered them, he marked it on the back of the canvas."[23] In his lifetime, it cost less to buy a painting from him directly than to acquire it on the market, as his works were highly sought after. "You will always get a better price from him than from others who adore his works," advised the abbé Louis Fouquet in a letter of 1655 from Rome to his brother, the superintendant of finance.[24] Poussin's fortune of 15,000 écus (or 45,000 livres), in Bellori's estimate, seems modest in comparison with Pietro da Cortona's 100,000 or Bernini's 400,000.[25] Poussin did not sell his drawings; in the 1660 estate inventory of Pointel,[26] the eighty sheets attributed to him were valued at 330 livres, little compared with some paintings: 400 livres for the *Holy Family with Ten Figures* (Dublin) or 2,000 livres for the *Judgment of Solomon* (Louvre). Few of his drawings are on the art market today or sold at auction. Oddly, they are not exceedingly expensive.[27]

"He cared nothing for money, and . . . was in no way interested in it," asserted Caylus in his biography of Watteau.[28] "It was there [in England, in 1719–20] where he began to take a liking to money, for which he had shown no inclination up to then, having so little regard for it that he thought nothing of parting with it, and always finding that his works brought much more than they were worth."[29] Nevertheless, as soon as 1715, the artist agreed to part with several of his drawings. Some twenty-five counterproofs of Watteau (fig. 204) and some of the original sheets today in the Nationalmuseum, Stockholm, were acquired by the young Tessin (he was only twenty years old) when he paid a visit to the artist on

FIG. 205. Gilles-Marie Oppenordt (1672–1742), *Study of Architecture and a Fountain*. Red chalk on paper, 11 x 7¾ in. (28.1 x 19.8 cm). Nationalmuseum, Stockholm

FIG. 206. Formerly attributed to Anthony van Dyck (1599–1641), *Virgin and Child*. Pen and brown ink on paper, dimensions unknown. Formerly in the Nationalmuseum, Stockholm

13 June 1715. (Tessin observed that Watteau owned numerous architectural drawings by Oppenordt [fig. 205] and enjoyed copying the two Van Dyck drawings—at least, what he believed to be Van Dyck drawings—that the Swedish architect had recently bought [fig. 206].) The amount Tessin paid for the drawings in 1715 is not known, although it was probably a modest sum. In 1741, twenty-six years later at the Crozat sale, he bought five drawings by Watteau (among many other sheets; fig. 35) for 31 livres 5 sols.

The 1735 estate inventory of the abbé Haranger contained 1,100 drawings by Watteau, about a quarter of his output. These were divided into fifty lots, and their estimated values (but not their sale price) are known—and are generally very low. Lot 46, "Two drawings by Watteau, very fin[ished], appraised at 12 livres" (Jeannine Baticle, who is responsible for finding this important document, reads "fine" *[fins]* rather than "finished" *[finis]*, incorrectly, we believe), confirms that the more finished sheets were given higher estimates and seemed to be more highly regarded.[30] This remained the case in 1767 at the Jullienne sale, except that the prices for Watteau's drawings had risen appreciably. Today, the artist's drawings are especially sought after and fetch considerable sums (fig. 26).[31]

FIG. 207. Jean-Honoré Fragonard, *Coresus Sacrifices Himself to Save Callirhoé,* 1769. Brown and bister wash over black chalk on paper, 13 ⅝ x 18 ¼ in. (34.7 x 46.5 cm). The Pierpont Morgan Library, New York

Fragonard marketed his drawings, which distinguishes him from his predecessors as well as from David and Ingres. In 1771 Mme d'Epinay warned, "He [Fragonard] wastes his time and his talent. He makes money."[32] "In an average year, he earned 40,000 francs from his talent," confirmed Charles-Paul Landon.[33] How did Fragonard go about it? Was he represented by a particular dealer? Did connoisseurs visit his studio in the Louvre? Did they select works from what he had "in stock" (as it is described today)? Or did he work on commission? The profits from the sale of prints, which multiplied starting in 1778, made after his drawings as well as his paintings, allowed him to buy a house in Charenton in 1782 for 8,000 livres. On the eve of the Revolution, the Fragonard family had "fifteen to eighteen thousand livres of government stock."[34]

Drawings accounted for a far from negligible portion of Fragonard's income, although the precise amount cannot be determined. And what role did Mme Fragonard, "my treasurer,"[35] play in the growth of his fortune? The past reveals few clues as documentation is scarce; in April 1787 (by which time Fragonard's popularity had declined), President François-Pascal Haudry wrote to the draftsman and engraver Aignan-Thomas

FIG. 208. Gabriel de Saint-Aubin, sketches on a page describing drawings by Fragonard in the Gros sale catalogue, 1778. Musée du Petit Palais, Paris

Desfriches (1715–1800) from Orléans: "Fragonard enjoys a prominent reputation; his best drawings bring their weight in gold, and they are worth it."[36] Contemporary sales corroborate this judgment: 800 and 720 livres for *The Bolt* and a study for *Coresus* at the Varanchan de Saint-Geniès sale in December 1777 (fig. 207), sums barely below those brought at the Gros sale in April 1778 (fig. 208). Fragonard was doubtless flattered. But the artist's glory did not last long. He became a forgotten figure in his own time (starting in 1785, we believe) without ever

FIG. 209. Jacques-Louis David, *The Combats of Diomedes,* 1776? Pen and black ink with gray wash and white heightening on several attached sheets of paper, 43¾ x 80 in. (111 x 203.5 cm) overall. Graphische Sammlung Albertina, Vienna

knowing why. During the Revolution David made him a civil servant, or, to be precise, named him curator for the new Musée du Louvre.[37] He died in poverty. Did he die confident in the judgment of posterity? Will we ever know? One of posterity's judgments was a glorious fate for his drawings.[38]

David amassed a tidy fortune in the course of his career. Schnapper recently explored the details of David's earnings.[39] Drawings in themselves did not account for a significant percentage of his income, since David rarely let go of them. We know of no drawing sold by the artist, with the possible exception of *The Combats of Diomedes,* now in Vienna, reportedly bought by the duke of Sachsen Teschen at the time of his first journey to Italy in 1776 (fig. 209).

Before his marriage in 1782, which brought the groom a respectable dowry, David had no resources aside from his work. He received 2,400 livres in 1782 for his *Funeral of Patroclus* (1778, fig. 251), 6,000 for *The Oath of the Horatii* (1784), and 7,000 for *Antoine-Laurent Lavoisier and His Wife (Marie-Anne Pierrette Paulze)* (1788). In addition, he received 12 livres a month from each of his students: "His studio must have brought [him] 4 to 5,000 livres a year."[40] And, as we have seen, drawing occupied a central role in David's educational program. His students had access to the drawings made in Italy and could consult them freely. Another source of income for David came from the entry fees to his exhibition of *The Sabine Women* (1800). At 1 franc 80 a head, he collected 65,627 francs, according to J. du Seigneur,[41] which enabled him to buy a farm in Marcoussis in 1801 for 80,000 francs. In 1824 *Mars Disarmed by Venus and the*

FIG. 210. Jacques-Louis David, *Regulus and His Daughter*, 1786. Pen and brown ink, gray and brown wash, and white gouache and black chalk on bluish paper, 12⅜ x 16¼ in. (31.5 x 41.4 cm). The Art Institute of Chicago, Clarence Buckingham Collection

Graces was presented at 115, rue de Richelieu in Paris. Over the course of a year, 9,538 visitors paid 2 francs for the privilege of seeing it. The replica of *The Coronation of Napoléon and Joséphine* (today in Versailles), commissioned in 1808 by "American landowners" *(proprietaires américains)* to use David's words, was sent to New York, Philadelphia, and Boston to be exhibited during 1826 and 1827.[42] Finally, David earned a substantial amount from the reproduction of his works (what was called "the right to make prints") and his salary as First Painter (12,000 francs).

David and his wife were almost millionaires and enjoyed a standard of living well above average (Mme David's initial assets made up no more than 40 percent of the total). The year following David's death in 1825 (his wife, Marguerite-Charlotte Pécoul, died later on 9 May 1826), his four heirs settled on the dispersion of the studio's contents, among which were most of the artist's drawings. Despite Delécluze's assertion that the "drawings and sketches brought reasonably high prices,"[43] "the sale had little success . . . and the majority of the drawings [thus, the twelve Roman albums] were bought in by the family."[44] At this sale of 17 April 1826, the

compositional study for *Leonidas* (fig. 89) was bought by the Louvre for 3,623 francs, including expenses (estimated in the estate inventory at 600 francs), and the *Regulus and His Daughter* (fig. 210), today in Chicago, sold for 163 francs (or, according to some copies of the sale catalogue, 279 francs) to M. Musigny. Among the unsold works was *The Oath of the Tennis Court,* the "most important and most finished drawing that M. David made," as the sale catalogue described it (fig. 90).[45] Estimated at 1,000 francs, it was sold for 15,000 francs to Eugène David (the large version on canvas, also in Versailles, for which the heirs wanted 10,000 francs, received a high bid of only 4,000 francs at auction and was bought in). Undoubtedly, the family's motivation for buying in so many of David's works stemmed as much from filial devotion as from the hope of future appreciation in value. The majority of David's graphic production remained until recently in the hands of his descendants. Its dispersion is under way. The drawings, with some rare exceptions, are affordable.[46]

Ingres did not always have an easy life. His beginnings were as humble as those of Poussin, Watteau, Fragonard, and David, although his entry into the art world may have been easier because of family connections. "The fall of the Murat family in Naples proved ruinous for me in paintings lost or sold but not paid for. . . . I was then forced to adopt a genre of drawing (pencil portraits)," he wrote to his friend Gilibert in 1818.[47] Ingres eked out a living by means of these portrait drawings in Rome, and then in Florence. When he returned to Paris, he earned a reasonable income from his salary as professor at the École des Beaux-Arts and his students, who "brought in 300 francs a month"[48] (this figure should be compared to the 4,000 to 5,000 livres a year that David received from his students). Ingres painted little and slowly. A tireless draftsman, he was not unaware that he could improve his income through selling his drawings, but he refused to do so. In 1825 he said, "He ['the worthy Girodet'] had at his bedside two of my drawings that he had earlier bought in a sale and which, at his own, sold for six times the price."[49] The first, *Holy Communion in Rome,* went for 202 francs (fig. 66). The second, a wonderful early sketch for *Antiochus and Stratonice* (fig. 211), now in the Louvre, brought 600 francs at the Girodet sale on 11 April 1825, a modest sum in comparison with current prices for Ingres's drawings.[50]

For Ingres, as for David, the drawing filled a prominent pedagogic function. As such, it constituted for both a significant resource (the double teaching of David and Ingres is deserving of a comparative study). Its importance went further, however. If both of them accorded a major role to drawing—as technique, as exercise, like a pianist practicing the scales daily—they still considered it as a discipline, an indispensable regimen. This is why neither cared to sell his drawings and parted with so few; the drawings served as their most useful as well as their most precious and private possession.

FIG. 211. Jean-Auguste-Dominique Ingres, *Antiochus and Stratonice,* c. 1806. Graphite and brown wash on paper, 11⅜ x 15¾ in. (29 x 40 cm). Département des Arts Graphiques, Musée du Louvre, Paris

It would be agreeable to imagine that such prodigious draftsmen as Poussin, Watteau, Fragonard, David, and Ingres had desired to acquire the works of their predecessors or their most illustrious contemporaries or that they wished to compare their graphic inventions with those of other great creators. This was far from the case; none of them, not even Ingres, could pass for a collector on the level of Rubens, Reynolds, or Lawrence.

Poussin, according to an "inventory of the furnishings found in Rome in the study of monsieur Nicolas Poussin and that are now for sale under the auspices of sieur Joanni [Jean Dughet] his cousin and heir in 1678,"[51] owned several books of prints after Raphael, Dürer, Carracci, Polidoro da Caravaggio, Titian, Mantegna, and Giulio Romano, as well as some marbles, antique busts, and four alabaster vases. They were given a modest estimate. If the inscription at the bottom of a drawing from Raphael's studio, now in the Uffizi, is reliable, it once belonged to Poussin (fig. 212).[52]

We know nothing of Watteau's collections, except that in 1715 Tessin observed that the studio held "a good number of architectural sketches as well as a book of fountains, the first in wash, the others in red chalk, made

FIG. 212. After Raphael (1483–1520), *Melpomene.* Pen and ink on paper, 14½ x 8¼ in. (37 x 21.1 cm). Gabinetto Disegni e Stampe, Galleria degli Uffizi, Florence

and drawn by Oppenordt."[53] Fragonard bought heavily at the estate sale of Boucher on 18 February 1771: paintings by La Fosse;[54] drawings by Bramer, Roos, Verdier, Stella, and Boucher; and prints by the Flemish and Dutch schools.

Reading the estate inventory of David's Parisian apartment indicates that the works mentioned in it—Langlois, Bourgeois, Odevaere, Broc, a "drawing by Wicar, the *Tomb of Drouais*"—are presents from his students rather than acquisitions. We note, however, a "drawing by M. Ingres after la Belle Feyronnière [*sic*], appraised at the sum of eighty francs" (fig. 213), "Eight prints under glass, landscapes after Poussin and seven others, the *Seven Sacraments* after the same."[55] David also owned prints after Poussin's *Flood* and *The Testament of Eudamidas.*

Ingres was justifiably considered an artist-collector, even though he

had limited funds at his disposal. A visit to the Musée Ingres in Montauban confirms the variety of his interests: Italian primitives (fig. 214), French seventeenth-century canvases (Ingres thought he owned a painting by Chardin, described, not without reason, as a "small horror" by the great connoisseur Laurent Laperlier),[56] and Greek vases and Etruscan bronzes. Ingres's will of 1866 lists some two hundred "plasters cast from the antique" and "small Etruscan terra-cotta tombs," studied by Meredith Shedd in 1992.[57] These works, some authentic, some not, or in any case wrongly attributed, excited the artist's imagination and were used as a source of inspiration.

Ingres's modest prosperity and David's much greater fortune were, as mentioned above, partly composed of the fees brought in by their students. We know the full importance of David's studio and of *l'atelier d'Ingres* (the studio of Ingres), to borrow the title of a famous book;[58] we

FIG. 214. Masolino da Panicale
(1383–1440), *Scenes from the Legend
of Saint Julian the Hospitaler.* Tem-
pera on panel, 8¼ x 15⅜ in. (21 x
39 cm). Musée Ingres, Montauban

are aware of the position drawing occupied in the training of artists, the
sometimes considerable role that masters gave their best students, calling
on them to collaborate on their own work. One question remains, albeit
with no answer. Why, in the century of the Carracci, of Rubens, and of
Le Brun, did Poussin not have a workshop; why, in the period of Boucher
and Tiepolo, did Watteau and Fragonard not have students?

Poussin made a drawing of a studio, but it is certainly not his own
(fig. 215). His brother-in-law Gaspard Dughet was sometimes consid-
ered his student, although Poussin taught him only the rudiments: "how
to hold the colors, brushes, and palette ready for use," according to San-
drart.[59] Poussin collaborated with Jean Lemaire (1601–1659), working on
at least one painting together.[60] And, again, the decoration of the Grande
Galerie in the Louvre in Paris presupposes numerous collaborators.
Poussin, however, proved incapable of directing a workshop. He could
work only in isolation and meditative quiet. He had no true students, did
not want any, and could not have managed them. It is all the more para-
doxical that the solitary Poussin should be considered the tutelary spirit
and the inescapable point of reference of the Académie de France in
Rome, an academy whose extraordinary influence in the eighteenth
century depended on the quality of its teaching and of its successive
directors.

Watteau also had no pupils (which did not lessen the number of his
imitators or forgers). Ballot de Sovot, his biographer, reports that he
advised Lancret to leave Gillot, his first master, in order to devote him-

self to the study of "nature," the "master of masters," and also to serve Watteau.[61] However, very quickly, "all connection" between the two artists "was cut off . . . and they remained on this footing until Watteau's death."[62] The young Pater, like Watteau born in Valenciennes, "found a master [Watteau] too difficult in temperament, and too impatient in nature to have the capacity to yield to a student's weakness and advancement; he had to leave [Watteau's studio]," a confirmation that comes from Gersaint.[63] A month before the artist's death, Pater went back to Watteau; he recognized "that he owed all he knew to that short space of time."[64] These citations summarize what the old texts offer on Watteau as a teacher, who seems to have been irascible.

Nor did Fragonard have students or collaborators. In 1767 Jean-François Martin of Cahors and, the following year, André Dalbeau are mentioned. There was also Pierre Delaunay from Bayeux;[65] the name of Alexandre-Evariste Fragonard, who was twenty-six years old when his father died, is rarely cited. Only Marie-Anne Gérard, who became Mme Fragonard in 1769, and her younger sister, the beautiful Marguerite Gérard, qualify as students. We were able to identify the former as the author of several lovely miniatures that had long passed as the work of her husband (see fig. 18).[66] Of the latter's work, her early efforts in etching are known.[67] Marguerite collaborated on a few of her brother-in-law's paintings, such as *The First Steps of Childhood* (fig. 216). Her conception of painting—and drawing—differed considerably from that of her master (fig. 217).[68] Fragonard, with his dynamic vision, could hardly paint without the movement, the impulse, or the exuberance that gave life to his figures as well as his objects. Marguerite focused more on detail, painting small, overly finished works, in the Dutch style that was very popular in

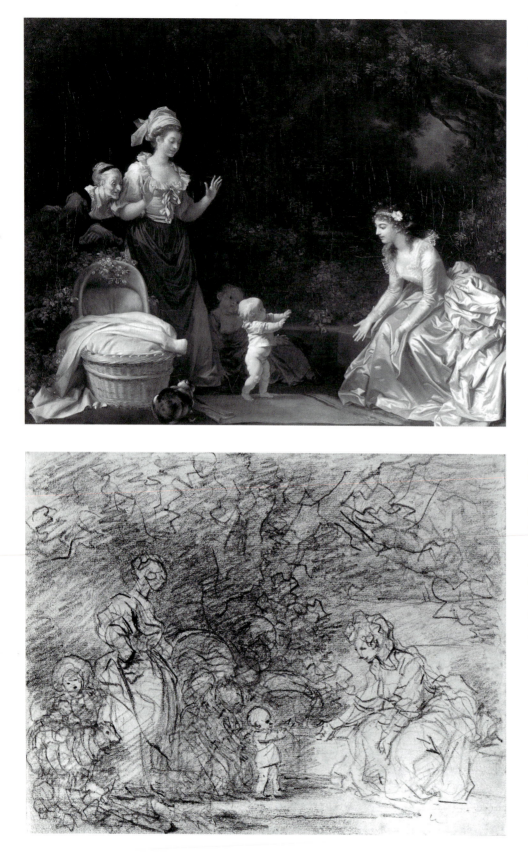

FIG. 216. Marguerite
Gérard and Jean-Honoré
Fragonard, *The First Steps of
Childhood,* c. 1786. Oil on
canvas, 17 3/8 x 21 5/8 in. (44 x
55 cm). Fogg Art Museum,
Harvard University,
Cambridge, Massachusetts,
gift of Charles E. Dunlap

FIG. 217. Jean-Honoré
Fragonard, *The First Steps
of Childhood,* c. 1786.
Black chalk with white
heightening on green paper,
6 3/4 x 8 7/8 in. (17.1 x 22.4
cm). Fogg Art Museum,
Harvard University,
Cambridge, Massachusetts,
Isabella Grandin Fund and
Marian H. Phinney Fund

FIG. 218. Géraud Vidal, after Marguerite Gérard, *The Interesting Student,* 1786. Engraving. Département des Estampes et de la Photographie, Bibliothèque Nationale de France, Paris

FIG. 219. Jean-Honoré Fragonard, *The Fountain of Love,* c. 1785. Oil on canvas, 25 x 19⅞ in. (63.5 x 50.7 cm). The Wallace Collection, London

the time of Louis XVI. Nonetheless, certain private references between the two painters demonstrate their artistic complicity. In Marguerite Gérard's *Interesting Student* (c. 1787; fig. 218), for example, the subject contemplates Fragonard's *Fountain of Love* (fig. 219).

A painter without collaborators and pupils—but not without models—Fragonard made an admirable drawing of a woman artist at work, herself studying models: a young couple and their child standing on a box, posed as the Holy Family.[69] He also drew the Académie de Dessin run by the duc and duchesse de Rohan Chabot in Paris, where Hubert Robert, Vien, Pierre, Desfriches, and Moreau le Jeune, among others, taught. The duchesse, née La Rochefoucault, also made drawings: "After which she sat down and began to draw, for an entire hour, in the company of other Messieurs, who were all seated in a circle around a large table. . . . In brief, I finally began to play, on that miserable and detestable *piano-forte.* But what annoyed me most was that Madame and all her Messieurs did not stop drawing for an instant."[70] This scene took place in Paris in 1778, and the pianist was the young Mozart. The "Messieurs" repaid him with "a shower of praises [*Menge Elogen*]." Was Fragonard present for this "recital"? While no evidence proves that he was, nothing prevents us from supposing that he was not.

David rebelled against the teaching of the Académie, where he had studied. He made his arguments known: "I said that I would demonstrate the harm that the Academies do to the art they teach, and I will keep my word," he wrote on 8 August 1793, adding:

Twelve professors in a year, that is, one for each month . . . rush to destroy the basic principles that a young artist has learned . . . from his master . . . , the poor young man, in order to please them in turn, must change his way of seeing and working twelve times a year; and for having learned his art twelve times, ends up knowing nothing . . . yet should he, through the rare gifts he received from heaven, transcend this awful instruction, oh, then this child with so many fathers . . . arouses the base jealousy of all his masters together, aimed at destroying him. The policy of kings is to maintain the balance of crowns; the policy of Academies is to maintain the balance of talents.[71]

In criticizing the Académie, "the last refuge of all the aristocracies," David undoubtedly wanted to make it bear responsibility for his repeated failure to win the Grand Prix, representing this series of rebuffs as injustices.

In truth, David's studio functioned like those he frequented in his youth, that is to say, those he campaigned to abolish. In 1801, compelled to give up one of his studios, he offered a sorry defense: "I alone, Citizen Minister, am as good as an academy. The students come forth from my school every day, the prizes they win every year in public competitions confirm this truth. Modesty has no part in an affair of this importance; this is not really about the attempt to drive me away from a paltry studio but the desire on the part of certain people to see the academies restored."[72]

Some of David's students recorded their master's teaching style: "Properly speaking, there is no dominant practice; the students draw as they will on colored or white paper, the latter nonetheless more generally used; we block in our figure gradually but solidly, with a crayon. . . . M. David likes the drawing to be broad and pithy, he doesn't like small details."[73] "He doesn't want to hear anyone speak of finished drawings; he only wants the small sketches in the genre of those you make from nature. We finish them more because we devote a session to each one, that is, the model changes the pose every day; in a month, two weeks are given over to drawing from the antique and two to drawing from life."[74]

Delécluze presented a particularly vivid picture of David's studio, including the debates of all kinds that divided them and the ways and jokes of the students. The mediocre and today deservedly obscure Jacques-Louis-Michel Grandin (Delécluze described him as "good and honest" and added, "as a painter, he lacked propensity; as a man, he lacked intelligence")[75] had been made responsible for collecting, at the

end of each month, the "retributions," or fees, from the other students. On seeing him "enter the studio," the students would greet him with the jest, "Messieurs . . . is it the 30th? Here is Grandin!"[76] Reading Délécluze's description, we are struck by the impressive list of foreign students, Italian or German (not to mention the Belgian disciples of the studio in Brussels); by David's generosity in exacting fees only from the well-off among his students, barely more than half in a group of sixty; and by the master's tolerance toward the most factious political or religious opinions.

Délécluze also delineated the clans or sects that divided the studio. There were the "filthies" *(crassons),* who rebelled against hygiene; the "thinkers" *(penseurs)* or the "primitives" *(primitifs),* later called the "beards" *(barbus),* including Broc, Maurice Quai, the Franque brothers, Jean-Pierre and Joseph; Lucile, "the young woman" of one of the Franque brothers, troubled the poet Charles Nodier's heart, who championed a return to the Greeks and had some part in David's decision to paint the heroes of his *Leonidas* nude (see fig. 89); the "aristocrats" *(aristocratiques),* who included among its members Granet, Fleury-François Robert (called Fleury-Richard), Pierre-Henri Révoil, Louis-Nicolas-Philippe Forbin; and, finally, the "daubers" *(rapins),* the most modest of the students.

FIG. 221. Jean-Auguste-Dominique Ingres, after Jacques-Louis David, *Portrait of Juliette Récamier,* c. 1800–1806. Graphite and bister wash on paper, 2 ⅝ x 4 ½ in. (6.8 x 11.3 cm). Musée Ingres, Montauban

Some of them—Girodet, Gérard, and Gros—whose style was more or less understood by David, would make their reputations. Looking at Girodet's *Ossian,* David exclaimed, "Really, my good friend, I must confess, *I know nothing of this kind of painting.*" Delécluze reported David's stupefaction: "Now then! Girodet is a lunatic. . . . These are figures made of crystal he gives us here. . . . What a pity! With his fine talent."[77]

A quotation from *Le Pausanias français: Etat des arts du dessin en France* by Pierre-Jean-Baptiste Chaussard conveys the full importance David accorded his art: "The master sometimes sent away from the studio those Students whose inclinations seemed purely technical to him. . . . M. David thus never ceases to repeat that the execution is nothing, that *the thought is everything* [emphasis added]."[78] Some students participated directly in the execution of David's paintings: Drouais, in *The Oath of the Horatii,*[79] Langlois, Jean-François Garneray, and many other pupils. The most famous of his collaborators was Ingres. He posed nude for his comrades in David's studio (fig. 220); he painted the candlestick and footstool for *Portrait of Juliette Récamier;* he copied the same work (fig. 221), as well as the head of a figure stricken with the plague in the *Saint Roch* (or in a drawing for this painting; fig. 222); he owned an important sheet by David made for *The Sabine Women,* which he gave to the Louvre in 1856 (fig. 79), and others that entered into the collection of the Musée Ingres in Montauban; and, finally, he placed his master among the figures of his *Apotheosis of Homer* (see fig. 91).[80] Ingres's opinion of David affirms the veneration of the student for the master: "David based his teaching on the truest, the strictest, and the purest principles." "David was the only master of our century."[81]

Ingres, in his turn, directed a workshop: in 1825, a private studio on the rue des Marais-Saint-Germain (actually, 3, rue des Beaux-Arts),[82] then in 1829, at the École des Beaux-Arts, before he was awarded the

directorship of the *pensionnaires* at the Académie de France at the Villa Medici. During this period of about ten years, he had more than 150 students. Some of the names have come down to us: the Flandrin brothers, Chassériau, Etex, Chenavard, Lehmann (whom Ingres wanted to take with him to Rome, which was not possible), several Germans or Swiss, and even a Brazilian named Mello. The atmosphere, Amaury-Duval relates, was serious and quite different from that of David's studio.[83] Like David, Ingres exempted the poor students from paying fees and drew numerous collaborators from among his students. Unlike David, he would no more tolerate a Rubens than he would the Romantic artists (open-mindedness was not in his nature), and he did not welcome students in his own studio (they worked in their own) and showed his paintings only "when he had just finished [them]," except to some "select few."[84]

In fact, Ingres's character, his "candor" and "disposition toward isolation," his "fund of brusque honesty, which never compromise[d] with anything unfair or cruel" and his "solemn character" joined "to the lack of a liveliness of thought that is called spirit in France," ascribed to him by Delécluze and which already characterized him in his years with David, go a long way to explain the oppositions and divergences between the two studios.[85] Students came to Ingres's studio to learn how to draw; painting came later. Learning how to draw meant learning how to draw after prints, from cast, and then from life. Learning how to paint meant admiring and not hesitating to imitate the old masters: Raphael and Poussin, the Italian Primitives. Students also came to venerate an adulated master, to listen to him roar or see him carried away by enthusiasm, and to be inspired by his example. This last proved fatal to a great many of his students, who believed in a recipe that lacked and would always lack Ingres's intelligence of the eye—this gift of heaven.

Chapter 6 Drawing and Design

DESSIN (DRAWING) AND DESSEIN (DESIGN)—this play of words
is untranslatable. They share the same meanings as the English terms, *dessein* and *design* both incorporating the idea of design as intention, purpose, meaning, as well as preliminary sketch or outline. In Italian, the single word *disegno* comprehends both *drawing* and *design*.

It is worth repeating that Poussin, Watteau, Fragonard, David, and Ingres all considered drawing of primary importance, although they treated it very differently, depending on their temperament, ambitions, and conceptions. Their place in the history of drawing, especially of French drawing, is quite distinctive, particularly in comparison to artists who did not draw or drew little (Georges de La Tour, the Le Nain brothers, Chardin), to those who did nothing but draw (Callot, Saint-Aubin, Moreau le Jeune), and to artists such as Claude, Boucher, Greuze, or Pierre-Paul Prud'hon.

What distinguishes our five artists is the continuous interpenetration of the reflection given to drawing and that given to painting. This interpenetration is uninterrupted, challenging, stimulating, stirring, and it participates directly in the mystery of the creative process. No other artist born between 1594 and 1780, at least in France, had tried with such audacity to transform an image, an impression, an invention, a thought, or an idea into a painting by means of a pen or pencil.

In the course of these two centuries, were there many artists who would have dared to take this path and pursue it with such perseverance? The names of Rembrandt, Francisco de Goya, Giovanni Battista Piranesi, and Giovanni Battista Tiepolo immediately come to mind, as well as Caspar David Friedrich. Annibale Carracci, Rubens, and Delacroix fall outside these chronological boundaries. However, upon further contemplation, did these geniuses, who undoubtedly found the imagination and sometimes the imaginary essential to their work, have the capacity to push the reflection as far as Poussin and Ingres did, not so much in their drawing as an independent work of art but in its importance as a research tool, as a means of expression and a medium of transmission, in both the most abstract and the most practical sense of the terms?

To transform a thought into line, to give form to ideas—that is the

FIG. 223. Nicolas Poussin, *Self-Portrait,* 1649. Oil on canvas, 30⅞ x 25⅜ in. (78.3 x 64.5 cm). Gemälde-galerie, Staatliche Museen zu Berlin-Preussischer Kulturbesitz, Berlin (photograph taken before restoration)

special ambition, more or less conscious, that drove these five artists, more or less stubbornly, more or less successfully. Each of the five took different paths toward this goal. One of them, color, is by its nature anti-nomic to the art of drawing. In his well-known essay on Ingres, Alain remarked, "Color destroys drawing"; "color eclipses drawing"; and "drawing is always fighting with color."[1]

Poussin became known as the enemy of color and advocate of the line. At the end of the seventeenth century, a dispute between Rubenists and Poussinists divided France, although the stakes no longer seem entirely clear. Poussin's *Self-Portrait* in Berlin (fig. 223) carried the inscription "De lumine et colore" (removed during its recent restoration, but visible on the print made by Jean Pesne that probably dates from 1661),[2] over which too much ink has been spilled. These discussions, theoretical

Drawing and Design 177

FIG. 225. Antoine Watteau,
Landscape with River and Steeple,
after 1711–12? Watercolor and red
chalk on paper, 6⅜ x 8⅝ in. (16.2 x
22 cm). Teylers Museum, Haarlem

Opposite:
FIG. 224. Nicolas Poussin, *The
Death of the Virgin,* before 1623. Pen
and brown ink, brown wash, and
highlights of watercolor over red
chalk on paper, 15⅜ x 12⅜ in. (39 x
31.4 cm). Private collection, England

to begin with, have obscured the fact that Poussin sometimes drew on
colored paper, usually blue (fig. 49), and that on at least one occasion—
in his youth and before he became established in Rome—he added high-
lights of watercolor to his drawing (fig. 224). While it is not incorrect to
view Poussin as a champion of line, his strong assets as a colorist also
demand recognition. Poussin left nothing in his writings to indicate that
he held firm ideas on the issue; rather these have been ascribed to him,
sometimes because of the qualities of the artists who championed him.

Watteau seldom turned to watercolor (fig. 225) and rarely relin-
quished his cherished cream-colored paper. An admirer of Rubens and
La Fosse, he could be classed among the greatest practitioners of color,
as evidenced by the range of tones and the variety of tints he achieved in
his red chalk drawings; his technique of the three-colored chalks (fig.
226), not its inventor but one of its most virtuoso practitioners; and his
proclivity for using the stump and subdued washes. To our knowledge,
Watteau never overtly placed himself on the side of the Rubenists (except
to copy their work) and did not officially participate in a debate that
remained lively in the first years of the eighteenth century.

Fragonard also made occasional use of colored papers and knew all the techniques, including watercolor and pastel. No one has yet sufficiently explored the artist's predilection at the beginning of his career for crayons, black chalk, or red chalk (fig. 227) or his pronounced affinity for warm bister washes in his mature years.[3]

David and Ingres, of course, are always ranged with the unconditional defenders of line, in the tradition of Poussin. Although they employed colored papers, their red chalk drawings (such as fig. 228) can be counted on the fingers of one hand. David made but few watercolors (witness his costume projects of the Revolutionary period; fig. 229), Ingres somewhat more (often when reworking a finished composition to have it made into a print; fig. 230). Both contributed peremptory declarations: "you let drawing come after the color. Well, my friend, that's like putting the cart before the horse," David inveighed.[4] "Drawing includes everything, except color," exclaimed Ingres.[5]

In this debate—which we think concerned critics and art historians more than the artists themselves, and which today resides more in the

FIG. 227. Jean-Honoré Fragonard, *The Temple of Vesta and the Sybil at Tivoli*, 1760. Red chalk over black chalk on paper, 14½ x 19⅝ in. (37 x 50 cm). Musée des Beaux-Arts et d'Archéologie, Besançon

FIG. 228. Jacques-Louis David, *A Peasant Woman of Frascati*, 1775–76. Red chalk on paper, 6 x 5⅜ in. (15.3 x 13.7 cm). Art market

FIG. 230. Jean-Auguste-Dominique Ingres, *Birth of the Last Muse*, 1856. Watercolor on paper mounted on copper, 10⅛ x 21 in. (25.7 x 53.2 cm). Musée du Louvre, Paris

Opposite:
FIG. 229. Jacques-Louis David, *"The Legislator,"* 1794. Pen and black ink with watercolor over black crayon on paper, 11¾ x 7⅞ in. (30 x 20 cm). Musée National du Château, Versailles

realm of theory than practice—it seems that an essential participant has been underestimated and neglected: the *tool* employed.

Holding a pencil or pen and holding a brush are radically different gestures by nature. The brush is par excellence *already* the instrument of the painter, and the five draftsmen under study here used it to varying degrees. Poussin favored the pen. A wash, generally a refined tone of bister set down with the brush, embellished the line, offering an elegant accompaniment. Watteau used pencils almost exclusively (including graphite), the brush rarely, the pen never. Fragonard knew how to do everything and wanted to demonstrate that he could do everything: draw paintings and paint drawings. He chose his instruments to correspond with his clients' wishes or the inspiration of the moment. He is the most painterly of the five draftsmen; he is the only draftsman-painter. David loved the severity of black chalk, graphite, and the pen enhanced by a gray or, sometimes, black wash. Ingres also was partial to the pencil. He, too, knew how to do everything but had a horror of appearing to be a virtuoso—a Nicolò Paganini of drawing ("all traces of facility must be made to disappear").[6] He stubbornly reserved the use of the brush for his paintings.

How have the lapidary maxims of Alain fared? To claim that "the color destroys the drawing" in the work of Watteau partakes of the absurd. Already the distinction between draftsmen and draftsmen-painters is less fruitless than it seems. It reveals two attitudes, two ways of proceeding; it isolates Fragonard who paints when he draws and draws when he paints. As to the division of our draftsmen into colorists and par-

FIG. 231. Nicolas Poussin, *The Saving of the Infant Pyrrhus,* 1634. Oil on canvas, 45⅝ x 63 in. (116 x 160 cm). Musée du Louvre, Paris

tisans of the line, it holds together better. It is reasonable to oppose the preference for line, the somewhat distancing reserve and rigor of the latter (all of whom, nevertheless, are masters of color in their paintings) to the sensuality and warmth of the former.

Another path leads us to movement. Etienne Gilson observed in 1955, "What the painter tries to obtain is not stability of space but, rather, movement in the painting."[7] He was clearly thinking of Delacroix, whose *Journal* provided a constant source of inspiration to the author. Nonetheless, our artists seem more preoccupied by the solidity of forms, the "concrete stability . . . of objects"[8] than by "movement."

This statement has its clear demonstration in Poussin (in which he foreshadows Paul Cézanne). Two of his compositions, *The Saving of the Infant Pyrrhus* (1634) and *A Dance to the Music of Time* (proximate in date), illustrate this ambition perfectly. The subject of the Louvre canvas, taken from Plutarch, is well known (figs. 231, 232): during an uprising, Pyrrhus, son of King Aeacides, was protected by his father's partisans,

FIG. 232. Nicolas Poussin, *The Saving of the Infant Pyrrhus,* c. 1633. Pen and brown ink with brown wash over red chalk on paper, 8½ x 13½ in. (21.5 x 34.5 cm). Royal Library, Windsor Castle

who brought him across a lifesaving river. Poussin wished to express in a single image—the unity of place substituting for unity of time—the various stages from danger, on the composition's right, to safety, at left, passing through fright and fear (the two women who look behind them), the appeal for help (the soldier who lifts Pyrrhus, his neighbor who indicates him), and dawning hope. He placed the actors on the same level and recapitulated the action by repeating the same pose three times.

The drawing in Edinburgh of *A Dance to the Music of Time* (fig. 233), perhaps less than the painting in the Wallace Collection (fig. 234), is also completely static. It represents Time marking on his lyre the dance of four allegorical figures: Poverty, Industry, Wealth, and Lust. What is striking overall is the deliberate, determined attempt to destroy the impetus and immobilize the gesture, to make the composition rigid—and, thus, to make it timeless. As Sutherland Harris quipped in reference to a drawing she had hoped to attribute to the artist (fig. 235), "with Poussin, the people don't run that fast."[9]

FIG. 233. Nicolas Poussin, *A Dance to the Music of Time*, 1632–34. Pen and brown ink with brown wash on paper, 5⅞ x 7¾ in. (14.8 x 19.8 cm). National Gallery of Scotland, Edinburgh

FIG. 234. Nicolas Poussin, *A Dance to the Music of Time,* 1632–34. Oil on canvas, 32⅝ x 41⅜ in. (83 x 105 cm). The Wallace Collection, London

FIG. 235. Guillaume Courtois (1628–1679), *Man Running, Leg Study.* Red chalk on paper, 14⅝ x 10⅛ in. (37.3 x 25.8 cm). Hessisches Landesmuseum, Darmstadt

FIG. 236. Jean-Honoré Fragonard, *A Priest (?) Stabbing a Young Girl on an Altar,* c. 1770. Bister wash over black chalk on paper, 13¼ x 18½ in. (33.7 x 47 cm). Musée de la Faculté de Médecine, Montpellier, Atger Collection

FIG. 237. Jean-Honoré Fragonard, *The Bolt,* 1776–79. Oil on canvas, 28¾ x 36⅝ in. (73 x 93 cm). Musée du Louvre, Paris

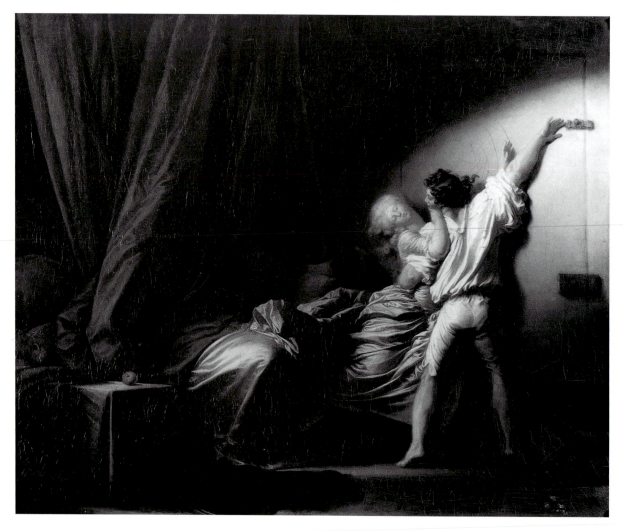

At first glance, no connection can be seen between Poussin and Watteau. Among Watteau's most famous works—his *Pierrot*, also known as *Gilles,* the immobile *Pierrot, Gersaint's Shop Sign*—let us look more closely at *The Pilgrimage to the Island of Cythera.*[10] Its very title (the original title, not *The Embarkation for Cythera* given later) reveals the artist's ambitions: the painting is as much a departure *toward* the island of love as a departure *from* the island, a pilgrimage as an allegory. The island itself is a "nonplace." The painting is more suspension than action; it is simultaneously an instant and outside of time—atemporal. The unity of time and the unity of place are both destroyed and respected. It is in discarding the representation of movement that Watteau created this unique world where illusion and reality are inextricably intertwined. The artist's drawings contain nothing that contradicts this analysis.

At first Fragonard's intention seems radically opposite in nature. His drawings and paintings give the impression of snapshots, and it is useless to deny that he was preoccupied with rendering movement. The dynamism of his stroke, the vitality of his pencils have long been admired. Nonetheless, even in his *Figures de fantaisie* (1769), the most "baroque"—a word we object to—work of the artist (and in the history of eighteenth-century French painting), he attempts not so much to paint the displacement of a body as to capture it. Fragonard captures the instant the way the best photographer immortalizes his model.

His *Priest (?) Stabbing a Young Girl on an Altar* (fig. 236), a drawing whose subject remains a mystery, gains its power from its friezelike composition, its violence, and its pivoting, almost cinematographic, movement, which the strange effect of the close-up emphasizes. Fragonard aimed to recover the gesture, not to seize it. In his so-called late paintings (the artist was not yet forty-five!), such as *The Bolt* (fig. 237), in which the Neoclassical ideal can be perceived, Fragonard stressed his impulse to freeze the composition. He painted not the moment of pleasure but the image of desire.

David's ambitions are clear. His world is one of captured gestures, his heroes like so many sculptures. Some of his drawings demonstrate his concern to seize a pose (fig. 238). In David's paintings, he does not shrink from movement: he denies it. This is the price he pays for transforming human beings into legendary characters, which is as true of his *Brutus* as it is of his *The Coronation of Napoléon and Joséphine.*

"I cannot repeat it too often: movement is life."[11] Ingres had no problem living with contradiction between his precepts—not altogether devoid of dogma—and his practice, where he displayed the greatest independence. As with David, he liked to study gestures, and he multiplied arms in a great variety of poses (fig. 239). This gives his drawings an odd, unreal note, which has been characterized as almost "surrealist," surprising and seducing our contemporaries. Is Ternois correct in supposing that

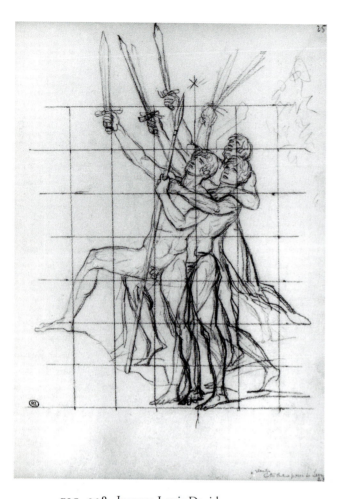

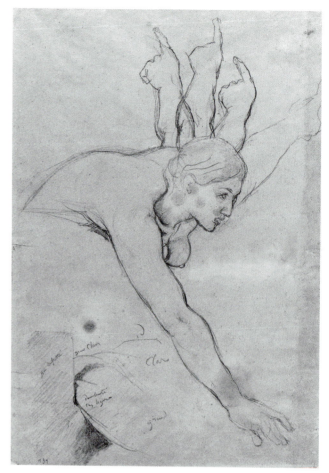

FIG. 238. Jacques-Louis David, *Study of Three Men* (fol. 23r of a notebook), c. 1808–10. Black crayon on paper, 10 x 8 in. (25.5 x 20.4 cm). Département des Arts Graphiques, Musée du Louvre, Paris

FIG. 239. Jean-Auguste-Dominique Ingres, *The Mother (Study for "The Martyrdom of Saint Symphorian")*, 1827–34. Graphite and black chalk on paper, 14⅜ x 9¾ (36.6 x 25 cm). Musée Ingres, Montauban

"the choice of gesture being finally decided, these same figures transposed on the canvas seem frozen"?[12] The figures of his drawings look as frozen to our eyes as those of his canvases (figs. 240, 241). Ingres demonstrates a clear intention, a manifest will, in contrast to Delacroix, to place the subjects of his paintings outside of time—to remove them from reality as well, another feature that brings him closer to Poussin and Watteau, and also to David (despite the *Sacre*), and to the Fragonard of *Coresus Sacrificing Himself to Save Callirhoé* and *The Invocation to Love*.

Whether colorists or advocates of the line, severe or voluptuous in their draftsmanship, how did Poussin, Watteau, Fragonard, David, and Ingres approach the question of the nude? Or, to put it differently, were they sensual painters?[13]

Poussin experienced no constraint in painting or drawing the female nude, which he did from his youth up to the final *Apollo and Daphne*. This work holds a place in Poussin's career comparable to *The Turkish Bath* (fig. 241) in Ingres's. In his various Venuses dating before 1630, Poussin makes no mystery of his predilection for erotic subjects, of a joyous and unequivocal sensuality (fig. 242). The disappearance of his

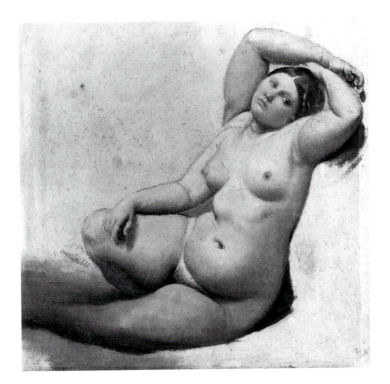

FIG. 240. Jean-Auguste-Dominique Ingres, *Study for "The Turkish Bath,"* 1815? (before 1862). Oil on paper, 9¾ x 10¼ in. (24.9 x 25.9 cm). Musée Ingres, Montauban

FIG. 241. Jean-Auguste-Dominique Ingres, *The Turkish Bath,* 1862. Oil on canvas mounted on panel, diameter 43¼ in. (110 cm). Musée du Louvre, Paris

FIG. 242. Nicolas Poussin, *Venus Spied on by Satyrs*, 1626–27. Oil on canvas, 26⅛ x 19¾ in. (66.4 x 50.3 cm). National Gallery, London

Venus Attended by Three Putti, which belonged to Loménie de Brienne and shocked the Lazarist brothers with whom the impetuous and muddleheaded councilor of state had found refuge is regrettable: "The indecency consisted in that the goddess, sleeping or feigning sleep, lifted a leg to reveal too much of the nude seat of love."[14] In three studies for a *Bacchanal,* Poussin barely disguised the erect phallus of a satyr clearly attracted by the charms of a young nymph (fig. 243). But for all that, could it be asserted that Poussin's work is "feminine"?[15]

In contrast, the femininity of Watteau's work is misleading. Not only did he love to draw the female body, he also seems to have been continually attracted by feminine fashion, coquetry, elegance, and by woman's flesh, seductiveness, and intimacy. There is nothing licentious, troubling, or crude in his work—no smutty innuendos; on the contrary,

FIG. 243. Nicolas Poussin, *Study of a Woman Placing a Mask on the Face of a Faun, with Recumbent Figures behind Them,* c. 1637–38 *(right), Study for the Resurrection of Lazarus,* c. 1650 *(left).* Pen and brown ink with brown wash over black chalk on paper, 7 x 10¼ in. (17.8 x 26 cm). The British Museum, London

FIG. 244. Antoine Watteau, *The Intimate Toilette,* 1715. Oil on panel, 13⅝ x 10⅜ in. (34.6 x 26.5 cm). Private collection, Paris

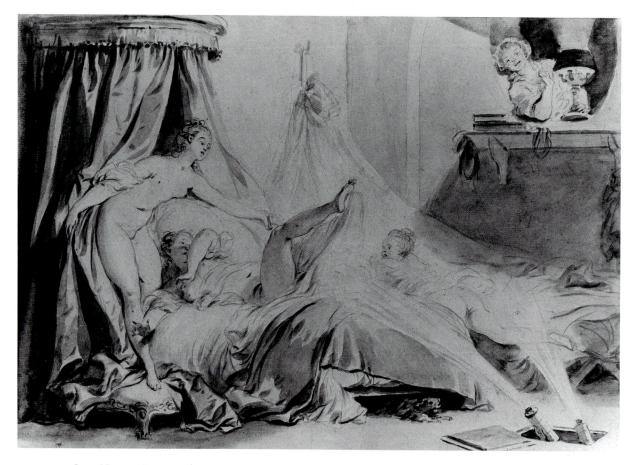

FIG. 245. Jean-Honoré Fragonard, *The Sprays of Water,* c. 1770. Bister wash over black chalk on paper, 10⅜ x 15⅛ in. (26.5 x 38.4 cm). The Sterling and Francine Clark Art Institute, Williamstown, Massachusetts

it displays a simplicity, a naturalness, a frankness, even an easiness, along with a respect for women and a nobleness that are Watteau's trademarks and distinguishes him from the many minor masters of the eighteenth century. Above all, Watteau's work evinces *modesty* (fig. 244).

Do these qualities describe Fragonard, the other "painter of the woman," to use an extremely unwelcome expression that has had its day? Fragonard's work certainly includes several frisky scenes, such as *Little Girl Making Her Dog Dance on Her Bed (La Gimblette),* or some mischievous scenes, such as *The Sprays of Water* (fig. 245) or *The Firecrackers,* but whatever might make these playlets saucy is effaced by the lightheartedness, liveliness, and cheerfulness with which Fragonard approached them and depicted their young actors. There is nothing indecent about *The Stolen Chemise* or *All Ablaze.* These are lively scenes, barely concealed, but they contain "neither filth, nor disgust, nor shame," to quote the preeminent connoisseurs of the nineteenth century, the Goncourt brothers.[16] Fragonard drew and painted the realities of love without the ambiguous innuendos dear to Greuze, which create an uneasy feeling. Fragonard never crossed the line—often a slippery one—into eroticism and soft pornography.

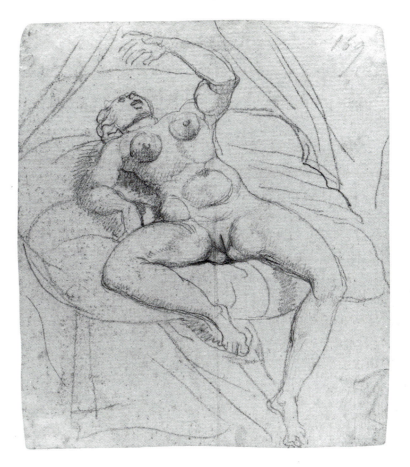

David's work is undeniably virile, but not because he lacks for
female heroines or because his female models lack charm. However, the
world of this painter and draftsman is devoid of all sensuality. This
differentiates him from Ingres, whose "erotic drawings"—a group of
twenty-five frankly salacious sheets preserved in Montauban (fig. 246),
usually dated about 1804–6, before Ingres left for Italy—are often men-
tioned. We seem to have lost sight of the fact that these are copies of
prints, after Giulio Romano in particular.[17] The fact that these drawings
did not originate with Ingres and were not drawn from his imagination
has disappointed some specialists and connoisseurs who had conceived a
wrong idea of the painter. However, we do not know what led Ingres to
make them.

Ingres made numerous nude studies for his Venuses, bathers, oda-
lisques, Virgins, and worldly portraits, as well as for *La Source, The
Golden Age.* He executed them using professional models, whose names
he scrupulously recorded—Mariuccia (fig. 247), Marietta la Romaine
(not to be confused with Camille Corot's model of the same name)[18]—
along with their addresses and fees (four francs a day). These nude stud-
ies, from the most modest to the most magnificent, marry keen observa-

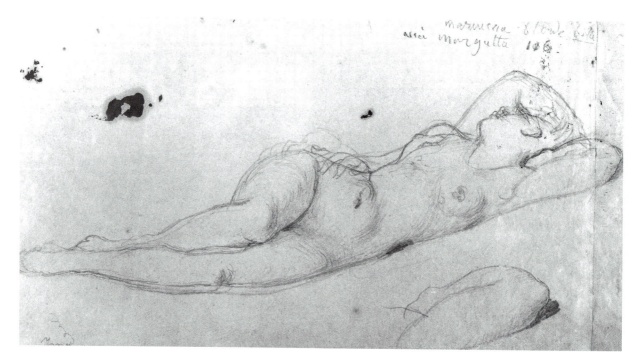

FIG. 247. Jean-Auguste-Dominique Ingres, *Study of a Recumbent Female Nude,* 1839. Graphite on paper, 5½ x 10⅜ in. (14 x 26.4 cm). Musée Ingres, Montauban

tion and sensuality in a manner both masterly and mysterious. Admiration for the elegance and suppleness of the female form, its shapes and curves, is coupled with an obsession with woman and her moistness, in the most provocative poses. And there is, above all, his veritable hymn to woman in which no men appear— *The Turkish Bath* (fig. 241), lovingly painted by a man of eighty-two years. Both chaste (in comparison to Gustave Courbet's *Sleep*) and sensual, it is as much an artistic testament as a "poem of the flesh."

Ingres's virtuosity leaves us astonished; that of Fragonard sometimes carries him into facileness. The pleasure that Watteau takes in drawing is communicative. Poussin's means are, admittedly, limited, but his hand transcribes a text with as much confidence as intelligence into a strong, upsetting image that gives life to the text that inspired it. Like Poussin, and with hardly superior technical abilities, David could satisfy his desire to invent by means of his numerous drawn studies.

THESE ALL TOO SUMMARY appreciations do not take into account an essential point: the evolution in time, the changes, the transformations of graphic style experienced by each of these five masters.[19] Poussin's initial drawings may be seen as awkward (see fig. 224). His last drawings reveal the effects of a trembling hand (fig. 248). Throughout his career, he employed the same technique and the same tones in his washes. His style changed little; the modifications that loom large in his paintings are much less noticeable in his drawings. At most, Poussin's tendency toward synthesis allied with boldness of expression grew stronger over the years.

FIG. 248. Nicolas Poussin, *Two Hermits in a Landscape,* c. 1660. Pen and brown ink over black chalk on paper, 7⅝ x 10¼ in. (19.5 x 26 cm). The Hermitage Museum, Saint Petersburg

The stylistic evolution of Watteau went hand in hand with his technical growth. It is all the more remarkable given the artist's brief career. Watteau quickly broke away from the influences of Gillot and Claude Audran III (fig. 249). During the years from 1711 to 1715 he mastered space and light, as well as expressiveness and monumentality. His compositional arrangements became more and more elegant and refined. In 1715 Watteau, it seemed, perfected the combination of red and black chalks. The introduction of white chalk added even more zest to a métier dedicated to drawing (fig. 250). The changes in Watteau's style consist not of abrupt breaks but, rather, delicate and harmonious inflections.

Fragonard not only evolved, he knew how to renew himself. The most prolific draftsman of his century—this "babbler of the drawing,"[20] this inspired jack-of-all-trades—rarely dated his work, which makes it impossible to determine if the stylistic transformations of the draftsman worked along the same lines as those of the painter and if they influenced one another. The changes in his style display little logic or coherence. Fragonard the draftsman worked with considerable independence from

FIG. 249. Antoine Watteau, *Seven Actors and a Gnome Musician; Study of Crossed Hands; and Fragment of an Arabesque,* c. 1711. Red chalk on paper, 3⅛ x 5⅛ in. (8 x 13 cm). Hessisches Landesmuseum, Darmstadt

FIG. 250. Antoine Watteau, *Pierrot Standing,* c. 1717. Red, black, and white chalks on paper, 9½ x 6⅛ in. (24.3 x 15.8 cm). Teylers Museum, Haarlem

FIG. 251. Jacques-Louis David, *The Funeral of Patroclus,* 1778. Pen and brown and black inks, with gray wash and white heightening over black chalk on four attached sheets of paper, 13 x 29⅝ in. (33 x 75.5 cm). Musée du Louvre, Paris

the painter, which distinguishes this artist from both Watteau and David. One unhappy day, on the eve of the Revolution, Fragonard stopped drawing. In contrast, Poussin, Ingres, Watteau, and David, died with brushes, pen, and pencils in their hands.

The evolution of David's graphic style is more pronounced than is generally acknowledged. After a modest beginning, an almost provocative will to renew the formulas then prevailing emerged in such works as the large sheets in Vienna, Paris (fig. 251), and Honfleur, as well as the frieze now divided between Sacramento and Grenoble. The artist found his technique and his path by 1780 at the latest. This is confirmed by some exceptional sheets—the *Head of the Dead Marat* (fig. 252), the *Woman Wearing a Turban*—some splendid draped studies (figs. 103, 253), and the portrait drawings made during David's second incarceration, from 30 May to 3 August 1795.[21] From the initial awkward studies to the drawings of the Brussels period (fig. 254), still unjustly slighted all too recently, and through the studies for *The Distribution of the Eagle Standards,* David's art gives evidence of subtle modulations. They establish that even if the drawing was above all a means or a tool, the artist did not underestimate either its usefulness or its value.

Sufficient attention has not been given to the modifications of style undergone by Ingres the draftsman. These are, in fact, considerable. Comparing a group portrait drawing of the difficult years between 1804 and 1824, such as *The Forestier Family* at the Louvre (1804; fig. 255), with those made much later (fig. 256), we see that the line is less incisive, not as sharp, not as fine; the pose has lost its spontaneity and is less refined—one might say that the atmosphere has become heavier. A comparison

FIG. 252. Jacques-Louis David, *Head of the Dead Marat*, 1793. Pen and brown and black inks over black chalk on paper, 10⅝ x 8¼ in. (27 x 21 cm). Musée National du Château, Versailles

Opposite:
FIG. 253. Jacques-Louis David, *Draped Personage, Standing (Study for "The Death of Socrates"),* 1786–87. Black chalk and stump with white heightening on paper, 20¾ x 14½ in. (52.9 x 37 cm). Musée des Beaux-Arts, Tours

FIG. 254. Jacques-Louis David, *Three Studies of Heads,* 1821. Black crayon on paper, 5¼ x 7¾ in. (13.5 x 19.8 cm). Denver Art Museum, lent by Mr. and Mrs. Esmond Bradley Martin

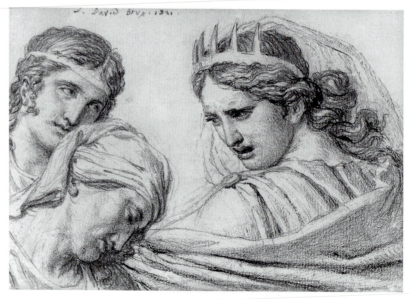

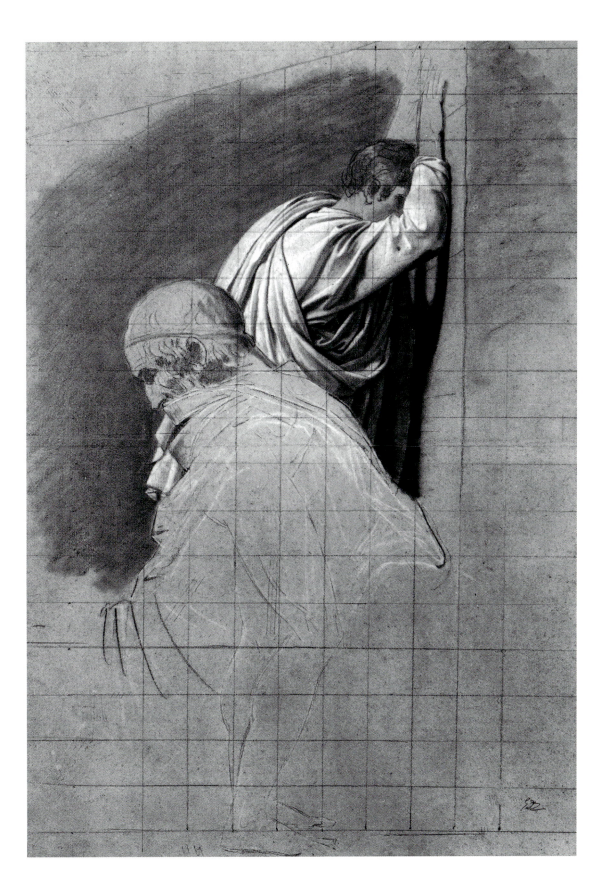

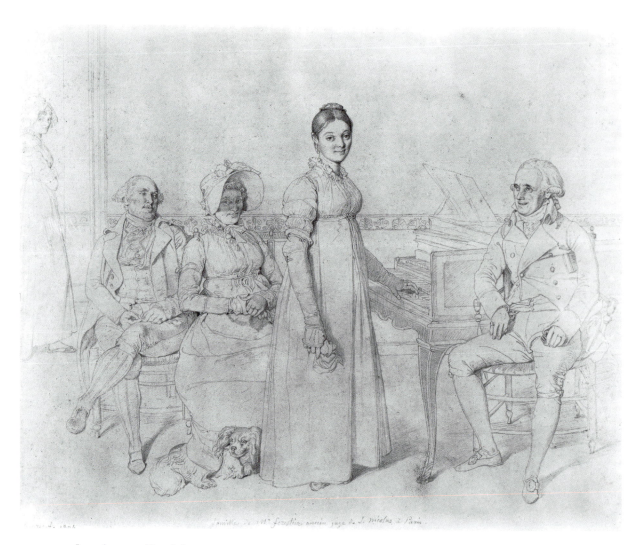

FIG. 255. Jean-Auguste-Dominique Ingres, *The Forestier Family*, 1804. Graphite on paper, 11 ¾ x 14 ⅝ in. (30 x 37.2 cm). Département des Arts Graphiques, Musée du Louvre, Paris

between the studies for the historic compositions of the first Italian visit (fig. 257) and *The Golden Age* will prove equally instructive.

Today, the drawings of Ingres and Watteau are valued more than their paintings. In contrast, no one would hesitate to take Poussin's canvases or, especially, those of David, over their drawings. Opinion on Fragonard remains divided. Has it always been thus?

Watteau "was more satisfied with his drawings than with his paintings"[22] and in all likelihood preferred drawing to painting. At the opposite pole, Ingres always looked on his drawings with condescension and disdain, despite his awareness that they evoked universal admiration. From the eighteenth century on, Watteau's drawings were prized by many connoisseurs. The dispute that set Gersaint against the author of an anonymous article in the *Dictionnaire abrégé de peinture et architecture* of 1746, which lasted a year, is in many ways illuminating. For Gersaint, "nothing is superior" to Watteau's drawings: "he will always stand as one

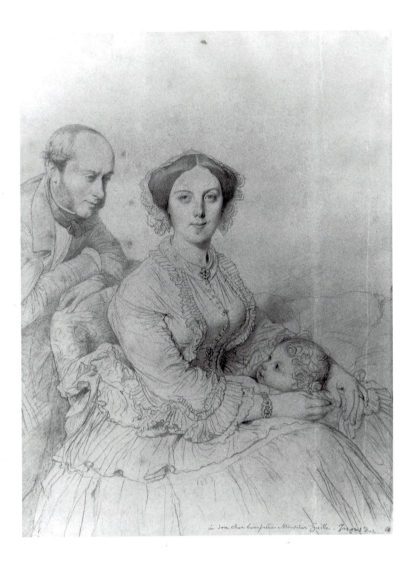

of the greatest and best draftsmen that France has produced." His paint-
ings, on the other hand, "reflect somewhat the impatience and instability
that shaped his character."²³ His adversary assured his audience that "the
reputation [of the painter] has greatly sunk today." As for the draftsman,
"[his] standing is highly overrated."²⁴ This debate has not yet lost its rele-
vance; even today, many prefer Watteau's drawings to his canvases.

The rehabilitation of David's drawings has begun, including the
works of the Brussels period. The recent exhibition dedicated to Poussin
revealed to many of its viewers the forceful originality of an occasionally
clumsy draftsman with immense emotional power. Ingres's case is particu-
larly interesting to study. Naef, in his introduction to the 1967 Ingres
catalogue for the Grand Palais, wrote: "Had Ingres left only his work as
portraitist, painted or drawn, his fame would be beyond discussion, great,
simple, immutable, similar to [Hans] Holbein's. But he made the mistake
of leaving a much richer oeuvre than the painter of three centuries ago,

Opposite:

FIG. 257. Jean-Auguste-Dominique Ingres, *Venus and Diomedes,* before 1805. Graphite on paper, 14¾ x 12½ in. (37.4 x 31.9 cm). Department of Drawings, National Gallery, Prague

whom he miraculously equaled, and sometimes surpassed. . . . Despite instances of extraordinary beauty in his history painting, Ingres was far from reaching by means of it what he thought he was surpassing; on the other hand, he created his true masterpieces, removed from time and criticism, on the edge of his ardent ambition."[25] Few scholars would share that point of view today.

"He drew so that he could better understand": this observation of Sutherland Harris concerning Poussin[26] seems applicable to all five artists and, most important, distinguishes them from their contemporaries, whether French or foreign—for example, Hubert Robert, Domenico Tiepolo, or Van Dyck. Mariette was of the same opinion: "When he drew, he aimed only at putting down his ideas."[27] Poussin himself referred to the importance of the *thought* many times in his correspondence: "I made a new composition for when Saint Paul is stricken, a different thought from the first having come to me."[28] For Poussin— to a far greater degree than for the vast majority of artists, whatever their country or period—each drawing was also a *dessein.*

Caylus assures us, "Watteau thought deeply," even if his "thoughts surpass his abilities."[29] Clearly, for Watteau drawing was not pointless, he did not draw for the sheer pleasure of looking. It was far more than that: it was intelligence of looking, looking with tenderness, which was never distant or arrogant, demonstrating that he wanted to be involved with and sought to understand its model.

Fragonard is the least "intellectual" of these draftsmen. Does not everything seem a game with him: pure virtuosity, skill, and facileness? Yet we think we discern in the works from the period 1774 to 1785 not so much a deepening of thought (nor an impulse to trigger a dreamlike state, which is a constant in his work) as a desire to induce reflection. The artist no longer drew physical love, the contact between two skins; he became devoted to Love. He preferred the transports of passion to the pure pleasure of adolescents.

Were David's drawings reflections of the dogmatism with which he is so often reproached? Did the moralist prevail over the artist? David viewed art as a "branch of public education," to quote Delécluze,[30] to be placed at the service of certain ideas. This explains the role he assigned to drawing, in its turn regarded as a means, a way station that enabled him to understand better the workings of his mind.

Does this definition of drawing as a medium that reveals the creative mechanism of the artist also apply to Ingres? Certainly. What separates Ingres from David, besides the former's "contemptible facileness" compared with the latter's "awkwardness," is Ingres's search for the beautiful, his ambition to realize the "beau idéal," as opposed to David's search for the true (and not historical realism).

Ingres, too, had his thoughts on the artist's *dessein:* "What takes

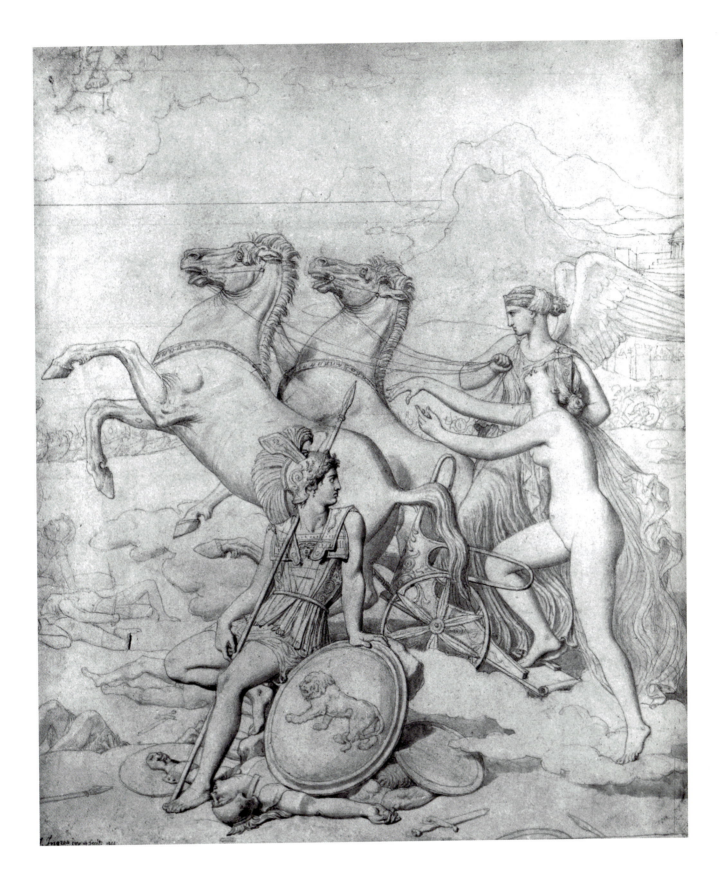

longest for a good painter is to *think through* the entire painting, to have it, so to speak, in one's head, in order to realize it with fire and as if it was made all of a piece."[31] In this respect, Ingres viewed drawings as the daily scales practiced by the performing musician. A wonderful anecdote, the veracity of which we have no reason to doubt, proves very revealing:

Ingres stopped on the sidewalk for a good while at the intersection of the rue d'Assas and the rue Vavin; motionless, he followed as if mesmerized the back-and-forth movement of a large brush loaded with a brownish color, which a house painter stroked with an even and rhythmic gesture on the wainscoting of a storefront. "Hey! My dear master, what are you doing there?" asked his colleague at the Institut Signol who, approaching him, became intrigued. In answer, Ingres indicated the worker: "Look," he said, "and admire with me: he takes up and he puts down *exactly what is needed.*"[32]

TAKING UP EXACTLY WHAT IS NEEDED in terms of ideas: that is also what Poussin, David, Watteau, Fragonard attempted to do, with more or less successful results.

Posterity has not always treated our five artists well. Whether they died in the full flower of fame, like Poussin, or forgotten, like Fragonard, or considered "outmoded" in their lifetime, like Fragonard and David, all experienced a purgatory, to different extents. Poussin became the symbol of a tedious academicism, pedantic and pretentious, until the monographic exhibition of 1960 in Paris. Even today, the only partial success of the recent exhibition at the Grand Palais indicates that this difficult artist—one who set a high standard—does not win over the masses, who are too accustomed to looking with eyes formed by the Impressionists.

Watteau was undeniably admired in the eighteenth century, although less than Charles-Antoine Coypel or Carle Van Loo. He was not a history painter; he upset the customary hierarchy of genres. Within his own genre—in truth, a very minor one—he was unique. The nineteenth century, which could be said to have begun in 1780, almost unanimously forgot him.

Fragonard was also swept aside by the Davidean aesthetic, the Neoclassical reaction. Line prevailed over color, straight over curved, the finished over the sketch, moral example over frivolity, virtue over amorality (or immorality), learned over lighthearted, and the serious over the buoyant. In his turn David, in exile in Brussels, experienced obscurity. "As a painter, his influence in France shrank to zero," observed Delécluze following his death. He added, "The majority of artists of the new School [this is in 1825] would no more understand his speeches than his pictures."[33]

Ingres suffered the same fate. Constantly undergoing comparison

with the rival strand of romanticism, he lived long enough to witness the beginning of Impressionism. The art of Ingres was considered reactionary; that of David and Fragonard backward. Like Watteau, Fragonard fell victim to the eighteenth century's disaffection. All were condemned in the name of "modernity," the "avant-garde," and the progress of the arts; they became "outmoded" and "rearguard."

Time has avenged them: Poussin is *the* painter of painters and art historians, the painter of an intellectual elite. Watteau has seduced the world of fashion, theater, and film. Is Fragonard one of the "precursors" that our period prizes so highly? From Honoré Daumier to Auguste Renoir, from Pierre Bonnard to Jean Dubuffet, from Impressionists to action painters—the artists in whom his direct influence is seen are legion. He is the one who "liberated" painting. Fragonard's "gesture" already foreshadowed Jackson Pollock. While this analysis no doubt contains a germ of truth, it also has a large dollop of exaggeration. But let us rejoice that Fragonard is fashionable. David's rehabilitation is now complete (even though he is far overshadowed by the renown currently enjoyed by his contemporary Goya). Artist of the rearguard in the view of his contemporaries (despite the admiration of Degas, who collected his work),[34] Ingres is undoubtedly the painter and draftsman whose influence on the art of the twentieth century—from Henri Matisse to Pablo Picasso—has been the greatest and the deepest. Let us take care not to judge artists in terms of progress. Leave such evaluations to criticism. Art historians must learn to keep their distance, so that they are not seduced by the ephemeral and the clamorous.

DRAWING IS POPULAR TODAY; exhibitions, catalogues, and books devoted to it abound. It has its own periodical, dealers, collectors, scholars, which are more numerous than ever. One explanation for this popularity—or, at any rate, this infatuation—which has notably increased since World War II, and from which Poussin, Watteau, Fragonard, David, and Ingres have particularly benefited, is that drawing often lacks a subject. In other words, drawing can be enjoyed without regard to its subject. This does not apply to the major paintings of Poussin, David, and Ingres (and even some by Watteau and Fragonard). The *Death of Germanicus* or *The Shepherds of Arcadia*, *The Oath of the Horatii* or *The Sabine Women*, *The Martyrdom of Saint Symphorian* or *The Apotheosis of Homer* cannot be fully understood or appreciated in all their richness without a knowledge of their subject.

In order to savor these paintings, we think it necessary to read history in just the way the artist looked on it in order to narrate it with his brushes. He sometimes became attached to his story and wished to "leave a message," offer a lesson, educate, present an example of virtue, share his ideals and faith. These subjects, many of which demand an eru-

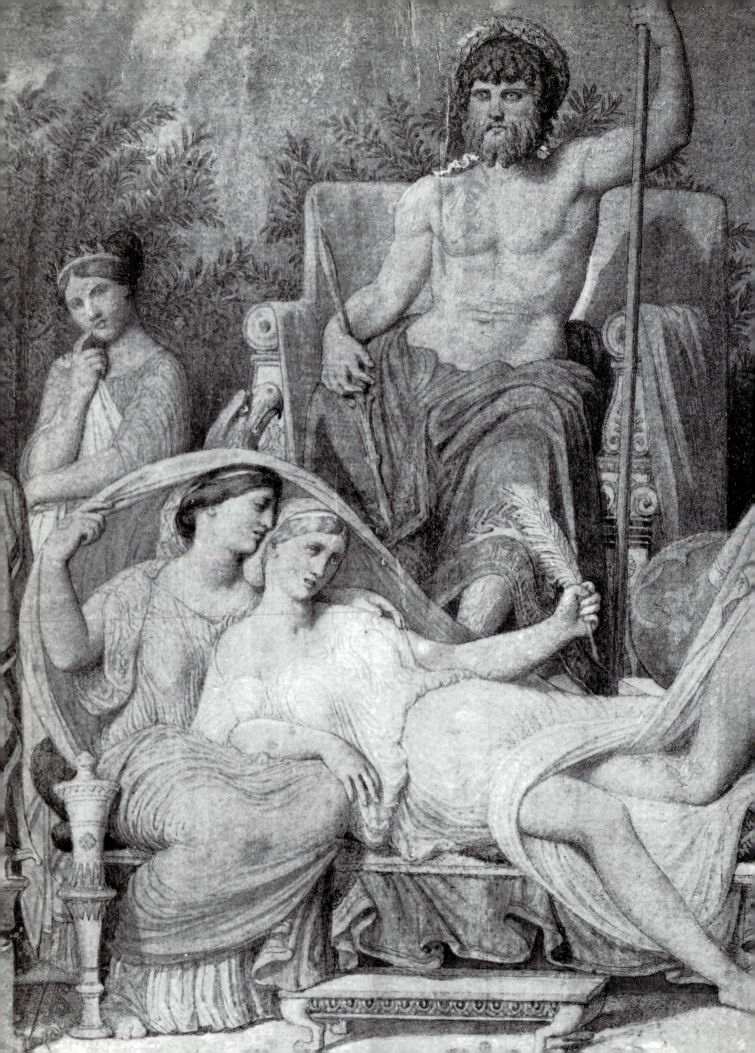

dition that is no longer in fashion—biblical, mythological, and literary studies that have increasingly become the realm of specialized rather than general education—have proved an obstacle to these paintings, often to those that have occasioned from their authors the greatest efforts and in which they had placed their greatest aspirations. On the occasion of the Poussin exhibition of 1994–95 at the Grand Palais, the lack of iconographic knowledge of even the most rudimentary sort clearly distanced a great many visitors from the works on view. A good story, of course, does not suffice to make a good painting, as the host of failures in this area attests, but past examples, including the recent one of *Guernica,* are there to remind us that a subject, a history, or History have never prevented the creation of a masterpiece.

Such specialized knowledge is not indispensable to the enjoyment of a drawing. Its value arises from other criteria. In its negation of the subject, it has even been described with some audacity as abstract. Drawing has won its autonomy in relation to the painting; it enjoys a status as an independent work of art.

Yet what makes it successful and explains its singular status with connoisseurs and a vast public, what constitutes its "modernity," we believe, is also its limitation. It is through drawing that we penetrate the artist's being. We are closer to him. We "are there, live" at "the creation." "There is a certain type of connoisseur who goes into throes of ecstasy over a single sketch; he searches for the soul and the thoughts of the man of genius, whom he is able to see and recognize," remarked the anonymous expert for the Varanchan de Saint-Geniès sale in 1777 in relation to drawings by Fragonard.[35] The artist would not have wished it so. He wanted to be judged by his finished work, which combined line and color, composition and narrative. That is what Poussin, Watteau, Fragonard, David, and Ingres envisioned.

But we have no wish to end on a negative note. There is a word that we have not sufficiently employed—deliberately, as it has given rise to all manner of divagations—and that word is *beauty.* As much from their pencils as their brushes, Poussin, Watteau, Fragonard, David, and Ingres, each according to his conception, his style, his language, his vision, his ideal, have proven far from stingy in that quality.

Notes

Spelling varies among the older French sources. For example, one may find both *étoit* and *dessein* as well as *était* and *dessin*.

CHAPTER 1

1. "maladie des poumons." Cited in Antoine de La Roque, obituary of Watteau, *Le Mercure,* August 1721, 81–83; reprinted in Rosenberg 1984, 5.

2. See, nevertheless, Christian Michel, "Les Fêtes galantes: Peintures de genre ou peintures d'histoire?" in *Antoine Watteau, 1684–1721, le peintre, son temps, sa légende* (acts of a symposium held in Paris, 1984) (Paris and Geneva, 1987), 111–12.

3. In 1648 the establishment of the Académie royale de peinture et de sculpture brought about the renewal of the artist's training essentially based on drawing copies. The Académie assumed responsibility for the expensive practice of life drawing and in addition offered technical and theoretical courses on anatomy and perspective. At the same time, students had to follow the teaching of their master in his studio, as in the past. See Antoine Cahen's excellent contribution to this subject, "Les Prix de quartier à l'Académie royale de peinture et de sculpture," *Bulletin de la Société de l'histoire de l'art français 1993* (1994): 62–84.

Academy drawings—"imitation of a living model, drawn, painted, or sculpted, [which has] as its goal to study in particular the forms and entirety of the human body, to train by means of these studies, or to use them in preparation for a projected work" ("imitation d'un modèle vivant, dessiné, peint ou modelé [qui a] pour objet d'étudier particulièrement les formes et l'ensemble du corps humain, de s'exercer à ces études, ou de se préparer à quelque ouvrage projeté"), according to the

definition given by C. H. Watelet and P. C. Levesque, *Dictionnaire des arts de peinture, sculpture et gravure* (Paris, 1792; reprint, Geneva, 1972)—convey the hegemony of the Académie royale throughout the eighteenth century, until its suppression at David's instigation.

4. On the Crozat collection, see Cordelia Hattori, "À la recherche des dessins de Pierre Crozat," *Bulletin de la Société de l'histoire de l'art français 1997* (1998): 179–208.

5. "Fu egli di statura grande, proporzionato in tutte le parti del corpo, con raro temperamento; era il suo colore alquanto olivastro, e negri erano i capelli, in gran parte canuti per l'età. Gli occhi avevano alquanto del cilestre; il naso affilato e la fronte spaziosa rendevano nobile il suo volto con aspetto modesto." Bellori 1672, 1976, 455.

6. "Si trattava egli onestamente; il suo vestire non era splendido, ma grave ed onorato. . . . In casa poi non voleva ostentazione alcuna, usando la stessa libertà con gli amici, ancorché di alta condizione. Visitato un giorno nel suo studio da monsig. Camillo Massimi, oggi degnissimo cardinale, che per le sublimi qualità sue egli sommamente amava e riveriva, nel trattenersi e discorrere insieme avanzatasi la notte, Pussino nel partire l'accompagno' con la lucerna in mano per le scale sino alla carrozza; dove per lo disagio di portare il lume dicendigli quel signore: 'Io vi compatisco che non abbiate un servidore,' rispose Nicolo': 'Ed io compatisco più V.S. Illustriss. che ne ha molti.'" Ibid., 455–56.

7. "Era Pussino d'ingegno accorto e sagace molto." Ibid., 455.

8. "Watteau était de taille moyenne et de constitution faible: il avait l'esprit vif et pénétrant, et les sentiments élevés. Il parlait peu mais bien, et écrivait de même. Il méditait presque toujours, grand admirateur de la nature et de tous les maîtres, qui l'ont copiée. Le travail assidu l'avait rendu un peu mélancolique, d'un abord

froid et embarrassé, ce qui le rendait quelquefois incommode à ses amis, et souvent à lui même; il n'avait point d'autre défaut que celui de l'indifférence, et d'aimer le changement." Jullienne 1726; see Rosenberg 1984, 16.

9. "Il voulut vivre à sa fantaisie, et même obscurément." Gersaint 1744; see Rosenberg 1984, 34.

10. "sa figure n'était point imposante." Ibid.; see Rosenberg 1984, 35.

11. "Ses yeux n'indiquaient ni son talent ni la vivacité de son esprit." Caylus 1748; see Rosenberg 1984, 85.

12. "D'un naturel doux et affable." See Rosenberg 1984, 5.

13. "d'un caractère triste," [un] "tempérament délicat et usé." Gersaint 1744; see Rosenberg 1984, 38.

14. "Une santé absolument délabrée." Mariette, annotations on his copy of Père Orlandi's *Abecedario pittorico* of about 1745, preserved in the Département des Manuscrits, Bibliothèque Nationale de France; see Rosenberg 1984, 4.

15. "Taille de quatre pieds onze pouces visage rond, front haut, cheveux gris, yeux gris, sourcils gris, nez ordinaire, bouche moyenne, menton rond, marqué [ce qui veut dire que son visage portait les traces de la petite vérole], résidant à Paris depuis cinquante-six ans." Fondation Jacques Doucet, box 14, Bibliothèque d'Art et d'Archéologie, Paris.

16. "Il était petit, assez rond, avec des cheveux gris très ébouriffés. Son costume habituel était une houppelande, ou, comme on l'appelait alors, une roquelaure en drap gris mélangé, comme la robe des soeurs grises." The account is from Mme Hyppolite Lecomte, née Camille Vernet, reported by H. Delaroche-Vernet, "Mémoires inédits sur les Vernet," *Revue de l'art ancien et moderne* 49 (June–December 1923): 223–24.

17. "peintre excellent pour son talent, qui m'est nécessaire surtout en Italie, mais d'ailleurs très commode pour voyager, et toujours égal." Bergeret 1895, 17:67.

18. "Toujours égal!—Parce qu'il avoit joué cette égalité et toute la souplesse qu'il paraît avoir ne vient que de lâcheté, poltronnerie, ayant peur de tout le monde et n'osant donner un avis franc en négative, disant toujours ce qu'il ne pense pas. Il en est convenu lui-même." Ibid. The manuscript is in the Bibliothèque Municipale de Poitiers (ms 109, Mélanges Bonsergent, box 1, pièce 6).

19. "la grosse joue." See Wildenstein 1973, 112, no. 1119.

20. Request for a passport for England dated 26 June 1815 (F⁷ 4330, dossier 7, Archives Nationales, Paris), cited in Wildenstein 1973, 197, no. 1715, and in Paris-Versailles 1989–90, 620.

21. "Il régnait dans son habillement une recherche grave, une propreté tout opposées aux habitudes de la plupart des révolutionnaires. Bien plus, malgré le gonflement d'une de ses joues qui le défigurait, et quoique son regard eût quelque chose d'un peu dur, dans l'ensemble de sa personne régnait un certain air d'homme de bonne compagnie que peu de gens avaient conservé depuis les années orageuses de la Révolution. Si l'on excepte la petite cocarde tricolore qu'il portait à son chapeau rond, tout le reste de son costume, ainsi que sa manière d'être, l'auraient plutôt fait prendre pour un ancien gentilhomme en habit du matin, que pour l'un des membres les plus ardents du comité de sûreté générale." Delécluze 1855, 29.

22. John Gibson Lockhart, *Memoirs of the Life of Sir Walter Scott*, vol. 2 (Paris, 1837), 185.

23. "My goodness, how very ugly he is!" ("O mon Dieu qu'il est laid!") exclaimed a lady on seeing the young Ingres, according to Henry Lapauze, *Ingres: Sa Vie et son oeuvre (1780–1867)* (Paris, 1911), 15.

24. Ternois 1971, nos. 18 (a, b) and 161 (a, b, c). Two self-portrait drawings are known; Naef 1980, vol. 5, nos. 265 and 364; see also vol. 4, no. 96, location unknown.

25. "Il n'y avait pas à s'y tromper! C'était bien son crâne en pain de sucre, aux cheveux, encore d'un noir méridional, séparés par le milieu, à la manière des anges dans les tableaux de la Renaissance italienne. C'était son front fuyant, ses vastes oreilles, ses yeux ardents, rageurs, faisant l'effet de charbons incandescents sous les épaisses arcades sourcilières. C'était son teint bilieux, son nez lancé en avant, dédaigneux même dans sa fureur, sa solide mâchoire, son menton volontaire, solennellement tyrannique. C'était aussi sa personne trapue, vigoureuse malgré le faux air de ballon." Rioux de Maillou, *Souvenirs des autres* (Paris, 1917), quoted by Faure in Amaury-Duval 1924, 220.

26. "A voir ce petit homme gros, et sans élégance, jamais un étranger ne supposerait l'âme d'artiste qui se cache sous cette enveloppe, à moins qu'il n'ait surpris l'énergie de son expression ou le feu de son regard." Louis Flandrin, *Hippolyte Flandrin* (Paris, 1909), 27.

27. Gabriel de Saint-Aubin drew in the margin of his catalogue of the Mariette sale (1775–76) a copy of a bust of Mme Poussin by François Duquesnoy, location unknown; reproduced in Paris 1994–95, 133. No other

portrait is known. On this question, see Ursula Schlegel, *Staatliche Museen Preussischer Kulturbesitz: Die Bildwerke der Skulpturengalerie Berlin,* vol. 1, *Die italienischen Bildwerke des 17. und 18. Jahrhunderts in Stein, Holz, Ton, Wachs und Bronze mit Ausnahme der Plaketten und Medaillen: Die Erwerbungen von 1978 bis 1988* (Berlin, 1988), 9–12, no. 2a.

28. See Paris-New York 1987–88, 223–24.

29. On Mme Fragonard's work as a miniaturist, see Pierre Rosenberg, "De qui sont les miniatures de Fragonard?" *Revue de l'art,* no. 111 (1996): 66–76.

30. See Paris-Versailles 1989–90, 484–85.

31. "mes étourderies." David 1880–82, 1:294; see also Antoine Schnapper, "David et l'argent," in *David contre David* 1993, 2:925 n. 18.

32. *David contre David* 1993, 2:925 n. 24.

33. "[I]l a fallu qu'il me ravît ma femme! Elle est morte, elle m'est enlevée pour toujours, cette femme admirable, sublime par sa fin cruelle. Non, rien n'égale mon affreux désespoir, et l'on ne peut mourir de tant de douleur! . . . Ah, que je l'aurais voulu suivre! On m'en a empêché; on m'a enlevé d'auprès d'elle. Elle est morte, mes amis de coeur! elle est morte et je ne la reverrai jamais plus. Mon désespoir continuel est difficile à décrire. Femme innocente, admirable, héroïque, je ne la reverrai plus, plus jamais. Ah! je me meurs de douleur." Quoted in Boyer d'Agen 1909, 397–98.

34. "Puis voilà qu'après tant de bruit, un silence se fait autour de Fragonard; ils se regardaient, lui et Greuze et se demandaient où et comment tout cela s'en était allé! Car David et sa nouvelle école attiraient tous les yeux!" See Valogne 1955.

35. Marie-Madeleine Aubrun, "La vie intellectuelle et culturelle à Rome sous le directorat de Monsieur Ingres" (proceedings of the symposium *Ingres et Rome* held in Montauban in 1986), *Bulletin spécial des amis du Musée Ingres* (1986): 105; see also Hans Naef, "Ingres, Fanny Hensel et un dessin inédit," *Bulletin du Musée Ingres,* no. 36 (December 1974): 19–23.

On Ingres and music, see also *Papiers d'Ingres,* no. 10 (1993).

On the other hand, in Berlioz's memoirs, vol. 1 (Paris, 1969), 103, we learn that Ingres considered that composer an "abominable musician, a monster, an outlaw, an Antichrist" ("musicien abominable, un monstre, un brigand, un antéchrist"), but the musician readily forgave him in view of their shared passion for Gluck.

The violin of Ingres appears in a beautiful drawing of unknown authorship in the Musée Bonnat, Bayonne (fig. 70), which shows the artist painting his *Romulus Victorious over Acron.*

36. Watteau "avait de la délicatesse pour juger de la musique." Caylus 1748; see Rosenberg 1984, 68.

37. Later, we will touch on their aesthetic preferences; they are found in more or less reliable contemporary accounts or in their correspondence, especially that of Ingres.

38. See Bordes 1983, 60.

39. Jacques Thuillier, "Poussin et Dieu," in Paris 1994–95, 29–34; and Jacques Thuillier and Marc Fumaroli, "Poussin, païen ou chrétien?" interview in *Le Figaro,* 27 September 1994, 10–11.

40. "Il mourut avec tous les sentiments de religion qu'on pourrait désirer, et les derniers jours de sa vie il s'occupa à peindre un Christ en croix pour le curé de Nogent. Watteau avait le coeur droit et sa résignation a dû être sincère. D'ailleurs il n'était emporté par aucune passion; aucun vice ne dominait et il n'a jamais fait aucun ouvrage obscène. Il poussa même la délicatesse jusqu'à désirer, quelques jours avant sa mort, de ravoir quelques morceaux qu'il ne croyait pas assez éloignés de ce genre, pour avoir la satisfaction de les brûler: ce qu'il fit." Caylus 1748; see Rosenberg 1984, 85.

41. Mme Fragonard, like Marguerite Gérard and Mme David, joined the delegation of wives and daughters of artists who went to the Assemblée nationale on 7 September 1789 to "offer their jewels to the Country." Many newspapers and periodicals of the period announced the event: *Le Moniteur universel,* no. 54 (8 September 1789): 223; *Journal général de France,* 10 September 1789, 450; and *Mercure de France,* 1789, 202–3.

42. In fact, until 1797 he was one of six members of the Muséum central committee, established in 1792, which fixed the salaries of attendants, set the hours the museum was open to the public, decided the fate of confiscated works of art, arranged for their transport to different repositories, hung them, and also created the "musée spécial de l'école française" in Versailles, among other responsibilities.

43. "Le pauvre état auquel ont été et sont de présent les affaires de notre pauvre France. . . . J'eusse donné commencement à votre Vierge en grand si ce n'eut été les mauvaises nouvelles qui journellement nous arrivent de

Paris que ces mauvais Français mettaient déjà à sac par leurs discours enragés." Letter to Chantelou, 24 May 1649; Jouanny 1911, 398–99.

44. "Cependant c'est un grand plaisir de vivre en un siècle là où il se passe de si grande chose pourvu que l'on puisse se mettre à couvert en quelque petit coin pour pouvoir voir la Comédie à son aise." Letter to Chantelou, 17 January 1649; Jouanny 1911, 395.

45. "défaut de cet éclat de pensée," "d'esprit," "la gravité de son caractère." Delécluze 1855, 84.

46. "Le dessin est un acte de l'intelligence." Paul Valéry, "Art et esthétique," in *Cahiers II,* ed. Judith Robinson-Valéry (Paris, 1974), 950.

47. Thuillier 1994.

48. Camesasca and Rosenberg 1982.

49. Rosenberg 1989.

50. Ternois 1971.

51. "Alli 19 di Novembre pure del 1665 giusto al suono del mezzo giorno spiro' l'anima al suo Creatore. . . . Il giorno seguente fu portato il suo cadavere nella Chiesa di S. Lorenzo in Lucina come sua Parrocchia. . . . e fu sepolto con dolore, e lagrime dell'universale." Passeri 1934, 331.

52. "Je ne pense qu'à mourir, qui sera l'unique remède aux maux qui m'affligent." Letter of 26 July 1665 to the abbé Nicaise, unknown to Jouanny (see Jouanny 1911), but published in Blunt 1964, 166, and Blunt 1989, 177.

53. "Nous avons perdu le pauvre Watteau qui a fini le pinsseau [*sic*] à la main." Quoted in Washington, D.C.-Paris-Berlin 1984–85, 29.

54. "Il mourut à 5 heures du matin, chez Véri." Death certificate, 22 August 1806, preserved in the Archives Nationales, Paris (Minutier central, LXXVIII, 1080); see Paris-New York 1987–88, 594–95.

55. "à la suite d'une assez courte maladie." Obituary in *Journal de Paris,* no. 237 (22 August 1806): 1742; see Paris-New York 1987–88, 595.

56. "il a peint jusqu'au 15 de ce mois, mais il ne pouvait plus tenir le pinceau." Letter from Navez to Gros, 29 December 1825 (MS 318, no. 39, Bibliothèque de l'École Nationale Supérieure des Beaux-Arts, Paris) quoted in Paris-Versailles 1989–90, 633.

57. [sa] "rudesse de manières ne prévenaient pas en sa faveur: mais, dans l'intimité, il avait de la simplicité et de la bonhomie." Thibaudeau 1826, 39–40; about the identity of Thibaudeau as the author of *Vie de David,* see Paris-Versailles 1989–90, 19.

58. "rond, replet, fringant, toujours alerte, toujours gai." Delaroche-Vernet 1923 (see n. 16 above), 242; see Paris-New York 1987–88, 556.

59. "sur le tard de sa vie la tristesse, le découragement et l'effroi." Quoted in Paris-New York 1987–88, 16.

60. "il ne peign[a]it plus, et mourut malheureux." Alexandre Lenoir, "Fragonard," in *Biographie universelle Michaud,* vol. 15 (Paris, 1816), 421.

61. Watteau "avait le coeur droit," "doux et affable," "il n'était pas fort caressant," "Inquiet," "embarrassé, ce qui le rendait quelque fois incommode à ses amis," "timide," "toujours mécontent de lui-même." Caylus; La Roque; Jullienne; Gersaint; see Rosenberg 1984, 5, 16, 39, 85.

62. "Dans la nuit du 8 au 9 janvier 1867, Ingres avait quitté son lit pour aller, à demi nu, ouvrir une fenêtre et dissiper ainsi la fumée répandue dans sa chambre par un tison qui venait de rouler de l'âtre de la cheminée sur le parquet. Une fluxion de poitrine se déclara." Delaborde 1870, 66 n. 1.

63. "Sensitif, nerveux à l'excès et toujours irrité, heureux, malheureux." Letter from Ingres to Gilibert, 10 January 1839; Boyer d'Agen 1909, 281.

CHAPTER 2

1. The first volume is devoted to drawings with biblical subjects—"Biblical subjects (Old Testament, New Testament)"; the second to ancient history ("History, Romance, Allegories"); the third to mythology ("Mythological subjects"); the fourth combines landscape drawings (treated by John Shearman and Rudolf Wittkower), drawings made for illustrations, and studies for the Grande Galerie of the Louvre ("Studies for the long Gallery. The Decorative drawings. The illustrations to Leonardo's treatise. The landscape drawings"); and the fifth, in addition to copies from the antique, carries additions and corrections to the preceding volumes ("Drawings after the antique. Miscellaneous drawings. Addenda").

2. Rosenberg and Prat 1994.

3. We have been severely criticized for daring to reject one of Poussin's most famous drawings, his so-called *Self-Portrait* in the British Museum (Rosenberg and Prat 1994, vol. 2, R 489, ill.; see also Nicholas Turner, "L'*Auto-portrait* dessiné de Poussin au British Museum," in *Nicolas*

214 *Notes to Chapter 2*

Poussin 1996, 1:79–97). According to the long, hand-written note in Italian that can be read on the mount, the sheet was given by Poussin to Cardinal Massimi, the last of the artist's major patrons. Poussin supposedly drew himself "nello specchio" about 1630, "nella convalescenza della sua grave malattia." The inscription draws its inspiration from Bellori's biography of Poussin, which appeared in 1672 (Bellori 1672). It was very likely written by Francesco Maria Nicolò Gaburri (1676–1742), art historian, collector, and friend of Mariette, who had acquired the drawing between 1722 and 1724. But how could it have left the Massimi collection, which, it seems, remained intact until 1735? On the death of Gaburri, the sheet went to England before being bought by the British Museum in 1901; see Nicholas Turner, "The Gabburri/Rogers Series of Drawn Self-Portraits and Portraits of Artists," *Journal of the History of Collections* 5, no. 2 (1993): 179–216, esp. 203–4, fig. 20.

Very few authors have contested this icon of orthodox Poussinism. Before us, only Bernard Dorival, "Les Autoportraits de Poussin," *Bulletin de la Société Poussin* 1 (June 1947): 39, frontispiece (ill.), then Wild in 1980, 95, ill., 191—cautiously—questioned its authenticity.

In fact, it is in no way certain that the drawing represents Poussin. A morphological comparison between the two famous self-portraits (figs. 6 and 223) is inconclusive. Most important, what is known about the painter is hardly congruent with the self-deprecating manner in which he is represented here. The date has been questioned, as early as 1962 by Mahon, "Poussiniana," *Gazette des beaux-arts* 104 (August 1962): 133–34 n. 399, who sees not a man of about thirty-six years, as the inscription specifies, but rather one closer to forty-five. More recently Thuillier (1994, 42) placed the date at c. 1624–25, which is when he thinks Poussin suffered his "grave malattia."

The sheet's style has nothing in common with any other drawing attributed to Poussin, which Blunt previously noted; Anthony Blunt, "Poussin Studies I: Self-Portraits," *Burlington Magazine* 89 (August 1947): 219–20, pl. Ib. It recalls the realistic approach of the Carracci and their followers and, in certain aspects, the art of the French artists around Jean de Saint-Igny, to whom are now attributed the portraits in red chalk previously grouped under the name of Jacques Bellange. Ann Sutherland Harris (written communication, 2 April 1991) thinks the sheet is close to Carlo Maratta. To us, it seems to

belong to a graphic tradition radically different from Poussin's. As noted, its first definitive owner, Gaburri, bought it between 1722 and 1724, a time when Poussin's renown might have enticed a collector—especially one whose passion for drawing was apparently much greater than his discernment; Mariette (1853–54, 2:275) found his "collection . . . more extensive than beautiful" ("collection . . . plus nombreuse que belle")—to let himself be carried away by his imagination.

4. For major reviews of the work see Hugh Brigstocke, *Apollo,* no. 405 (November 1995): 60–63; Martin Clayton, *Burlington Magazine* 138, no. 1120 (July 1996): 467–69; Henry Keazor, *Zeitschrift für Kunstgeschichte* 58 (1995): 425–37; idem, *Kunstchronik,* August 1995, 337–59; idem, *Konsthistorisk Tidskrift* 66 (1997): 155–65; Michael Kitson, *Burlington Magazine* 137, no. 1102 (January 1995): 28–34; Alain Mérot, *Revue de l'art,* no. 112 (1996): 70–72; Ann Sutherland Harris, *Master Drawings* 34, no. 4 (1996): 421–28.

5. Inv. P.M. 1865 (ascribed to Jacques Prou); it went up for sale at Christie's, London, 2 July 1985, no. 46 (ascribed to Passeri).

6. Karl Parker, *The Drawings of Antoine Watteau* (London, 1931).

7. The first volume places together "Dessins de jeunesse, compositions de jeunesse, figures de modes et figures françaises et comiques, arabesques et ornements, figures pour les tableaux militaires, copies d'après les maîtres, paysages d'après et dans le genre des maîtres, paysages d'après nature et compositions originales, figures populaires, nus"; the second consists of "femmes, hommes, enfants, têtes, persans, musiciens et études de mains, compositions de maturité, animaux, portraits," as well as addenda to the first volume.

8. Rosenberg and Prat 1996 (the catalogue of autograph drawings contains 669 numbers, plus two *bis*). Our no. 562, illustrated here as figure 26, recently entered the Département des Arts Graphiques of the Musée du Louvre, given by the Société des Amis du Louvre.

To date, few reviews of our work have appeared; see Marianne Roland Michel, *Burlington Magazine* 140, no. 1148 (November 1998): 749–54; Colin Bailey, *On Paper,* no. 5 (May 1997): 45–48; Humphrey Wine, "Watteau's Drawings," *Apollo,* no. 429 (November 1997): 59–60; Martin Eidelberg and Seth A. Gopin, "Watteau's Chinoiseries at La Muette," *Gazette des beaux-arts* 130 (August 1997): 19–46; and Martin Eidelberg, "An Album

of Drawings from Rubens' Studio," *Master Drawings* 35, no. 3 (1997): 234–66.

9. "Scènes familiales, scènes de genre, sujets légers, têtes et portraits, la femme, l'homme, divertissements et scènes rustiques, animaux, bergers et lavandières, parcs et paysages, scènes mythologiques, allégories, histoire ancienne, dessins d'après les maîtres, dessins d'illustrations."

10. Notably, Eunice Williams, *Drawings by Fragonard in North American Collections,* exh. cat. (Washington, D.C.: National Gallery of Art; Cambridge, Mass.: Fogg Art Museum, Harvard University, 1978).

11. Sérullaz 1991. Sérullaz also wrote the entries for the drawings exhibited at the David retrospective in 1989–90; see Paris-Versailles 1989–90.

12. Naef 1977–80; Ternois 1959; Vigne 1995.

13. For the history of catalogues raisonnés, see Antoine Schnapper, "Raphaël, Vasari, Pierre Daret: A l'aube des catalogues," in *"Il se rendit en Italie": Etudes offertes à André Chastel* (Rome and Paris, 1987), 235–41.

14. "un libro di disegni fatti da monsieur Poussin dal antico," "libro di designi della sua inventione," "di paesi," "di animali," "alcune teste." *Mémoire des pièces qui se sont trouvées à Rome dans le cabinet de monsieur Nicolas Poussin, et qui sont présentement à vendre entre les mains du sieur Joanni* [Jean Dughet], *son cousin et son héritier, en 1678,* published in Anatole de Montaiglon, "Dessins, estampes et statues de la succession de Nicolas Poussin (1678)," *Archives de l'art français* 6 (1858–60): 241–54.

15. "Je lui ei trouué [*sic*] la pensée. Je veus dire la conception de l'idée et l'ouvrage de l'esprit est conclu." Letter to Chantelou, 22 December 1647; see Jouanny 1911, 376 (for another example, see below, p. 204, and chap. 6, n. 28).

16. His estate inventory of 20–22 December 1660 was published by Jacques Thuillier and Claude Mignot, "Collectionneur et peintre au XVIIe siècle: Pointel et Poussin," *Revue de l'art,* no. 39 (1978): 39–58; see also Rosenberg and Prat 1994, vol. 2, M 9 (these eighty drawings are not further identified).

17. "Nous avions discouru de ces dessins, et je lui avais dit que c'étaient choses estimables, mais que moi qui aimais le dessin je n'avais point voulu m'embarquer dans cette curiosité, à cause de la facilité qu'il y a d'être trompé. Il m'a répondu que l'on l'était aussi en peinture. J'en suis demeuré d'accord, mais j'ai dit que l'on l'était moins." Paul Fréart de Chantelou, *Journal de voyage du Cavalier Bernin en France* (Paris, 1885; reprint, edited by J. P. Guib-

bert, Paris, 1981), 72; among the drawings by Poussin thus far known to have belonged to Chantelou, only one is rejected (Rosenberg and Prat 1994, vol. 2, R 43).

18. Poussin's drawings in Windsor were exhibited in 1995 at the Dulwich Picture Gallery, London, *Poussin, Works on Paper: Drawings from the Collection of Her Majesty Queen Elizabeth II* (catalogue by Martin Clayton), then in the United States (in Houston, Cleveland, and New York).

19. See chap. 4, pp. 101–6.

20. Thirty-four were in private hands in 1994. Since then, one that had belonged in a Swiss private collection (Rosenberg and Prat 1994, vol. 1, no. 115, ill.) entered the J. Paul Getty Museum in 1996 (inv. 96 GA 24; reproduced here as fig. 122).

21. "Au surplus on ne pourrait me reprocher que d'en avoir fait un grand dessinateur, puisque je donne une grande préférence à ses dessins sur ses tableaux. Watteau pensait de même à son égard. Il était plus content de ses dessins que de ses tableaux, et je puis assurer, que de ce côté-là, l'amour propre ne lui cachait rien de ses défauts. Il trouvait plus d'agrément à dessiner qu'à peindre. Je l'ai vu souvent se dépiter contre lui-même, de ce qu'il ne pouvait point rendre, en peinture, l'esprit et la vérité qu'il savait donner à son crayon." Note that Gersaint's text on Watteau dates from 1744; the passage quoted here is drawn from the catalogue of the Fonspertuis sale of 1747–48 and constitutes a response to an unsigned entry on Watteau in the *Dictionnaire abrégé de peinture et d'architecture,* published in 1746; see Rosenberg 1984, 44.

22. "Ce peintre dessinait continuellement." Dezallier d'Argenville 1745; see Rosenberg 1984, 49.

23. Caylus 1748; see Rosenberg 1984, 85.

24. [Watteau] "voulut que ses dessins dont il me fit le dépositaire, fussent partagés également entre nous quatre; ce qui fut exécuté suivant ses intentions." Gersaint 1744; see Rosenberg 1984, 39.

25. Jeannine Baticle, "Le Chanoine Haranger ami de Watteau," *Revue de l'art,* no. 69 (1985): 55–68.

26. "Il a laissé ses Dessins . . . à M. l'Abbé Harancher [*sic*] son ami." See Rosenberg 1984, 5.

27. On this point, see Rosenberg 1995, 540–41; and introduction to Rosenberg and Prat 1996, 1:xii–xvi.

28. Simon Jervis, "Mariette's Annotated Copies of the Tallard and Jullienne Sale Catalogues," *Burlington Magazine* 131, no. 1037 (August 1989): 561. See also Rosenberg 1991 (Italian edition of Rosenberg 1984), 129.

29. "Tous ces desseins de Wateau sont à peu près tout ce que le Peintre a fait pour lui servir d'études. Il les partagea à sa mort et les légua un quart à l'abbé Haranger, un autre quart à Gersaint, un 3e à M. Hénin mort Controllr. des batiments du Roi, et le 4e à M. de Julliene [*sic*] tous ses amis," "Ce dernier les réunit presque tous dans la suite car, à l'exception de la part de l'abbé Haranger qui fut vendu [*sic*] à sa mort, toutes les autres furent achetées par lui. Voilà pourquoi on en trouve ici un si grand nombre." This annotation is found in Mariette's copy of the Jullienne sale catalogue (Paris, 30 March–22 May 1767), preserved in the Victoria and Albert Museum, London, in the margin next to lot 769.

30. Only 422 drawings by Watteau appear in the catalogue of the connoisseur Jullienne, which proves that he was selling them (see Rosenberg and Prat 1996, 3:1427, which reproduces the text of the sale catalogue).

31. "Ce sont les Desseins que ce Peintre légua en mourant à M. Crozat, en reconnoissance de tous les bons offices qu'il en avoit reçûs." Catalogue of the Crozat sale, 10 April–13 May 1741, no. 1063 (see Rosenberg and Prat 1996, 3:1426).

32. The sale of the collection of his daughter Miss Sarah Ann James on 22–23 June 1891 at Christie's, London, made a sensation. Aside from the fact that he owned an important collection of drawings by Rembrandt, among others, little else is known about Andrew James. He was a grain merchant, and he asssembled, for the most part, the admirable collection owned by his daughter; see Gustav Friedrich Waagen, *Galleries and Cabinets of Art in Great Britain: Supplement* (London, 1857), 213–17.

33. On Camille Groult, see the catalogue of the recent exhibition *Degas, Boldini, Toulouse-Lautrec: Portraits inédits par Michel Manzi* (Bordeaux: Musée Goupil; Albi: Musée Toulouse-Lautrec, 1997), 123–26.

34. A portion of these catalogues was published by Emile Dacier, *Catalogues de ventes et livrets de Salons illustrés par Gabriel de Saint-Aubin*, 6 vols. (Paris, 1909–21). Additional illustrated sales catalogues, unpublished to date, have appeared since then, including examples at the Museum of Fine Arts, Boston; Bibliothèque Nationale de France, Paris; and the Philadelphia Museum of Art.

35. Fragonard's grandson Théophile recounted the incident (Valogne 1955): "On this journey our artist gathered a quantity of material, but the slightest sketches were themselves small masterpieces—at least, that's what our

financier thought, for, on their return to Paris, he decided if he were able to appropriate them, he would make a nice profit, in place of an agreeable, but very expensive, journey. . . . My grandfather requested his belongings on his return but received only his clothes. He had to go to court, and the arbitrators directed the *Fermier-général* to pay for the drawings or give them back." ("Dans ce voyage notre artiste réunit une quantité de matériaux, mais ses moindres croquis étaient eux-mêmes des petits chefs-d'oeuvre, c'est du moins ce qu'en pensait notre financier car, de retour à Paris, il pensa que s'il pouvait se les attribuer, il ferait une bonne affaire, au lieu d'un voyage agréable, mais fort coûteux . . . Mon grand-père réclama ses effets à son retour, on ne lui rendit que ses habits, il fallut plaider et des arbitres condamnèrent le fermier général à payer les dessins, ou à les rendre.")

36. Rosenberg and Brejon de Lavergnée 1986.

37. See n. 35 above.

38. Twelve paintings by Fragonard appeared in Hippolyte Walferdin's sale on 3 April 1880, ninety-four on the sale of 12–16 April 1880, plus nine "small paintings and miniatures," as well as many drawings (nos. 169–275 in the catalogue).

39. Sérullaz, in Paris-Versailles 1989–90, 65.

40. "cahiers," "albums romains." It seems, in fact, that David had assembled his Roman drawings into two albums as soon as he returned from Italy (probably nos. 19 and 20 in the estate inventory; see Wildenstein and Wildenstein 1973, 237), carefully numbering each page. These two volumes were transformed into twelve albums by his heirs in preparation for the sale of 1826 (on this point, see Sérullaz 1991, 9–42, esp. 19). Two of the twelve albums belong to the Louvre (Sérullaz 1991). The album and two sketchbooks in the Fogg Art Museum were published by Agnes Mongan, *David to Corot: French Drawings in the Fogg Art Museum* (Cambridge, Mass., 1996); the album in Stockholm was published by Per Bjurström in *French Drawings: Nineteenth Century*, vol. 5 of *Drawings in Swedish Public Collections* (Stockholm, 1986). The other albums and sketchbooks remain partially or entirely unpublished. Although twelve albums are said to exist, we have seen only nine; in addition to those mentioned in the Louvre, in Cambridge, and in Stockholm, one was acquired in 1994 by the Getty Research Institute, one in 1998 by the Pierpont Morgan Library, New York, with support from S. Parker Gilbert, of the International Music and Art Foundation, and from

Eugene V. Thaw, inv. 1998.1, and another one was even more recently purchased by the National Gallery, Washington. Two others have been dismembered. See also n. 50 below.

41. Philippe Bordes (1983) has studied the sketchbook at Versailles. The eight in the Louvre and the one in the Fogg were published respectively by Sérullaz and Mongan; see n. 40 above.

42. Vigne 1995.

43. See Marjorie B. Cohn and Susan L. Siegfried, *Works by J. A. D. Ingres in the Collection of the Fogg Art Museum,* exh. cat. (Cambridge, Mass.: Fogg Art Museum, Harvard University, 1980). See also Mongan (n. 40 above), 197–244.

44. "Je fus obligé d'adopter un genre de dessin (portraits au crayon), métier que j'ai fait à Rome près de deux ans." Letter to Gilibert, 7 July 1818; see Boyer d'Agen 1909, 36.

45. "Plusieurs Anglais ont engagé Ingres à venir à Londres, en l'assurant qu'en moins de cinq années il pourrait faire sa fortune seulement avec ses petits portraits dessinés," "Il a la bêtise de ne pas vouloir suivre ce conseil." *Lettres de P. J. David d'Angers à son ami le peintre Louis Dupré* (Paris, 1891), 45; quoted by Hans Naef in Paris 1967–68, xx.

46. See Vigne 1995, 88.

47. "notre plus grande détresse," "Croiriez-vous qu'à Florence, nous n'avions souvent pas de pain à la maison, et plus de crédit chez le boulanger?" Quoted in Amaury-Duval 1924, 36.

48. For the history of the Ingres bequest and the different inventories established by successive curators, see, most recently, Vigne 1995, 812–15. The *Papiers d'Ingres,* published regularly on the occasion of temporary exhibitions (by May 1999, twenty issues had come out), also has helped to familiarize the public with the Ingres bequest in Montauban.

49. Rosenberg and Prat 1994, vol. 1, no. 64, color ill.

50. In our catalogue raisonné of David's drawings (forthcoming), we intend to reconstruct these albums by following David's original numbering, a difficult task in many cases; the Seligman and Prouté–de Bayser albums have been taken apart sheet by sheet, and the album in the Fogg Art Museum has been handled many times, including recently.

51. "ravivés . . . par leurs possesseurs." Goncourt 1875, 341–42. For an example of a drawing by Watteau

that was reportedly "embellished" by Camille Groult (see n. 33 above), another collector who was known to meddle with the works that belonged to him, see Rosenberg and Prat 1996, vol. 2, no. 456, color ill.

52. Published in 1726 and 1728, the two volumes present a unique source of information for the drawings of Watteau. The prints are all reproduced in our catalogue raisonné of Watteau's drawings, either in the entries on the known drawings or in the section on lost drawings known by a print (a concordance between our catalogue raisonné and the prints is given in Rosenberg and Prat 1996, 1516. On the copy of *Figures de différents caractères* in the Bibliothèque de l'Arsenal, Paris, see Marianne Roland Michel, "Watteau et les figures de différents caractères," in *Watteau (1684–1721), le peintre, son temps et sa légende* (proceedings of a symposium, 1984) (Paris and Geneva, 1987), 117–27; and on the prints in the museum in Valenciennes, see Pierre Rosenberg, "Watteau: Le Recueil de Valenciennes," *Revue du Louvre,* nos. 4–5 (1986): 286–89.

53. See n. 40 above.

54. On Ingres's technique, see Marjorie B. Cohn, "Technical Appendix," in *Ingres: Centennial Exhibition 1867–1967,* exh. cat. (Cambridge, Mass.: Fogg Art Museum, Harvard University, 1967), 241–49; and Avigdor Arikha, introduction to *Ingres 53 dessins sur le vif du Musée Ingres et du Musée du Louvre,* exh. cat. (Jerusalem: Israel Museum; Dijon: Musée des Beaux-Arts, 1981), and 1986 in Houston, Museum of Fine Arts, and New York, Frick Collection.

55. On these prepared tablets, see Cohn, "Technical Appendix" (n. 54 above).

56. See Martin Clayton, "A Nivelle Watermark on Poussin's Marino Drawings," *Burlington Magazine* 133, no. 1057 (April 1991): 245, who demonstrates that the group of drawings called "Marino" (Rosenberg and Prat 1994, vol. 1, nos. 2–17) were realized on French paper and, thus, probably in France.

57. See Rosenberg and Prat 1994, vol. 1, no. 250; Rosenberg and Prat 1996, vol. 2, no. 630. See also Cordelia Hattori, "Dessins de Poussin (1594–1665) nouvellement révélés: Études pour la *Confirmation* de 1645 et une première pensée pour le décor de la Grande Galerie du Louvre," *Revue du Louvre,* no. 2 (April 1994): 41–44.

58. "Bons crayons fermes anglais 3H." Boyer d'Agen 1909, 491.

59. For a while it was believed that the drawings signed "Ango" were in fact by "Frago," who had disguised himself behind the former name. But Ango actually existed (see also below, chap. 4, n. 71).

60. On this point, see Vigne 1995, 103; and Paris 1967–68, nos. 55, 245.

61. The English publisher Harvey Miller intends to publish the entire *Museo cartaceo* under the title of *The Paper Museum of Cassiano dal Pozzo.* Four volumes have already appeared: Series A, *Antiquities and Architecture:* Part I, *Ancient Roman Mosaics and Wallpainting,* by Elen Whitehouse; Part II, *Early Christian and Medieval Antiquities,* Vol. 1, *Mosaics and Wallpaintings in Roman Churches,* by John Osborne and Amanda Claridge, and Vol. 2, *Other Mosaics, Paintings, Sarcophagi and Small Objects,* by John Osborne, Amanda Claridge, and Cecilia Bartoli; Series B, *Natural History:* Part I, *Citrus Fruit,* by David Freedberg and Enrico Baldini.

See also *The Paper Museum of Cassiano dal Pozzo,* exh. cat. (London: British Museum, 1993), introduction by F. Haskell.

62. See Rosenberg and Prat 1994, vol. 1, nos. 159–60, 166, 169–71, 176, 189, 192–93, 202, 207, 210–11, 230, 237, 239–40.

F. Solinas suggests that Poussin did not limit himself to copying the prints in this collection and that he executed, for the *Museo cartaceo* of Cassiano dal Pozzo, some drawings from the antique; see esp. "'Giovani ben intendenti del disegno': Poussin e il Museo Cartaceo," in *Poussin et Rome* 1996, 215–40; see also "Poussin et Cassiano dal Pozzo: Notes et documents sur une collaboration amicale," in *Nicolas Poussin* 1996, 1:287–336. He is not entirely convincing.

63. "Parmi tous les croquis de cette époque, il en est un donné par David à Étienne et qu'Étienne conserve d'autant plus soigneusement que son maître, en le lui remettant, y ajouta un commentaire verbal assez curieux. C'est le dessin de deux têtes. L'une est celle d'un jeune sacrificateur couronné de lauriers. Celle-ci, copiée fidèlement d'après l'antique, porte ce caractère de calme que les anciens imprimaient sur la figure des personnages dont ils voulaient relever la dignité morale. 'Voyez-vous, mon ami,' disait David à Étienne, 'voilà ce que j'appelais alors *l'antique tout cru.* Quand j'avais copié ainsi cette tête avec grand soin et à grand' peine, rentré chez moi, je faisais celle que vous voyez dessiné auprès. *Je l'assaisonnais à la sauce moderne,* comme je disais dans ce temps-là. Je

français tant soit peu le sourcil, je relevais les pommettes, j'ouvrais légèrement la bouche, enfin je lui donnais ce que les modernes appellent de *l'expression,* et ce qu'aujourd'hui (c'était en 1807) j'appelle de la *grimace.*" Quoted in Delécluze 1855, 112.

64. Ingres said so himself. He noted in 1859, "I am chided for being exclusive, I am accused of being unfair to everything that is not ancient or by Raphael" ("On me reproche d'être exclusif, on m'accuse d'injustice pour tout ce qui n'est pas l'antique ou Raphaël"); Delaborde 1870, 109. For the copies Ingres made, see Vigne 1995, chap. 12, 638ff.

65. On the *Recueil Jullienne,* see Dacier and Vuaflart 1921–29.

66. "Watteau est un très grand peintre! Connaissez-vous son oeuvre? C'est immense . . . J'ai tout Watteau chez moi, Monsieur, et je le consulte." Quoted in Amaury-Duval 1924, 121.

67. "le vrai restaurateur de l'art français et un très grand maître." Thomas Silvestre, *Histoire des artistes vivants—Etudes d'après nature—Ingres* (Paris, 1855), 14; quoted in Vigne 1995, 34. For the copies Ingres made after David, see Vigne 1995, nos. 4012, 4018–23.

68. According to G. Le Gentil, *Notice sur les tableaux des églises d'Arras* (Aras, 1871); cited in Washington, D.C.-Paris-Berlin 1984–85, 434.

69. "Il consacrera ses vieux ans à la garde des chefs-d'oeuvre dont il a concouru dans sa jeunesse à augmenter le nombre." David, *Rapport sur la suppression de la commission du Museum,* 18 December 1793, 4; quoted in Paris-New York 1987–88, 581; and Paris-Versailles 1989–90, 216.

70. See L. A. Prat, "Poussin, David et le Madianite," *Revue de l'art,* no. 124 (1999): 81–83.

71. Quoted in Delécluze 1855, 158; see also Wildenstein and Wildenstein 1973, 246, for the works after Poussin that appeared in his estate sale of 17 April 1826.

72. See Rosenberg and Brejon de Lavergnée 1986, nos. 29–32, 79, 93–95, 99, 104, 108, 306 (some of the works copied by Fragonard are no longer attributed to Poussin).

CHAPTER 3

1. For the work and its different editions, see Jacqueline Labbé and Lise Bicart-Sée, *La Collection de dessins*

d'Antoine-Joseph Dezallier d'Argenville . . . (Paris, 1996), 26–31. The frontispiece, drawn by Boucher, was engraved by Jean-Jacques Flipart (1719–1782); see Edmond Pognon and Yves Bruand, *Bibliothèque Nationale, Département des Estampes: Inventaire du fonds français; Graveurs du XVIIIe siècle*, vol. 9 (Paris, 1962), 229, no. 123.

2. A simple list accompanied the exhibition *La Politesse du goût: Dessins de la collection Dezallier d'Argenville* (Paris: Musée du Louvre, 1997).

3. "Elle est rangée chronologiquement par écoles, & composée d'environ neuf mille desseins originaux." Dezallier d'Argenville 1745, 1:xix.

4. Dezallier d'Argenville 1762, 1:xxxviii. Drawings that belonged to Dezallier can be recognized by means of a numeral followed by paraphs in the lower right or left (Lugt 2951, these paraphs were earlier said to be those of Crozat). This numeral refers to a classification that provides the attribution assigned by the collector (see n. 1 above).

5. "Les desseins infiniment superieurs aux estampes, tiennent un juste milieu entr'elles et les tableaux; ce sont les premières idées d'un peintre, le premier feu de son imagination, son style, son esprit, sa manière de penser. . . . Les desseins prouvent encore la fécondité, la vivacité du génie de l'artiste, la noblesse, l'élévation de ses sentimens, et la facilité avec laquelle il les a exprimés." Ibid., 1:xxxii.

6. "l'art de deviner l'auteur." Ibid., 1:xxxiv, xxxviii.

7. "Le goût du pays dans lequel a été fait le dessein, en constate l'école." Ibid., 1:l.

8. Ibid., 1:lx.

9. "Il y a donc deux sortes de style dans un peintre, son propre style, et celui de sa main. Son propre style est sa manière de penser, et de composer un sujet; le style de sa main est la pratique qu'il s'est fait de dessiner d'une manière ou d'une autre." Ibid., 1:lvi.

10. "[Les dessins] sont la meilleure instruction pour un amateur. C'est une source féconde, où il peut puiser toutes les lumières qui lui sont nécessaires; il conversera, pour ainsi dire, il s'instruira avec ces hommes célèbres: en examinant un recueil de leurs desseins, il se familiarisera avec eux; leurs différentes manières se dévoileront à ses regards." Ibid., 1:xxxviii.

11. "Le goût . . . de Watteau est extrêmement aisé à découvrir." Ibid., 1:liv.

12. Ibid., 1:xxxv.

13. "Les pensées sont les premières idées que le peintre jette sur le papier, pour l'exécution de l'ouvrage qu'il se propose; on les nomme aussi *Esquisses,* ou *Croquis,* parce que la main n'a fait que mettre en masse, et pour ainsi dire, que *croquer* les figures, les grouppes [*sic*], les ordonnances et les autres parties qui les composent. Ces desseins heurtés et faits avec beaucoup de vitesse, ne sont souvent pas extrêmement corrects, et peuvent manquer pour la perspective et les autres parties de l'art; mais ce ne sont point des défauts dans une esquisse, dont tout le but est de représenter une pensée exécutée avec beaucoup d'esprit, ou bien des figures détachées et imparfaites, qui doivent entrer dans quelque composition dont elles font partie." Ibid., 1:xxxv–xxxvi.

14. "touché de coups hardis et peu prononcés." Ibid., 1:xxxvi.

15. "il disegni che faceva di queste sue invenzioni non erano esattamente ricercati con li dintorni, ma formati più tosto con semplici linee e semplice chiaroscuro d'acquerella, che pero avevano tutta l'efficacia de'moti e dell'espressione." Bellori 1976, 453.

16. Joachim von Sandrart, *L'Academia todesca della architettura, scultura et pittura, oder Teutsche Academie der edlen Bau-, Bild-, und Mahlerey-Künste* (Nuremberg, 1675; reprint, Munich, 1925). For Sandrart's visit to Rome, see Christian Klemm, *Joachim von Sandrart: Kunstwerke und Lebenslauf* (Berlin, 1986), 338.

17. "il lui était impossible de faire la moindre indication, le plus simple croquis d'une figure, sans modèle. Constamment, il en faisait l'aveu à ses élèves, en leur recommandant de ne pas tomber dans la même faute que lui. Aussi les forçait-il en quelque sorte d'apprendre la perspective." Delécluze 1855, 222–23. Dezallier, of course, had already employed the word *perspective*.

18. "Les dessins finis sont les mêmes pensées plus digérées & plus arrêtées, que l'on appelle par excellence des desseins rendus, finis, *capitaux*: ils donnent une juste idée de l'ouvrage; et c'est ordinairement suivant ces morceaux, qui sont les derniers faits, qu'on en détermine l'exécution." "Défiez vous des desseins trop finis; rarement sont-ils originaux; ils sont même plus aisés à contrefaire que les autres." Dezallier d'Argenville 1745, 1:xvii–xviii, xxxii.

19. "Nous n'avons presque point de desseins arrêtés de sa main." Ibid., 2:253.

20. "Jamais il n'a fait ni esquisse ni pensée pour aucun de ses tableaux, quelque légères et quelque peu

arrêtées que ç'a pu être." Caylus 1748; see Rosenberg 1984, 78.

21. Rosenberg and Prat 1996, vol. 1, no. 21, ill., and vol. 3, R 60, ill.

22. Williams 1978 (see chap. 2, no. 10), 21, 150–51.

23. "Non, je n'aurais pas besoin d'invoquer les dieux de la fable pour échauffer mon génie." Letter from David to the president of the Assemblée nationale, 5 February 1792; quoted by Bordes 1983, 164–65, and Sérullaz, in Paris-Versailles 1989–90, 255.

24. See Georges Vigne, *Un Bal au château de Dampierre*, exh. cat. (Montauban: Musée Ingres, 1997–98); this was also published as *Papiers d'Ingres*, no. 18 (1997).

25. "Les *Etudes* sont des parties de figures dessinées d'après nature telles que des têtes, des mains, des pieds, des bras, quelquefois même des figures entières, lesquelles entrent dans la composition totale d'un tableau; les draperies, les animaux, les arbres, les plantes, les fleurs, les fruits et les paysages sont aussi des études qui y servent infiniment." Dezallier d'Argenville 1762, 1:xxxvi–xxxxvii.

26. Antoine Schnapper, in Paris-Versailles 1989–90, 497.

27. This is not to say, of course, that Ingres did not know how to capture a resemblance—quite the contrary. However, in his "official" portraits the use of a professional model is evident.

28. Ann Sutherland Harris, "Poussin dessinateur," in Paris 1994–95, 37.

29. "Sa coutume était de dessiner ses études dans un livre relié, de façon qu'il en avait toujours un grand nombre sous sa main. Il avait des habits galants, quelques-uns de comiques, dont il revêtit les personnes de l'un et de l'autre sexe, selon qu'il en trouvait qui voulait bien se tenir, et qu'il prenait dans les attitudes que la nature lui présentait, en préférant volontiers les plus simples aux autres. Quand il lui prenait en gré de faire un tableau il avait recours à son recueil. Il y choisissait les figures qui lui convenaient le mieux pour le moment. Il en formait ses groupes, le plus souvent en conséquence d'un fonds de paysage qu'il avait conçu ou préparé. Il était rare même qu'il en usât autrement." Caylus 1748; see Rosenberg 1984, 78–79.

30. "On donne le nom d'académies à des figures faites d'après nature, dans les attitudes convenables à la composition d'un tableau, pour en avoir exactement le nû, les contours, les lumières et les ombres; on drappe [*sic*]

ensuite ces figures d'après le manequin, de manière à *caresser* toujours ce nû, et à le faire deviner. Rien ne fait mieux connoître la correction d'un maître, que ces sortes de desseins; ils prouvent en même tems sa capacité dans l'anatomie." Dezallier 1762, 1:xxxvii.

31. "Il n'y a point d'Académies du Poussin." Ibid., 4:37.

32. "Si esercitava Nicolò anche nello studio delle Accademie che si costumano l'inverno in diverse case, e perche cessò quella del Domenichino per la sua partenza da Roma per Napoli alla quale andava volontieri per la stima che faceva di quel grande huomo, ando a quella di Andrea Sacchi nella quale si spogliava il Caporal Leone il qual fu uno de modelli migliori per lo spirito che dava all'attitudini nelle quali veniva posto." Passeri 1934, 326.

33. "Circa il naturale frequentava l'Accademia del Domenichino, che era dottissima." Bellori 1976, 427.

34. Sutherland Harris, "Poussin dessinateur" (see n. 28 above), 37–38.

35. "Là où il se fixait le plus, ce fut en quelques chambres que j'eus en différents quartiers de Paris, qui ne nous servaient qu'à poser le modèle, à peindre et à dessiner . . . N'ayant aucune connaissance de l'anatomie, et n'ayant presque jamais dessinné le nu, il ne savait ni le lire, ni l'exprimer; au point même que l'ensemble d'une académie lui coûtait et lui déplaisait par conséquent. Les corps des femmes exigeant moins d'articulation lui étaient un peu plus faciles. Cela revient à ce que j'ai déjà observé ci-dessus que les dégoûts qu'il prenait si souvent pour ses propres ouvrages partaient de la situation d'un homme qui pense mieux qu'il ne peut exécuter. En particulier cette insuffisance dans la pratique du dessin le mettait hors de portée de peindre ni de composer rien d'héroïque ni d'allégorique, encore moins de rendre les figures d'une certaine grandeur." Caylus 1748; see Rosenberg 1984, 71–73.

36. See n. 35.

37. "J'ay fait revivre un usage d'études qui se fesoit de mon tems à l'Académie, dans le tems de vaquances [*sic*], où nous dessinions d'après le modèle, des figures toutes drapées, variées dans toutes sortes de genres et de différent habits, surtout des habit [*sic*] d'église qui occasionnent de fort beau plis." Letter from Natoire to Marigny, 18 October 1758, in *Correspondance des directeurs* 1901, 239.

38. Inv. 466 and 467. For Bra, see the recent exhibition catalogue *The Drawing Speaks: Théophile Bra: Works*

1826–1855/Le Dessin parle: Théophile Bra: Oeuvres 1826–1855 (Houston: The Menil Collection; Iowa City: University of Iowa Museum of Art; Douai: Musée de la Chartreuse, 1998–99).

39. "Dans celle [école] de David, on posait *le modèle* deux fois par semaine, ou plutôt par *décade,* à cette époque. Pendant les six premiers jours on *posait* un modèle nu; les trois derniers, un modèle pour la tête seulement, et l'atelier était fermé le décadi." Delécluze 1855, 18 n. 1; see also below, chap. 5, n. 73.

40. [Plus pour] "l'élégance de leur stature et l'agilité de leurs mouvements que par les traits de leur visage," "L'exercice de la natation était fort à la mode alors à Paris," "les exercices gymnastiques et athlétiques," "Parmi les élèves de David, il y en avait plusieurs qui s'y distinguaient." Delécluze 1855, 228.

41. "David profita tout à la fois de cet avantage et de leur complaisance pour tracer, d'après une douzaine d'entre eux, le groupe du tableau des *Thermopyles,* qui se compose des divers personnages peignant leurs cheveux, agrafant leur chaussure, ou présentant des couronnes de fleurs près de celui qui écrit sur le rocher. Ce croquis remarquable, tracé à l'atelier même des élèves, devint le point de départ de l'ensemble de la composition." Ibid., 229.

42. "On prétendait dans le temps, mais je ne donne la chose que comme un bruit d'atelier de peintres, que cette même personne avait poussé l'amour de l'art jusqu'à poser la jambe et une portion de la cuisse pour le personnage du même tableau." Etienne-Jean Delécluze, *Journal de Delécluze 1824–1828,* ed. R. Baschet (Paris, 1948), 338.

43. For the academies of the eighteenth century, see James Henry Rubin, *Eighteenth-Century French Life-Drawing,* exh. cat. (Princeton: Art Museum, Princeton University, 1977), 16–42, esp. 40 n. 31.

44. "dessiner d'abord le nu que doit envelopper la draperie et ensuite la draperie qui enveloppera le nu." Charles Blanc, *Grammaire des arts du dessin* (Paris, 1867), 575 (in connection with Raphael).

45. "On les calque avec une pointe sur l'enduit frais d'un plafond." Dezallier d'Argenville 1762, 1:xxxviii.

46. We have dwelt only briefly on a very particular category of drawings: those that could be described as independent drawings, conceived without any picture in mind. Ingres's portrait drawings belong to this category of works, as do certain sheets by Fragonard. In any event, they make up a very small point in the immense graphic production of these five artists.

47. Avigdor Arikha, "De la boîte, des figurines et du mannequin," in Paris 1994–95, 44–47.

48. "Quand il s'agissait d'une histoire plus complexe, il montait une planche à damiers, sur laquelle il disposait des figurines de cire qu'il faisait dans ce but, des figurines nues, placées selon l'action de 'l'histoire' et conçues dans son esprit, qu'il habillait de papier mouillé ou de taffetas très fin, pour les draperies, selon l'exigence, puis il équipait le tout de fils tirés de telle façon que chaque figurine trouvait sa place correcte par rapport à l'horizon." Quoted in ibid., 47 (translated from German by Arikha).

49. "formava modelletti di cera di tutte le figure nelle loro attitudini in bozzette di mezzo palmo, e ne componeva l'istoria o la favola di rilievo, per vedere gli effetti naturali del lume e dell'ombre de' corpi." Bellori 1976, 452.

50. "une boëtte Cube," "regardant par là pour dessiner son Tableau sur le papier." Antoine Le Blond de Latour, *Lettre du sieur Le Blond de Latour à un de ses amis, contenant quelques instructions touchant la peinture* (Bordeaux, 1669); quoted by Arikha in Paris 1994–95 (see n. 47 above), 45–46.

51. Blunt 1967, 243; a new reconstitution of Poussin's box has been proposed by Diane de Grazia for the forthcoming exhibition in Cleveland devoted to *The Holy Family on the Steps.*

52. Arikha, in Paris 1994–95 (see n. 47 above), 47.

53. "où il a placé de petites figures en pied, dans le costume et l'attitude que les personnages avoient à la cérémonie du *Sacre.*" According to the *Affiches, annonces et avis divers . . .* of 7 December 1807; quoted by Schnapper, in Paris-Versailles 1989–90, 408.

54. "Il faut bannir les mannequins." Quoted in Delaborde 1870, 132.

55. "J'ai en cire une maquette, pour l'effet des ombres." Letter to Gilibert, 20 July 1843; Boyer d'Agen 1909, 365–66.

56. "Se faire une petite chambre à la Poussin: indispensable pour les effets." Quoted in Delaborde 1870, 136.

57. "grandes espérences [*sic*]." Letters from Natoire to Marigny, 24 October and 7 November 1759, in *Correspondance des directeurs* 1901, 317–18.

58. "Uzerches: . . . comme nous sommes arrivés de bonne heure dans l'endroit le plus affreux par la situation, sur une butte entourée de montagnes et terminée par une

rivière meublée de chaussées et moulins qui occasionnent des chûtes et cascades d'eau nous avons, en peintres et amateurs, admiré avec extase ce que personne n'admire et notre docteur M. Fragonard toujours laborieux et actif a projetté et exécuté un dessein de cette situation jusqu'à l'heure de notre dîner ou souper qui s'est fait avant 6 heures." Bergeret 1895, 73.

59. "La facilité: il faut en user en la méprisant." Delaborde 1870, 125.

60. "La pose était évidemment celle d'un jeune homme lançant une flèche, un Amour sans doute. Alors, devant nous, en un instant et en quelques coups de crayon, pendant que l'enfant posait sur une jambe, il fit un croquis d'ensemble; mais, comme la jambe en l'air changeait naturellement de place à chaque mouvement que faisait le modèle, M. Ingres en dessinait une autre, de façon que, dans le temps assez court que cet enfant put tenir la pose, il eut la merveilleuse habileté d'en achever l'ensemble et deux jambes de plus." Amaury-Duval 1924, 32.

61. "Il évitoit autant qu'il pouvoit les compagnies, et se déroboit à ses amis, pour se retirer seul dans les Vignes et dans les lieux les plus écartez de Rome, où il pouvoit avec liberté considerer quelques Statuës antiques, quelques vûës agréables, et observer les plus beaux effets de la Nature. C'étoit dans ces retraites et ces promenades solitaires qu'il faisait de legeres esquisses des choses qu'il rencontroit propres, soit pour le païsage, comme des terrasses, des arbres, ou quelques beaux accidens de lumieres; soit pour des compositions d'histoires, comme quelques belles dispositions de figures, quelques accomodemens d'habits, ou d'autres ornemens particuliers, dont ensuite il sçavoit faire un si beau choix et un si bon usage." André Félibien, *Entretiens sur les vies et sur les ouvrages des plus excellens peintres anciens et modernes,* 5 vols. (Paris, 1666–88; rev. ed. 1725), eighth conversation, 1685; see Clare Pace, *Félibien's Life of Poussin* (London, 1981), 112–14.

62. "Wateau [*sic*] se distingua . . . par une plus grande recherche de la nature, dont il ne s'est jamais éloigné." Dezallier d'Argenville 1762, 4:404.

63. "Fragonard parlait souvent de la beauté qu'il appelait la santé parfaite de la nature." Quoted in Paris-New York 1987–88, 28.

64. "recommandé d'étudier toujours la nature (et l'antique)."

65. "Une idée n'est qu'une intention, un projet vague, tant qu'au moyen d'une exécution sûre et savante, l'artiste n'a pu lui donner un corps et la rendre à la fois compréhensible et sensible. Il y a des gens qui ont des *idées* on ne peut plus heureuses, mais il leur est impossible de les rendre." Delécluze 1855, 227. Let us not confuse "idea" and "thought"; see below, chap. 5, p. 174 and n. 78.

66. "Lorsqu'on sait bien son métier et que l'on a bien appris à imiter la nature, le plus long pour un bon peintre est de *penser* en tout son tableau." "Dessiner ne veut pas dire simplement reproduire des contours, le dessin ne consiste pas simplement dans le trait: le dessin c'est encore l'expression, la forme intérieure." "Pour exprimer le caractère, une certaine exagération est permise, nécessaire même quelquefois, mais surtout là où il s'agit de dégager et de faire saillir un élément du beau." Delaborde 1870, 93, 123, 130.

67. "Il s'est fait un dessin à lui, d'une correction douteuse, bizarre." Amaury-Duval 1924, 192.

68. "Vous autres vous croyez avoir tout fait lorsque vous avez dessiné correctement une figure et mis chaque chose à sa place d'après les lois de l'anatomie! . . . et parce que vous regardez de temps en temps une femme nue qui se tient debout sur une table, vous croyez avoir copié la nature . . . La mission de l'art n'est pas de copier la nature, mais de l'exprimer." Honoré de Balzac, *Le Chef-d'oeuvre inconnu* (Paris, 1951), 9:392–94.

CHAPTER 4

1. Thus, does the Prado painting (fig. 116) represent *Diogenes Leaving Sparta for Athens,* as Charles Dempsey and Elizabeth Cropper propose in *Nicolas Poussin: Friendship and the Love of Painting* (Princeton, 1996), 126–27, or, as we believe, travelers in the Roman Campagna?

2. Note that *The Calm,* a masterpiece by Poussin (formerly collection Sudeley Castle, now in the J. Paul Getty Museum, Los Angeles), was catalogued as a work by Dughet by Sotheby's, sale of 27 March 1974, no. 14, withdrawn.

3. Antoine Schnapper, *Curieux du Grand Siècle: Collections et collectionneurs dans la France du XVIIe siècle* (Paris, 1994), 63.

4. See, for example, Konrad Oberhuber, "Les Dessins de paysage du jeune Poussin," in *Nicolas Poussin*

1996, 1:101–19. Clayton (see chap. 2, n. 4), 468, and Sutherland Harris (see chap. 2, n. 4), 423, share our strict approach. Specifically, Clayton questioned the attribution of the *View of the Aventine* (see n. 26 below).

5. Fort Worth 1988.

6. Hugh Brigstocke, *A Loan Exhibition of Drawings by Nicolas Poussin from British Collections,* exh. cat. (Oxford: Ashmolean Museum, 1990–91), nos. 12, 13, ill.

7. Fort Worth 1988, nos. D. 67 and D. 70.

8. Written communication, 2 April 1991.

9. Ann Sutherland Harris, review of *Poussin: The Early Years in Rome; The Origins of French Classicism* (Fort Worth, 1988), *Art Bulletin* 72, no. 1 (March 1990): 144–45.

10. "Païsages du Poussin, la plus grande partie faits d'après Nature dans les Vignes de Rome, ou aux environs de cette Ville." "Vingt-trois [dessins], parmi lesquels sont plusieurs copies de Païsages des Carraches, qu'on prétend avoir été faites par le Poussin." "Six [dessins]: grands Païsages, dont un exécuté d'une main tremblante, mais où l'on reconnoît pour la pensée, le même sublime, que dans tous les autres ouvrages de ce grand Maître." Crozat sale, 10 April–13 May 1741, nos. 974–84 (see Rosenberg and Prat 1994, 2:1154). Cordelia Hattori has undertaken a thesis on the collector, whose publication we eagerly await: "La Collection de dessins de Pierre Crozat: Etude sur le fonds d'art graphique du Musée du Louvre" (Mémoire de DEA, Université de Paris IV), 1991–93. She has already published an article on the subject, see chap. 1, n. 4.

11. Those that belonged to Mariette are most easily recognized, as they carry the stamp of the illustrious collector.

12. "Les sujets les plus simples et les plus stériles, devenoient entre ses mains interessans": one of the best definitions of Poussin's singular genius.

13. "L'on a un très-petit nombre de Desseins finis du Poussin. Quand il dessinoit, il ne songeoit qu'à fixer ses idées, qui partoient avec tant d'abondance, que le même sujet lui fournissoit sur le champ une infinité de pensées differentes. Un simple trait, quelquefois accompagné de quelques coups de lavis, lui suffisoit pour exprimer avec netteté, ce que son imagination avoit conçû. Il ne recherchoit alors ni la justesse du trait, ni la verité des expressions, ni l'effet du clair-obscur. C'étoit le pinceau à la main qu'il étudioit sur la toile ces differentes parties de son tableau. Il étoit dans la persuasion, que toute autre

méthode n'étoit propre qu'à rallentir le génie, et à rendre l'ouvrage languissant. Son raisonnement étoit bon pour de petits tableaux, et le Poussin en a fait très-peu de grands; mais si l'on ne voit point de ses Académies, ni d'Etudes de têtes et autres parties en grand, il ne faut pas en conclure qu'il méprisât l'Etude de la Nature. Personne, au contraire, ne l'a consulté plus souvent, l'on ne peut même lui reprocher d'avoir jamais rien fait de pratique: c'est pourquoi il suivoit par rapport au Païsage, une méthode differente de celle qu'il tenoit pour la figure. L'indispensable nécessité d'aller étudier sur le lieu le modéle [*sic*], lui a fait dessiner un grand nombre de Païsages d'après Nature avec un soin infini. Non-seulement il devenoit alors religieux observateur des formes; mais il avoit encore une attention extrême à saisir des effets piquans de lumiere, dont il faisoit une application heureuse dans ses tableaux. Muni de ces Etudes, il composoit ensuite dans son Cabinet ces beaux Païsages, où le spectateur se croit transporté dans l'ancienne Grece, et dans ces Vallées enchantées décrites par les Poëtes. Car le génie de M. Poussin étoit tout poëtique. Les sujets les plus simples et les plus stériles, devenoient entre ses mains, interessans. Dans les derniers jours de sa vie, qu'une main tremblante et appesantie lui refusoit le service, le feu de son imagination n'étoit point encore éteint, cet habile Peintre mettoit au jour des idées magnifiques, qui saisissent d'admiration, en même-tems qu'elles causent une sorte de peine de les voir si mal exécutées." Crozat sale catalogue, 1741, 114.

14. It was to John Shearman that Blunt entrusted the section concerning landscapes in the fourth volume of his work on Poussin's drawings, published in 1963; see Friedlaender and Blunt 1939–74.

15. "Landscape drawings attributed to Gaspard Dughet: G1–18: Uniform Format"; in ibid., 59–61.

16. "G19–42: Drawings stylistically consistent with this group"; in ibid., 61–64.

17. Brigstocke, *Drawings by Poussin* (see n. 6 above); Marco Chiarini, "Due mostre e un libro (Studi recenti sulla pittura de paesaggio a Roma fra Sei e Settecento)," *Paragone,* no. 187 (September 1965): 62–76; Eckhart Knab, in *Claude Lorrain und die Meister der römischen Landschaft im XVII. Jahrhundert,* exh. cat. (Vienna: Albertina, 1964–65); Sutherland Harris (see chap. 2, n. 4); Clovis Whitfield, "Poussin's Early Landscapes," *Burlington Magazine* 122, no. 933 (January 1979): 10–19; Wild 1980. Shearman also placed together two other groups of

landscapes: a "group A" ("Drawings closely connected with Poussin's landscapes") and a "group B" ("Landscape Drawings by imitators").

18. Published by Jules J. Guiffrey, "Testament et inventaire des biens, tableaux, dessins, planches de cuivre, bijoux, etc. . . . de Claudine Bouzonnet-Stella, rédigés et écrits par elle-même, 1693–1697," *Nouvelles archives de l'art français* (1877): 1–117.

19. "Au 44e feuillet, un dessein du Poussin: cinq arbre [sic] à la plume." Ibid., 51; Rosenberg and Prat 1994, vol. 2, R 746, ill.

20. In the review of Friedlaender, Blunt, and Shearman in *Master Drawings* 3, no. 2 (1965): 171–73.

21. Per Bjurström, "A Landscape Drawing by Poussin in the Uppsala University Library," *Master Drawings* 3, no. 3 (1965): 264–65; Rosenberg and Prat 1994, vol. 1, no. 351, ill.

22. Rosenberg and Prat 1994, vol. 2, R 259, ill.; Chantilly 1994–95, no. 109, ill.

23. Roseline Bacou, in *Mariette,* exh. cat. (Paris: Musée du Louvre, 1967), 154, under no. 255.

24. Frédéric Reiset, *Description abrégée des dessins de diverses écoles appartenant à M. Frédéric Reiset* (Paris, 1850), annotation written in the margin next to no. 198. In 1861 he sold his collection to the duc d'Aumale, who founded the Musée Condé in Chantilly.

25. The Crozat provenance of the drawing in Chantilly is probable. It was later part of the Moritz von Fries collection and then was owned by Frédéric Reiset.

26. Rosenberg and Prat 1994, vol. 1, no. 116, ill. The drawing appeared in a recent exhibition in Florence, *Disegni del seicento romano,* at the Gabinetto Disegni e Stampe degli Uffizi, in 1997, no. 8, fig. 9, catalogue by Ursula Verena Fischer-Pace. See also n. 4 above.

27. Denys Sutton, "Nicolas Vleughels (1668–1737)," *Old Master Drawings* 14 (1939–40): 52; Pierre Rosenberg, "A propos de Nicolas Vleughels," *Pantheon* 31 (1973): 143–52; Bernard Hercenberg, *Nicolas Vleughels: Peintre et directeur de l'Académie de France à Rome 1668–1737* (Paris, 1975). For drawings by Vleughels previously attributed to Watteau, see, for example, Rosenberg and Prat 1996, vol. 3, R 218, ill.

28. According to Dezallier (1762, 4:409), "tout lui était bon excepté la plume." Parker and Mathey judged authentic a pen drawing (no. 332) after J. Callot that we rejected (Rosenberg and Prat 1996, vol. 3, R 232).

29. This landscape by Delobel (R.F. 51727) comes

from the Mariette collection. The Rijksmuseum, Amsterdam (inv. 1956:57), owns another drawing by Delobel, this one signed and dated.

30. Beverly Schreiber Jacoby, "A Landscape Drawing by François Boucher after Domenico Campagnola," *Master Drawings* 17, no. 3 (1979): 261–72; see Rosenberg and Prat 1996, vol. 3, R 98, ill.

31. Margaret Morgan Grasselli, "Landscape Drawings by François Le Moyne, Some Old, Some New," *Master Drawings* 34, no. 4 (1996): 365–74; see Rosenberg and Prat 1996, vol. 3, R 393, R 579, R 581, R 732, R 752, R 824.

32. *J. H. Fragonard e H. Robert a Roma,* at the Villa Medici in Rome, 1990–91, catalogue by Catherine Boulot, Jean-Pierre Cuzin, and Pierre Rosenberg; unfortunately, the French edition was never published.

33. "J'ay fait, dans ces derniers tems, plusieurs desseins d'après des vues aux environs de Rome," "Je les [ses élèves] encourage . . . en les prêchant d'exemple." Letter from Natoire to Marigny, 17 January 1759, *Correspondance des directeurs* 1901, 259–60.

34. Giuliano Briganti, in his review of the exhibition *J. H. Fragonard e H. Robert a Roma* (see n. 32), *La Repubblica,* 16 January 1991, 34.

35. For the question of their attribution, see Jean-Pierre Cuzin and Pierre Rosenberg, "Fragonard e Hubert Robert: Un Percorso romano," in *J. H. Fragonard e H. Robert a Roma* (see n. 32), 26, fig. 6 on 24; see also Paris-New York 1987–88, 65–66, figs. 17, 18.

36. [Le] "tableau du paysage que tu as fait au Luxembourg." Quoted in David 1880, 1:295, and in Paris-Versailles 1989–90, 592. David was imprisoned twice, from September to December 1794 and from May to August 1795; see also below, chap. 6, n. 21.

37. "Des croisées de sa prison, il peignit les arbres du jardin, et fit le seul paysage qu'il ait jamais exécuté." Delécluze 1855, 178.

38. "Là, il fit sur toile, de sa fenêtre, deux paysages." Quoted in Wildenstein and Wildenstein 1973, 114, no. 1131.

39. Anna Ottani Cavina and Emilia Calbi, "Louis Gauffier and the Question of J.-L. David's 'Vue présumée du jardin du Luxembourg,'" *Burlington Magazine* 133, no. 1054 (January 1991): 27–33.

40. Anna Ottani Cavina, "Rome 1780: Le Thème du paysage dans le cercle de David," in *David contre David* 1993, 1:83–92; see also idem, *I Paesaggi della ragioni* (Turin, 1994).

41. Drouais's sketchbook was the subject of an exhibition at the Musée des Beaux-Arts of Rennes in 1985, for which Patrick Ramade wrote the catalogue, with Arlette Sérullaz responsible for the section on David's drawings, *Jean-Germain Drouais 1763–1788;* see also Sérullaz, "A propos d'un album de dessins de Jean-Germain Drouais au musée de Rennes," *Revue du Louvre,* nos. 5–6 (1976): 380–87.

42. Alvar Gonzalez-Palacios, "La Grammatica neoclassica," *Antichità viva* 12, no. 4 (1973): 29–55; this article was also published recently in *L'Armadio delle meraviglie* (Milan, 1997), 55–75.

43. For this point, see Pierre Rosenberg, "Fragonard et David," in *David contre David* 1993, 2:15n.

44. Hélène Toussaint, "Les Fonds de portraits d'Ingres: Peintures à fond de paysage," *Bulletin du Musée Ingres,* nos. 63–64 (1990): 19–24; for the collaboration of Desgoffe and Ingres, see also Ingres's letter to Gilibert, 2 June 1846, in Boyer d'Agen 1909, 386–87.

45. Hélène Toussaint, "Découvertes et attributions: Trois paysages romains," *Bulletin du Musée Ingres,* nos. 63–64 (1990): 59–65.

46. Cohn and Siegfried, *Works by J. A. D. Ingres* (see chap. 2, n. 43), no. 3, ill.

47. Naef 1977–80.

48. Published in Lausanne in 1960, the book was updated and reissued for the exhibition *Rome vue par Ingres* at the Musée Ingres, Montauban, 1973.

49. "si Ingres ne l'avait pas signé [c'était] à cause du dessin d'architecture qui est, paraît-il, l'oeuvre d'un grand prix d'architecture, camarade d'Ingres." Henry Lapauze, "Jean Briant, paysagiste (1760–1799), maître d'Ingres, et le paysage dans l'oeuvre d'Ingres," *Revue de l'art ancien et moderne* 29 (1911): 299–312. H. Naef in London-Washington, D.C.-New York 1999–2000, 170, does not find this information "trustworthy" and reattributes the landscape to Ingres.

50. Daniel Ternois, "Une correspondance entre Ingres, les frères Balze et les frères Flandrin," *Bulletin du Musée Ingres,* nos. 57–58 (1987): 12 n. 6. This correspondence was recently sold at auction in Vendôme, 15 February 1998.

51. The will of the comtesse Mortier, daughter of the sitter, dated 1866, confirms that the background for this portrait was painted by Granet and represents the Temple of the Sibyl at the Villa Gregoriana, Tivoli; see Isabelle Néto-Daguerre de Hureaux, "Granet et Ingres," *Bulletin du Musée Ingres,* nos. 63–64 (1990): 3–17. See also Hélène Toussaint, *Les Portraits d'Ingres, peintures des musées nationaux* (Paris, 1985), 50, 138 n. 69.

52. Toussaint, *Les Portraits d'Ingres* (see n. 51); and Toussaint, "Les Fonds de portraits d'Ingres" (see n. 44); For a more recent and different point of view on the subject, see Jon Whiteley, "Exhibition Review: London, Washington and New York, Ingres," *Burlington Magazine,* 141 (May 1999): 304–6.

53. Hélène Toussaint, "Ingres et les architectes: Rendons à Mazois . . . ," in *Hommage à Michel Laclotte: Etudes sur la peinture du Moyen Age et de la Renaissance* (Paris, 1994), 573–78.

54. Vigne 1995, nos. 2814–54, for the "Master of Small Dots," and nos. 3015–32 for the "Master of the Gardens of the Villa Medici." Vigne mentions in his monograph *Ingres* (Paris, 1995), 92, a "Master of Vivid Walls" ("Maître des murs animés") who is characterized by "deep washes" ("des lavis profonds"). He does not reproduce any of his drawings. Is Vigne referring to nos. 3061 or 3182 of his catalogue, which he seems to reject as the work of Ingres without specifying why? For Toussaint (see n. 53), the "Master of the Small Dots" is Mazois, an attribution with which Vigne disagrees. See "Ingres and Co: A Master and his Collaborators," in London-Washington, D.C.-New York 1999–2000, 526–28.

55. Hans Naef, "Un Chef-d'oeuvre retrouvé: *Le Portrait de la reine Caroline Murat* par Ingres," *Revue de l'art,* no. 88 (1990): 11–20.

56. Doris Wild, "Charles Mellin ou Nicolas Poussin," parts 1 and 2, *Gazette des beaux-arts* 68 (July–August 1966): 177–214; 69 (January 1967): 3–44. These two articles exist in offprint.

57. Jacques Thuillier, "Charles Mellin 'Très excellent peintre,'" in *Les Fondations nationales dans la Rome pontificale,* Collection de l'École française de Rome, 52 (Rome, 1981), 583–684. See also Daniel Ternois, Jacques Thuillier, and Michela de Macco, *Claude Lorrain e i pittori lorenesi in Italia nel XVII secolo,* exh. cat. (Rome: Accademia di Francia; Nancy: Musée des Beaux-Arts, 1982).

58. Philippe Malgouyres, "Quelques remarques sur Charles Mellin, peintre (Nancy [?], vers 1600–Rome, 1649)," in *Poussin et Rome* 1996, 169–79.

59. Pierre Rosenberg, "A propos d'un dessin de Charles Mellin," *Revue du Louvre,* nos. 4–5 (1969): 223–26.

60. Today on the New York art market; see Rosen-

berg and Prat 1994, vol. 2, R 673, ill. For Dezallier d'Argenville, see above, chap. 3.

61. Rosenberg and Prat 1994, see vol. 2, R 1151; see also Jacques Thuillier, "A propos de Charles-Alphonse Du Fresnoy: Du 'Maître de Stockholm' au 'Maître de Cassel,'" *Revue de l'art,* no. 111 (1996): 51–65.

62. Jacques Thuillier, "Propositions pour I. Charles Errard peintre," *Revue de l'art,* nos. 40–41 (1978): 151–72.

63. On Blanchard, see *Jacques Blanchard,* exh. cat. (Rennes, Musée des Beaux-Arts, 1998); Charles Sterling, "Les Peintres Jean et Jacques Blanchard," *Art de France* 1 (1961): 77–118; and Pierre Rosenberg, "Quelques nouveaux Blanchard," in *Etudes d'art français offertes à Charles Sterling* (Paris, 1975), 217–25. For Dufresnoy, see Jacques Thuillier, "Propositions pour II. Charles-Alphonse Du Fresnoy peintre," *Revue de l'art,* no. 61 (1983): 29–52.

64. Blunt 1979, 195 n. 22.

65. The drawing was, in fact, at the École Nationale Supérieure des Beaux-Arts (gift of Mathias Polakovits, inv. P.M. 650); see Pierre Rosenberg and Louis-Antoine Prat, "Annexe," *Revue de l'art,* no. 112 (1996): 57–58, ill.

66. Sylvain Laveissière, "Les *Tableaux d'histoire* retrouvés de Charles-Alphonse Dufresnoy," *Revue de l'art,* no. 112 (1996): 38–58.

67. Martin Eidelberg, "Quillard as Draughtsman," *Master Drawings* 19, no. 1 (1981): 27–39; see also Nuno Saldanha, "Pierre-Antoine Quillard," in *Jean Pillement: Le Paysagisme au Portugal au XVIIIe siècle,* exh. cat. (Lisbon: Fundaçao Ricardo do Espirito Santo Silva, 1997), 189–201.

68. Martin Eidelberg, "Watteau and Oppenort," *Burlington Magazine* 111, no. 793 (1969): 223.

69. Jean-Pierre Cuzin, "Deux dessins du British Museum: Watteau, ou plutôt La Fosse," *Revue du Louvre,* no. 1 (1981): 19–21; see Rosenberg and Prat 1996, vol. 3, R 206–R 207.

70. Paris-New York 1987–88, 430, 481.

71. Under no. 341 in the Natoire sale (14 December 1778), the expert catalogued under his name (which he spelled "Angot") "more than one hundred Drawings after the greatest Masters of the Italian School." Julien de Parme refers to him in his autobiography (published many times, notably in *L'Artiste* [1862]: 85) and in his correspondence (published by Pierre Rosenberg in *Archives de l'art français* 26 [1984]: 197–245). For Ango, see Alexandre Ananoff, "Fragonard et Ango, collaborateurs de Saint-Non," *Bulletin de la Société de l'histoire de l'art français, 1962* (1963): 117–20; idem,

"Les Paysages d'Ango," *Bulletin de la Société de l'histoire de l'art français 1965* (1966): 163–68; Marianne Roland Michel, "Un Peintre français nommé Ango," *Burlington Magazine* 123, no. 945 (December 1981): suppl. no. 40, ii–viii; Pierre Rosenberg, "La Fin d'Ango," *Burlington Magazine* 124, no. 949 (April 1982): 236–37; and idem, "Ango o il duplice equivoco," in *Sembrare e non essere: I Falsi nell'arte e nella civiltà* (Milan, 1993), 137–39.

72. James David Draper, "Ango after Michelangelo," *Burlington Magazine* 139, no. 1131 (June 1997): 398–99.

73. See Jean-Pierre Cuzin, "De Fragonard à Vincent," *Bulletin de la Société de l'histoire de l'art français, 1981* (1983): 113–14, figs. 17–20.

74. Ibid., figs. 29, 31.

75. Ananoff 1961–70.

76. Alexandre Ananoff, "Des Révélations sensationnelles," *Connaissance des arts,* no. 54 (August 1956): 38–41.

77. Claus Virch, *Master Drawings in the Collection of Walter C. Baker* (New York, 1962), no. 79, ill.

78. Lugt 1921, no. 779.

79. Our reproduction (fig. 176) comes from a proof that belongs to Denon's descendants.

80. Christie's, London, 29 June 1962, no. 46 (collection of Lord Curie and Mrs. Bertram Curie).

81. Jean Cailleux, "A Note on the Pedigree of Paintings and Drawings," *Burlington Magazine* 104, no. 714 (September 1962), suppl. no. 12, i–iii, fig. 2.

82. Virginia Lee, "Jacques Louis David: The Versailles Sketchbook," parts 1 and 2, *Burlington Magazine* 111, no. 793 (April 1969): 197–208; no. 795 (June 1969): 360–69; Marie-Dominique de La Patellière, "Rysunki jana Piotra Norblina Przedstawiajace, przysiege w Jeu de Paume w zbiorach amerykanskich," *Biuletyn historii sztuki,* no. 4 (1979): 413–28; Philippe Bordes, "David and Norblin, 'The Oath of the Tennis Court' and Two Problems of Attribution," *Burlington Magazine* 122, no. 929 (August 1980): 569–73; and Mongan 1996 (see chap. 2, n. 40), nos. 284–87.

83. Sérullaz 1991, 152, no. 193, ill.

84. "Un jour, en feuilletant ainsi ces cartons, David retrouva deux esquisses de la main d'Etienne. L'une représente Cimon faisant embarquer les femmes et les enfants au Pirée, pour défendre Athènes; et l'autre, Léonidas se préparant avec ses Spartiates au combat. Ces deux compositions, que David avait distinguées dans les concours institués dans l'atelier de ses élèves, avaient été honorablement placées par lui dans ses cartons. Le maître

. . . renouvela les éloges qu'il avait donnés autrefois à ces essais; puis, tirant tout à coup l'esquisse de Léonidas du carton: 'Tenez, mon cher Etienne,' dit-il, 'je vous rends ce dessin que vous m'avez prêté et qui m'a fourni l'idée de deux groupes que j'ai placés dans mon tableau des *Thermopyles*. Gardez-le, ce sera tout à la fois un souvenir de vos études et de la manière dont travaillait votre maître. Quant à celui de Cimon, cette esquisse me plaît, vous me l'avez donnée, je la garde.'" Delécluze 1855, 359.

85. Fort Worth 1988, 43–55, nos. D 10–D 24, ill.

86. Clayton, "Nivelle Watermark" (see chap. 2, n. 56), 245.

87. Rosenberg and Prat 1994, vol. 1, no. 146, color ill.

88. Rosenberg and Prat 1996, vol. 1, no. 203, color ill. ("about 1713–14 at latest").

89. Rosenberg and Prat 1996, vol. 2, no. 661, color ill. ("about 1720?").

90. Made into a print by Caylus for the *Recueil Jullienne* (Dacier and Vuaflart 1921–29, no. 182); Rosenberg and Prat 1996, vol. 1, no. 145, ill.

91. Rosenberg and Prat 1996, vol. 1, no. 226, ill. (1714 and 1717/18); see also nos. 82, 228, 229, 328, 397, 474, 483, 567.

92. Paris-Versailles 1989–90, nos. 178–81, ill.

93. Schnapper, in ibid., 412–13.

CHAPTER 5

1. The first Salons took place in 1699 and 1704; Watteau was too young to participate.

2. "Deux Desseins. Vûes de la Ville d'Este à Tivoli. Ils appartiennent à M. l'Abbé de Saint Non." More precisely, at least "two," as it is not impossible that the complete series was exhibited.

3. "Paysage, Un homme appuyé sur sa bêche," "un espèce de brocanteur, assis devant sa table dans un fauteuil à bras." Jean Seznec and Jean Adhémar, *Diderot: Salons,* vol. 3, *1767* (Oxford, 1963), 280.

4. "Il se contente de briller aujourd'hui dans les boudoirs et dans les gardes-robes." Bachaumont, *Mémoires secrets,* vol. 13 (1769), 32–33, quoted in Paris-New York 1987–88, 228.

5. Such as the Salon de la Correspondance, where Fragonard exhibited as many paintings as drawings and even some prints and "watercolors" in 1779, 1781, 1782, 1783, and 1785.

6. Emile Galichon, "Description des dessins de M. Ingres exposés au Salon des Arts-Unis," *Gazette des beaux-arts* 9 (15 March 1861): 344.

7. "Non, me répondit-il, on ne regarderait que cela." Amaury-Duval 1924, 160–61.

8. "Je crois que M. Ingres, en disant ce mot, se rendait bien compte de la valeur de ses croquis, qui sont supérieurs, à mon sens, à tout ce qu'il a fait en peinture, ou du moins qui le mettent à part de tous les artistes passés et présents; il n'y a rien d'analogue dans aucune époque, et ces dessins innombrables et merveilleux constituent en grande partie son originalité." Ibid., 161. Ingres, like Watteau, was aware that many people preferred his drawings to his paintings.

9. For the prints after Poussin, see A. Andresen, *Nicolaus Poussin: Verzeichnis der nach seinen Gemälden gefertigten gleichzeitigen und späteren Kupferstiche* (Leipzig, 1863); Georges Wildenstein, *Les Graveurs de Poussin au XVIIe siècle* (Paris, 1955, 1957), who records almost two hundred prints before 1700; and idem, "Catalogue des graveurs de Poussin par Andresen . . . Traduction française abrégée, avec reproductions," *Gazette des beaux-arts* 104 (1962): 139–202; Martin Davies and Anthony Blunt, "Some Corrections and Additions to M. Wildenstein's 'Graveurs de Poussin au XVIIe siècle,'" *Gazette des beaux-arts* 104 (1962): 205–22.

10. Fabrizio Chiari made prints of *Mars and Venus* (Rosenberg and Prat 1994, vol. 1, no. 35, ill.) and *Venus and Mercury* (Rosenberg and Prat 1994, vol. 2, R 729, ill.). For the illustrations for Leonardo, Virgil, Horace, and Ferrari, see Rosenberg and Prat 1994, vol. 1, nos. 129, 225, and vol. 2, A 84–A 86.

11. See Rosenberg and Prat 1996, vol. 1, nos. 36–43 *(Figures de modes)*; and Dacier and Vuaflart 1921–29, vol. 3, no. 178 *("Recruë allant joindre le Regiment")* and no. 130 *("Les Habits sont Italiens")*.

12. The prints after Watteau's paintings from Jullienne's collection have been reproduced and studied by Dacier and Vuaflart 1921–29.

13. "Les moindres morceaux qu'il a produits sont précieux et ne peuvent être recherchez [*sic*] avec trop de soin." Jullienne, in his introduction to *Figures de différents caractères* (Paris, 1726), n.p.

14. Wildenstein 1956, 28, no. XIX; 25, no. XVI *(Two Prophets,* after Annibale Carracci, and *The Disciples at the Tomb,* after Tintoretto).

15. We published it, with reproductions of the draw-

ings by Fragonard, his etchings, and Saint-Non's aquatints (Rosenberg and Brejon de Lavergnée 1986). A new edition is planned for 1999.

16. Wildenstein 1956, 38.

17. "Le peintre l'a représenté tout à la fois opposant d'une main l'égide de Minerve à la foudre qu'il a su fixer par des conducteurs, et de l'autre ordonnant à Mars de combattre l'avarice et la tyrannie; tandis que l'Amérique, noblement appuyée sur lui et tenant un faisceau, symbole des Provinces-Unies, contemple avec tranquillité ses ennemis terrassés." Pahin de La Blancherie, in *Nouvelles de la république des lettres et des arts,* 26 January 1779, 4, no. 1; quoted in Paris-New York 1987–88, 489.

18. "Francklin [*sic*], à qui nul art n'étoit étranger, aimoit à s'en entretenir avec SAINT-NON. Il fut curieux de connoître le procédé ingénieux et si expéditif dont il se servoit pour sa gravure au lavis. Le jour fut pris pour cela. Francklin vient déjeûner chez lui; et, tandis que le thé se prépare, on arrange la planche. Tout est disposé; SAINT-NON se met à l'oeuvre: il s'étoit muni d'une presse; on tire la planche, et il en sort une charmante gravure, où l'on voit le génie de Francklin planant sur l'hémisphère du Nouveau Monde, et couronné des mains de la Liberté. Quelle agréable surprise pour le Brutus de l'Amérique!" Gabriel Brizard, *Notice sur Jean-Claude Richard de Saint-Non: Analyse du voyage pittoresque de Naples et de Sicile* (Paris, 1792; reprint, Geneva, 1973), 24–25.

19. "David et son école donnèrent une impulsion si différente au goût des artistes et des amateurs que Fragonard vit cesser sa vogue." Valogne 1955, quoted in Rosenberg 1989, 12.

20. Heinrich Schwarz, "Ingres graveur," *Gazette des beaux-arts* 54 (December 1959): 329–42. One of the drawings was sold at auction recently in Paris (Drouot, 25 April 1997, no. 143, color ill.).

21. "Il faut cependant te dire que ma léthargie a été, depuis le mois passé, assez éveillée par les soins que je donne avec la plus vive passion au dessin de mon tableau d'*Homère* que je fais moi-même, pour être gravé. Ce dessin est très grand; c'est la même composition, mais augmentée de nouveaux personnages et de toutes les perfections dont je puis être capable. Je veux que cette composition soit l'oeuvre de ma vie d'artiste, la plus belle et la plus capitale." Letter from Ingres to Pauline Gilibert, 26 February 1856; Boyer d'Agen 1909, 431. The print after Ingres's drawing (fig. 91) was not realized.

22. For Poussin and money, see Thuillier 1994, 95ff.;

see also Donatella L. Sparti, "Appunti sulle finanze di Nicolas Poussin," *Storia dell'arte,* no. 79 (1993): 341–50; and Olivier Michel, "La Fortune matérielle de Poussin," in *Poussin et Rome* 1996, 1:25–44.

23. "Con questo signore e con altri suoi amici non trattò mai il prezzo de'suoi quadri, ma quando li aveva forniti l'annotava dietro la tela." Bellori 1976, 456.

24. Letter from the abbé Louis Fouquet, 23 August 1655; portions of letters published by E. de Lepinois and Anatole de Montaiglon, *Archives de l'art français* (1862): 266–309; see Thuillier 1994, 169.

25. See n. 22 above. See also Antoine Schnapper, "Fonds d'atelier et collections de Mignard: Inventaires connus ou disparus," in *Pierre Mignard "le Romain"* (proceedings of a symposium, 1995) (Paris, 1997), 227–39.

26. See above, chap. 2, n. 16.

27. His *Moses and the Daughters of Jethro* (Rosenberg and Prat 1994, vol. 1, no. 304, ill.) brought 1.5 million francs at auction in 1985.

28. "Il n'aimait point l'argent, et . . . n'y était nullement attaché." Caylus 1748; see Rosenberg 1984, 67.

29. "C'est là où il commença à prendre du goût pour l'argent dont il n'avait fait jusqu'alors aucun cas, le méprisant même jusqu'à le laisser avec indifférence, et trouvant toujours que ses ouvrages étaient payés beaucoup plus qu'ils ne valaient." Gersaint 1744; see Rosenberg 1984, 36.

30. "Deux desseins de Watteau très finy, prisé 12 livres." See Baticle, "Chanoine Haranger" (see chap. 2, n. 25), 55–68.

31. The drawing recently given to the Musée du Louvre by the Société des Amis du Musée (Rosenberg and Prat 1996, vol. 2, no. 562), reproduced herein as fig. 26, cost 10 million francs.

32. "Il perd son temps et son talent. Il gagne de l'argent." Letter to the abbé Galiani, published in *Correspondance de Diderot,* ed. G. Roth, vol. 11 (1964); quoted in Paris-New York 1987–88, 300.

33. "Année commune, il se faisait 40 000 francs de son talent." Charles-Paul Landon, *Annales du musée: École française moderne* (1832), 93; quoted in Paris-New York 1987–88, 16, and in Rosenberg 1989, 5.

34. Quoted in Paris-New York 1987–88, 418.

35. "ma caissière." According to Théophile Fragonard; see Valogne 1955.

36. "Fragonard jouit de la plus grande réputation, ses

bons dessins se payent au poids de l'or et ils le méritent." Paul Ratouis de Limay, *Un Amateur orléanais au XVIIIe siècle, Aignan-Thomas Desfriches (1715–1800)* (Paris, 1907), 26–27; quoted in Paris-New York 1987–88, 429.

For Desfriches, see the recent monograph by Micheline Cuénin, *Mr Desfriches d'Orléans 1715–1800* (Orléans, 1997).

37. See above, chap. 1, n. 42.

38. Thus, in 1990, Fragonard's drawing *Renaud in the Gardens of Armide,* formerly in the collection of Natoire, sold in Paris for more than 3 million francs.

39. Schnapper, in *David contre David* 1993 (see chap. 1, n. 31), 909–26.

40. "Son atelier devait rapporter 4 à 5000 livres de revenu annuel." Ibid., 913.

41. J. du Seigneur, "Appendice à la notice du P. Chaussard sur L. David," *Revue universelle des arts* 18 (1863–64): 359–69; see also n. 78 below.

42. See Paris-Versailles 1989–90, 534, no. 233.

43. "[ses] dessins et croquis se sont vendus assez chers." Delécluze, *Journal* (see chap. 3, n. 42), 344.

44. Arlette Sérullaz, "David dessinateur," in Paris-Versailles 1989–90, 43.

45. "[Le] dessin le plus capital, et le plus terminé qui ait été fait par M. David." No. 26 in the sale of 17 April 1826.

46. For example, the *Portrait of Joseph Nicolas Barbeau Dubarran* was sold at auction in Strasbourg in 1989 for 4.8 million francs.

47. "La chute de la famille Murat, à Naples, m'a ruiné par des tableaux perdus ou vendus sans être payés . . . Je fus obligé alors d'adopter un genre de dessin (portrait au crayon)." Letter to Gilibert, 7 July 1818; Boyer d'Agen 1909, 35–36.

48. Letter to Gilibert, 1 January 1830; Boyer d'Agen 1909, 221.

49. "Il avait à son chevet deux dessins de moi qu'il avait autrefois acquis dans une vente et qui, à la sienne, viennent de se vendre six fois plus." Letter to Gilibert, 13 May 1825; Boyer d'Agen 1909, 126.

50. *The Comtesse d'Agoult and Her Daughter Claire,* which came directly from the descendants of the sitters, fetched 7 million francs in 1989.

51. *Mémoire des pièces . . .* (see chap. 2, n. 14), 241–54.

52. Inv. 1220E; see Rosenberg and Prat 1994, vol. 1, xi, fig. 1; John A. Gere was the first to point out this drawing, in *Drawings by Raphael and His Circle from British and North American Collections,* exh. cat. (New York: Pierpont Morgan Library, 1987), 82, under no. 16. The drawing in the Uffizi is a copy; the original is in the Ashmolean Museum, Oxford, inv. P II 541.

53. "Chez Watteau, j'ai vu une quantité de projets d'architecture ainsi qu'un livre de fontaines, les premiers au lavis, les autres en sanguine, faits et dessinés par Oppenordt." Tessin, entry of 13 June 1715, in his *Journal,* quoted in Washington, D.C.-Paris-Berlin 1984–85, 24; see also Per Bjurström, *French Drawings: Eighteenth Century* (Stockholm, 1982), after no. 1312; and Carl Nordenfalk, "The Stockholm Watteaus and Their Secret," *Nationalmuseum bulletin* 3, no. 3 (1979): 105–39.

54. One of the paintings by La Fosse bought by Fragonard may well be the one today in the Caen museum (inv. 64.4.1; diam. 101 cm; we thank Françoise Debaisieux for sending us her entry on the painting that will appear in a forthcoming museum catalogue); see also Paris-New York 1987–88, 300.

55. "Un dessin par Wicar, le *Tombeau de Drouais*"; "Un dessin par M. Ingres d'après la Belle Feyronnière, prisé la somme de quatre vingt francs"; "Huit estampes sous verres, paysages d'après le Poussin et sept autres, les *Sept sacrements* d'après le même." Wildenstein and Wildenstein 1973, 236–38, no. 37.

56. Letter from Laurent Laperlier (1805–1878) to the Goncourt brothers dated 19 January 1864, today in the Bibliothèque Nationale de France (9579 N.A.F. 22467, fols. 145–150v. See Pierre Rosenberg, "Ingres et Chardin," *Bulletin du Musée Ingres,* no. 49 (December 1982): 15–18.

57. "[Des] plâtres moulés sur l'antique," "[Des] petits tombeaux étrusques de terre cuite." Meredith Shedd, "Collecting as Knowledge: Ingres' Sculptural Replicas and the Archaeological Discourse of His Time," *Journal of the History of Collections* 4, no. 1 (1992): 67–87.

58. Amaury-Duval's work, which we cite so often, came out in a new edition by Daniel Ternois in 1993.

59. "pour lui tenir les couleurs, les pinceaux et la palette prêts à usage." Sandrart, *L'Academia todesca* (see chap. 3, n. 16), part 2, book 2, chap. 26.

60. Musée Condé, Chantilly, in Chantilly 1994–95, no. 4, color ill.; Maurizio Fagiolo dell'Arco, *Jean Lemaire pittore "antiquario"* (Rome, 1996), no. 42, ill.

61. Ballot de Sovot, *Eloge de Lancret peintre du roi . . . ,* ed. Jules J. Guiffrey (1743; reprint, Paris, n.d.), 18.

62. "Toute liaison fut rompuë . . . et les choses ont subsisté sur ce pied jusqu'à la mort de Watteau." Ibid., 19.

63. "[Pater] trouva un maître d'une humeur trop difficile, et d'un caractère trop impatient pour se pouvoir prêter à la foiblesse et à l'avancement d'un eleve; il fut obligé d'en sortir." Gersaint 1744 (in the entry for *Pater* in the Quentin de Lorangère sale), quoted in Mariette 1851–60, 6:135.

64. "[Il reconnut] qu'il devoit tout ce qu'il savoit à ce peu de tems." Ibid., 6:136.

65. See Paris-New York 1987–88, 223, 227–28.

66. See Rosenberg, "De qui sont les miniatures de Fragonard?" (see chap. 1, n. 29), 66–76.

67. Paris-New York 1987–88, nos. 239, 240, ill.

68. Like Eunice Williams, "Drawings for Collaboration," in *Drawings Defined* (New York, 1987), 280–84, and idem, *"Gens, Honorez Fragonard!": Works from the Collections of Harvard University and Harvard Friends*, exh. cat. (Cambridge, Mass.: Fogg Art Museum, Harvard University, 1993), no. 21, ill., we think that the drawing acquired by the Fogg Art Museum in 1992 is by Fragonard; see also our review of the 1993 exhibition in *Burlington Magazine* 135, no. 1088 (November 1993): 787. For the painting and Fragonard's participation in its execution, see Paris-New York 1987–88, no. 303, color ill.

69. Graphische Sammlung Albertina, Vienna.

70. "Dann setzte sie sich nieder und fingen an eine ganze Stunde zu zeichnen en compagnie anderer Herren, die alle in einem Zirkhel um einem grossen Tisch herumsassen. . . . Endlich, um kurz zu sein, spielte ich auf dem elenden miserablen Pianoforte. Was aber das Argste war, dass die Madame und all die Herren ihr Zeichnen keinen Augenblick unterliessen." Letter to his father, 1 May 1778, in *Wolfgang Amadeus Mozart: Briefe* (Leipzig, 1945), 81.

71. "J'ai dit que je prouverois le tort que les Académies font à l'art qu'elles professent, je tiendrai parole. Douze professeurs par année, c'est-à-dire un pour chaque mois . . . s'empressent à l'envi de détruire les premiers principes qu'un jeune artiste a reçu [*sic*] . . . de son maître . . . le pauvre jeune homme, pour leur complaire alternativement, est obligé de changer douze fois l'année de manière de voir et de faire; et pour avoir appris douze fois l'art, finit par ne rien savoir . . . mais surmonte-t-il, par les rares dispositions qu'il a reçu [*sic*] du ciel, cette mauvaise instruction, oh, c'est alors que l'enfant de tant de pères . . . excite la basse jalousie de tous ses maîtres réunis, pour le perdre. La politique des rois est de maintenir l'équilibre des couronnes, la politique des Académies est de maintenir aussi l'équilibre des talens."

From a speech David gave to the Convention, 8 August 1793; see Wildenstein and Wildenstein 1973, 56.

72. "Seul, Citoyen Ministre, je vaux [*sic*] une académie. Les élèves sortent journellement de mon école, les prix qu'ils remportent annuellement dans les concours publics confirment assés [*sic*] cette vérité. Loin de moi la Modestie dans une affaire de cette importance; il s'agit moins d'un chétif atelier dont on veut me chasser, que de l'envie qu'ont certaines personnes de voir relever les académies." Letter to Chaptal, the minister of the interior, 1 April 1801, quoted in Paris-Versailles 1989–90, 599.

Delécluze (1855, 19–22) described the studio as it was in 1796 (although he was writing "57 years" later): "This studio overlooked the esplanade of the Louvre under the great colonnade; on the side walls were placed, at left on entering, the painting of the Horatii and at right that of Brutus. The furnishings were faithfully copied from the antique and executed by the most skillful cabinetmaker of the time, Jacob, after drawings by David and Moreau" ("Cet atelier donnait sur l'esplanade du Louvre sous la grande colonnade, sur les parois latérales étaient placés, à gauche en entrant le tableau des Horaces et à droite celui de Brutus. Le mobilier avait été fidèlement imité de l'antique et exécuté par le plus habile ébéniste de ce temps, Jacob, d'après les dessins de David et de Moreau").

73. "Il n'y a pas à proprement parler de manière dominante, les élèves dessinent indifféremment sur du papier de couleur ou blanc; celui-ci est cependant plus généralement en usage; nous massons avec du crayon notre figure au fur et à mesure, mais solidement . . . M. David aime que le dessin soit gras et moelleux, il n'aime pas les petits détails." Letter from Pierre-Théodore Suau (1786–1855), who came from Toulouse, to his father, Jean (1755–1841), 1 December 1811, published in Paul Mesplé, "David et ses élèves toulousains," *Archives de l'art français: Les Arts à l'époque napoléonienne* 24 (1969): 95; quoted in Wildenstein and Wildenstein 1973, 185.

74. "Il ne veut pas entendre parler de dessins finis; il ne veut autre chose que de petits croquis dans le genre de ceux que vous faites d'après nature. Nous les arrêtons davantage parce que nous employons une séance pour chacun, c'est-à-dire que le modèle change tous les jours de pose; dans un mois, deux semaines sont consacrées à l'antique et deux au modèle vivant." Letter of 8 November 1812, in Mesplé, "David et ses élèves" (see n. 73 above), 95–96; quoted in Wildenstein and Wildenstein 1973, 192.

75. "le bon et honnête Grandin," "il n'avait ni dispo-

sition comme peintre ni esprit comme homme." Delécluze 1855, 68.

76. "Messieurs . . . est-ce que c'est le 30? Voilà Grandin!" Ibid.

77. "Ma foi, mon bon ami, il faut que je l'avoue; *je ne me connais pas à cette peinture-là,*" "Ah ça! Il est fou Girodet . . . Ce sont des personnages de cristal qu'il nous faits [*sic*] là . . . Quel dommage! avec son beau talent." Ibid., 266; the painting had been commissioned in 1800 for Malmaison.

78. "Le maître a quelquefois éloigné de l'atelier des Élèves dont les dispositions lui paraissaient purement manuelles . . . M. David ne cesse donc pas de répéter que l'exécution n'est rien, que la pensée est tout" (p. 166); it is now known that the author of *Pausanias français* is definitely Pierre-Jean-Baptiste Chaussard.

79. Schnapper, in Paris-Versailles 1989–90, 119, 166.

80. He appears only in the second drawn version, in the Louvre, begun in 1840 and finished in 1865.

81. "David établit son enseignement sur les principes les plus vrais, les plus sévères et les plus purs," "David a été le seul maître de notre siècle." Quoted in Delaborde 1870, 22, and Amaury-Duval 1924, 209.

82. There was, in fact, "a studio for the young ladies and one for the gentlemen" ("un atelier pour les demoiselles et un pour les garçons"); for Ingres's studio, see Boyer d'Agen 1909, 310ff.

83. Amaury-Duval 1924, 47.

84. Ibid., 56.

85. "Ce qui est vrai de sa personne ne l'est pas moins de son caractère, qui a conservé un fonds d'honnêteté rude qui ne transige jamais avec rien d'injuste et de mal. . . . Dans l'école il était un des plus studieux, et cette disposition, jointe à la gravité de son caractère et au défaut de cet éclat de pensée que l'on appelle esprit en France." Delécluze 1855, 84.

CHAPTER 6

1. "La couleur détruit le dessin," "la couleur efface le dessin," "le dessin combat toujours la couleur." Alain, *Ingres,* Collection Les Demi-dieux (Paris, 1949), [1, 7].

2. Paris 1994–95, no. 189.

3. These could be compared with the lovely gray washes that Greuze used for his drawings.

4. "Tu fais passer le dessin après la couleur. Eh bien, mon cher ami, c'est mettre la charrue avant les boeufs." Delécluze 1855, 60.

5. "Le dessin comprend tout, excepté la teinte." Delaborde 1870, 123.

6. "Il faut faire disparaître les traces de la facilité." Ibid., 125. Jean Cocteau said on this subject, "The more talented a man is, the more he masters himself, the more he fights against this gift, which predisposes his ink to run too fast, the more he strives to subdue and contain it" ("Plus un homme est doué, plus il se surmonte, plus il lutte contre ce don qui prédispose son encre à couler trop vite, plus il s'efforce de la dompter et de la contenir"). *Poésie critique,* vol. 2, *Monologues* (Paris, 1960), 94.

7. Etienne Gilson, *Painting and Reality: The A. W. Mellon Lectures in the Fine Arts for 1955,* Bollingen Series, vol. 35, no. 4 (Princeton, 1957). The expanded and revised French edition is cited here: *Peinture et réalité* (Paris, 1958), 33.

8. Ibid.

9. Sutherland Harris, in Paris 1994–95 (see chap. 3, n. 28), 38.

10. See Washington, D.C.-Paris-Berlin 1984–85, no. 69, especially for the interpretation of the subject of *Pierrot (Gilles).*

11. "Je ne saurais trop vous le répéter, le mouvement c'est la vie." Delaborde 1870, 124.

12. Ternois 1971, 7. It should be remembered, however, that Ingres drew from the model and painted from his drawings.

13. We will not go back to the question of the male nude academy, already treated above (chap. 1, n. 3); its study was obligatory for every future artist.

14. "L'indécence . . . consistait en ce que la déesse, dormant ou faisant semblant de dormir, levait une jambe qui découvrait trop le nu du siège de l'amour." Loménie de Brienne, "Discours sur les ouvrages des plus excellens peintres . . . ," manuscript (1693–95), published in Thuillier 1994, 44.

15. "Feminine" as opposed to "virile"; see Rosenberg and Prat 1994, vol. 1, nos. 96, 98, 99.

16. "l'impureté même chez lui n'a ni ordure, ni dégoût, ni honte." Goncourt and Goncourt 1865, 144.

17. For Ingres's erotic drawings, see José Cabanis, "J. D. Ingres," *Essais,* no. 2 (1967): 56–66; and Georges Vigne, *Les Dessins érotiques de Monsieur Ingres* (Toulouse, 1997).

18. See the exhibition catalogue *Corot* (Paris: Grand Palais; Ottawa: National Gallery of Canada; New York: Metropolitan Museum of Art), no. 85, pp. 256–57, ill.

19. Clearly, this has nothing to do with progress.

20. "bavard du dessin." Goncourt and Goncourt 1865.

21. Today, nine portrait drawings that belong to this series are known. David had been imprisoned—this time, in the Quatre-Nations (today's Institut de France), not, as previously, in the Luxembourg—on 30 May 1795, with eight Montagnard representatives, but other Montagnard deputies apparently preceded them.

22. "Il était plus content de ses dessins que de ses tableaux." Gersaint 1747; see Rosenberg 1984, 44; and above, p. 31 (chap. 2, n. 21).

23. "rien n'est au-dessus," "Il passera toujours pour un des plus grands et des meilleurs dessinateurs que la France ait donnés," "Ses tableaux se ressentent un peu de l'impatience et de l'inconstance qui formaient son caractère." Gersaint 1744; see Rosenberg 1984, 40.

24. "Mais sa réputation est aujourd'hui fort déchue," "Il faut beaucoup rabattre de cet éloge." Anonymous, 1746; see Rosenberg 1984, 41–42.

25. Hans Naef, "Ingres dessinateur de portraits," introduction to Paris 1967–68, xix. Even though we disagree with Naef on this issue, our admiration for him is complete; his research on Ingres is exemplary.

26. Sutherland Harris, in Paris 1994–95 (see chap. 3, n. 28), 40.

27. "Quand il dessinoit il ne songeoit qu'à fixer ses idées." Catalogue of the Crozat sale, 1741, 114.

28. "J'ai fait une nouvelle composition pour la chute de saint Paul, m'étant venue une autre pensée que la première." Letter to Chantelou, 25 November 1658 (see also the letter of 22 December 1647, quoted above, p. 30 (chap. 2, n. 15); Jouanny 1911, 449.

29. "Watteau pensait profondément," "[il] pense mieux qu'il ne peut exécuter." Caylus 1748; see Rosenberg 1984, 72; and above, pp. 80–81, and chap. 3, n. 35. Caylus's contradictory statement further on, that Watteau "drew without a purpose," should be ignored in favor of this assertion.

30. "Dans les discours de David, l'art n'est donc présenté que comme une des branches de l'instruction publique." Delécluze 1855, 176.

31. "Le plus long pour un bon peintre est de *penser* en tout son tableau, de l'avoir pour ainsi dire dans sa tête, afin de l'exécuter ensuite avec chaleur et comme d'une seule venue." Delaborde 1870, 93.

32. "Depuis un bon moment, Ingres est arrêté sur le trottoir, à l'angle des rues d'Assas et Vavin; immobile, il suit d'un regard captivé le va-et-vient du large pinceau imbibé de couleur brunâtre, qu'un peintre en bâtiment promène, d'un geste égal et rythmé, sur les boiseries de la devanture d'un épicier. 'Eh! cher maître, que faites-vous là?' demande, venant à passer et assez intrigué, son confrère de l'Institut Signol. Pour toute réponse, Ingres, montrant l'ouvrier: 'Voyez, dit-il, et admirez comme moi: il en prend et en met *juste ce qu'il faut.*'" Jules Laurent, *La Légende des ateliers,* 292 of the annotated manuscript at the Imguimbertine Library of Carpentras, which we quote here (also quoted in Amaury-Duval 1924, 203, with a transcription slightly different from the manuscript).

33. "Comme peintre, son influence en France était devenue nulle," "La plupart des artistes de la nouvelle École ne comprendraient pas plus ses discours que ses ouvrages." Delécluze, *Journal* (see chap. 3, n. 42), 119, 294.

34. See the recent exhibition catalogue *The Private Collection of Edgar Degas* (New York: Metropolitan Museum of Art, 1997–98), vol. 2, nos. 615–736.

35. Quoted in Paris-New York 1987–88, 421 (introduction to the Varanchan de Saint-Geniès sale, 29–31 December 1777).

Selected Bibliography

Amaury-Duval 1878, 1924, 1993
Amaury-Duval, Eugène-Emmanuel [Eugène-Emmanuel Amaury Pineu-Duval]. *L'Atelier d'Ingres.* Paris, 1878. Reprint, edited by Elie Faure, Paris, 1924. Rev. ed., edited by Daniel Ternois, Paris, 1993.

Ananoff 1961–70
Ananoff, Alexandre. *L'Oeuvre dessiné de Jean-Honoré Fragonard (1732–1806): Catalogue raisonné.* 4 vols. Paris, 1961–70.

Bayonne 1994–95
Bayonne, Musée Bonnat. *Nicolas Poussin (1594–1665): La Collection du Musée Bonnat à Bayonne.* Catalogue by Pierre Rosenberg and Louis-Antoine Prat.

Bellori 1672, 1976
Bellori, Giovanni Pietro. *Le Vite de' pittori, scultori ed architetti moderni.* Rome, 1672. Reprint, edited by Evelina Borea, with preface by Giovanni Previtali, Turin, 1976.

Bergeret 1895, 1948
Bergeret de Grancourt, Pierre-Jacques-Onésyme. "Bergeret et Fragonard: Journal inédit d'un voyage d'Italie 1773–74." In Albert Tornézy, *Bulletin et mémoires de la Société des antiquaires de l'Ouest 1894* 17 (1895). Abridged ed., annotated by Jacques Wilhelm, Paris, 1948.

Blunt 1964, 1989
Blunt, Anthony. *Nicolas Poussin: Lettres et propos sur l'art.* Paris, 1964. Reprint, with preface by Jacques Thuillier and postscript by Avigdor Arikha, Paris, 1989.

Blunt 1967
Blunt, Anthony. *Nicolas Poussin: The A. W. Mellon Lectures in the Fine Arts 1958.* 2 vols. New York, 1967.

Blunt 1974
Blunt, Anthony. "Newly Identified Drawings by Poussin and His Followers." *Master Drawings* 12, no. 3 (1974): 760–63.

Blunt 1979
Blunt, Anthony. "Further Newly Identified Drawings by Poussin and His Followers." *Master Drawings* 17, no. 2 (1979): 119–46.

Blunt 1979
Blunt, Anthony. *The Drawings of Poussin.* New Haven and London, 1979.

Bordes 1983
Bordes, Philippe. *"Le Serment du Jeu de Paume" de Jacques-Louis David: Le Peintre, son milieu et son temps, de 1789 à 1792.* Paris, 1983.

Boyer d'Agen 1909
Boyer d'Agen, Auguste-Jean [Boyé, Auguste-Jean], ed. *Ingres d'après une correspondance inédite.* Paris, 1909.

Camesasca and Rosenberg 1982
Camesasca, Ettore, and Pierre Rosenberg. *Tout l'oeuvre peint de Watteau.* Paris, 1982.

Caylus 1748
Caylus, Anne-Claude-Philippe, comte de. "La Vie d'Antoine Watteau: Peintre de figures et de paysages; Sujets galants et modernes." Lecture delivered at the Académie Royale, 3 February 1748. *See* Rosenberg 1984.

Chantilly 1994–95
Chantilly, Musée Condé. *Nicolas Poussin (1594–1665): La Collection du Musée Condé à Chantilly.* Catalogue by Pierre Rosenberg and Louis-Antoine Prat.

***Correspondance des directeurs* 1901**
Correspondance des directeurs de l'Académie de France à Rome avec les surintendants des bâtiments. Edited by Anatole de Montaiglon and Jules Guiffrey. Vol. 11

(1754–63). Paris, 1901. From manuscripts in the Archives Nationales, Paris.

Dacier and Vuaflart 1921–29
Dacier, Emile, and Albert Vuaflart, with Jacques Hérold. *Jean de Jullienne et les graveurs de Watteau au XVIIIe siècle.* 4 vols. Paris, 1921–29.

David 1880–82
David, Jules-Louis. *Le Peintre Louis David 1748–1825: Souvenirs et documents inédits.* 2 vols. Paris, 1880–82.

David contre David **1993**
Michel, Régis, ed. *David contre David.* Proceedings of a symposium held at the Musée du Louvre, Paris, 1989. 2 vols. Paris, 1993. Some of the essays were published in *Atti della "Natio Francorum,"* 2 vols., Bologna, 1993, in Italian, following the symposium held in Bologna in 1989.

Delaborde 1870
Delaborde, Henri, comte. *Ingres, sa vie, ses travaux, sa doctrine, d'après les notes manuscrites et les lettres du maître.* Paris, 1870.

Delécluze 1855, 1983
Delécluze, Etienne-Jean. *Louis David, son école et son temps.* Paris, 1855. Reprint, edited by Jean-Pierre Mouilleseaux, Paris, 1983.

Dezallier d'Argenville 1745, 1762
Dezallier d'Argenville, Antoine-Joseph. *Abrégé de la vie des plus fameux peintres. . . .* 2 vols. Paris, 1745. Rev. ed., 4 vols., Paris, 1762.

Fort Worth 1988
Fort Worth, Kimbell Art Museum. *Poussin: The Early Years in Rome: The Origins of French Classicism.* Catalogue by Konrad Oberhuber.

Fragonard 1847
Fragonard, Théophile. Letter from Théophile Fragonard to Théophile Thoré, 9 October 1847. *See* Valogne 1955.

Friedlaender and Blunt 1939–74
Friedlaender, Walter, and Anthony Blunt, eds. *The Drawings of Nicolas Poussin.* 5 vols. London, 1939–74. Vol. 1, 1939; 2, 1949; 3, 1953; 4, 1963; 5, 1974.

Germer 1994
Germer, Stefan, ed. *Vies de Poussin: Bellori, Félibien, Passeri, Sandrart.* Paris, 1994.

Gersaint 1744
Gersaint, Edme-François. "Abrégé de la vie d'Antoine Watteau." In *Catalogue raisonné des diverses curiosités du Cabinet de Feu M. Quentin de Lorengère,* 172–88. Paris, 1744. *See* Rosenberg 1984.

Gersaint 1747
Gersaint, Edme-François. Writings in *Catalogue raisonné des bijoux, porcelaines, bronzes . . . de M. Angran, Vicomte de Fonspertuis,* 261–66. Paris, 1747. *See* Rosenberg 1984.

Goncourt 1875
Goncourt, Edmond de. *Catalogue raisonné de l'oeuvre peint, dessiné et gravé d'Antoine Watteau.* Paris, 1875.

Goncourt and Goncourt 1860
Goncourt, Edmond, and Jules de Goncourt. *L'Art du dix-huitième siècle.* Paris, 1860.

Goncourt and Goncourt 1865
Goncourt, Edmond, and Jules de Goncourt. "Fragonard." *Gazette des beaux-arts* (January 1865): 32–41; (February 1865): 132–62.

Jouanny 1911
Jouanny, Charles. "Correspondance de Nicolas Poussin." *Archives de l'art français, nouvelle période* 5 (1911). Reprint, Paris, 1968.

Jullienne 1726
Jullienne, Jean de. *Abrégé de la vie d'Antoine Watteau. . . . 1726.* Introduction to *Figures de différents caractères. See* Rosenberg 1984.

London-Washington, D.C.-New York 1999–2000
London, National Gallery; Washington, D.C., National Gallery of Art; New York, The Metropolitan Museum of Art. *Portraits by Ingres: Image of an Epoch.* Catalogue by Philip Conisbee, Andrew Carnington Shelton, Hans Naef, Christopher Riopelle, and Gary Tinterow.

Lugt 1921
Lugt, Frits. *Les Marques de collections de dessins et d'estampes. . . .* Amsterdam, 1921. *Supplément.* The Hague, 1956.

Mariette 1851–60
Mariette, Pierre-Jean. *Abecedario de P.J. Mariette. . . .* Edited by Philippe de Chennevières and Anatole de Montaiglon. 6 vols. Paris, 1851–60.

Naef 1977–80
Naef, Hans. *Die Bildniszeichnungen von J.-A.-D. Ingres.* 5 vols. Bern, 1977–80.

Nicolas Poussin **1996**
Mérot, Alain, ed. *Nicolas Poussin 1594–1665.* Proceedings of a symposium held at the Musée du Louvre, Paris, 1994. 2 vols. Paris, 1996.

Papiers d'Ingres
Bulletin published by the Musée Ingres, Montauban, on the occasion of temporary exhibitions that display the museum's Ingres bequest. 20 issues to date.

Paris 1967–68
Paris, Petit Palais. *Ingres.* Catalogue by Lise Duclaux, Jacques Foucart, Hans Naef, Maurice Sérullaz, and Daniel Ternois.

Paris 1994–95
Paris, Galeries Nationales du Grand Palais. *Nicolas Poussin 1594–1665.* Catalogue by Pierre Rosenberg and Louis-Antoine Prat.

Paris-Cleveland-Boston 1979
Paris, Grand Palais; Cleveland Museum of Art; Boston, Museum of Fine Arts. *Chardin 1699–1779.* Catalogue by Pierre Rosenberg. French and English editions.

Paris-New York 1987–88
Paris, Galeries Nationales du Grand Palais; New York, The Metropolitan Museum of Art. *Fragonard.* Catalogue by Pierre Rosenberg. French and English editions.

Paris-Versailles 1989–90
Paris, Musée du Louvre; Versailles, Musée National du Château. *Jacques-Louis David 1748–1825.* Catalogue by Antoine Schnapper and Arlette Sérullaz.

Parker and Mathey 1957
Parker, Karl Theodor, and Jacques Mathey. *Antoine Watteau: Catalogue complet de son oeuvre dessiné.* 2 vols. Paris, 1957.

Passeri 1772, 1934, 1976
Passeri, Giovanni Battista. *Vite de' pittori, scultori ed architetti che hanno lavorato in Roma morti dal 1641 al 1673.* Written before 1678; exists in various manuscript forms. Rome, 1772. Reprint, Milan, 1976. In German: *Die Künstlerbiographien von Giovanni Battista Passeri.* Edited by Jacob Hess. Leipzig and Vienna, 1934.

Poussin et Rome 1996
Bonfait, Olivier, ed. *Poussin et Rome.* Proceedings of a symposium held at the Académie de France, Rome, 1994. Paris, 1996.

Rosenberg 1983
Rosenberg, Pierre. *Tout l'oeuvre peint de Chardin.* Paris, 1983.

Rosenberg 1984, 1991
Rosenberg, Pierre. *Vies anciennes de Watteau.* Paris, 1984. In Italian: Rev. ed. Bologna, 1991. These texts first appeared in Pierre Champion, *Notes critiques sur les vies anciennes d'Antoine Watteau.* Paris, 1921.

Rosenberg 1989
Rosenberg, Pierre. *Tout l'oeuvre peint de Fragonard.* Paris, 1989.

Rosenberg 1995
Rosenberg, Pierre. "Les Dessins de Watteau." In *Japan and Europe in Art History.* Tokyo, 1995. Symposium held in Tokyo, 1991.

Rosenberg and Brejon de Lavergnée 1986
Rosenberg, Pierre, and Barbara Brejon de Lavergnée. *Saint-Non, Fragonard: Panopticon italiano, un diario di viaggio ritrovato 1759–1761.* Rome, 1986.

Rosenberg and Prat 1994
Rosenberg, Pierre, and Louis-Antoine Prat. *Nicolas Poussin, 1594–1665: Catalogue raisonné des dessins.* 2 vols. Milan, 1994.

Rosenberg and Prat 1996
Rosenberg, Pierre, and Louis-Antoine Prat. *Antoine Watteau, 1684–1721: Catalogue raisonné des dessins.* 3 vols. Milan, 1996.

Rosenberg and Prat forthcoming
Rosenberg, Pierre, and Louis-Antoine Prat. *Jacques-Louis David, 1748–1825: Catalogue raisonné des dessins.* 2 vols. Milan, forthcoming.

Rouen 1961
Rouen, Musée des Beaux-Arts. *Poussin et son temps: Le Classicisme français et italien contemporain de Poussin.* Catalogue by Pierre Rosenberg.

Sérullaz 1991
Sérullaz, Arlette. *Musée du Louvre, Cabinet des dessins: Dessins de Jacques-Louis David, 1748–1825.* Inventaire général des dessins; École française, Paris, 1991.

Ternois 1959
Ternois, Daniel. *Les dessins d'Ingres au Musée de Montauban: Les Portraits.* Inventaire général des dessins des Musées de province. Vol. 3. Paris, 1959.

Ternois 1971
Ternois, Daniel. *Ingres: Tout l'oeuvre peint.* Paris, 1971. In Italian: Milan, 1968.

Thibaudeau
Thibaudeau, Antoine [pseud., A. Th.]. *Vie de David, premier peintre de Napoléon.* Brussels, 1826.

Thuillier 1994
Thuillier, Jacques. *Nicolas Poussin.* Paris, 1994. With

updated catalogue of *Tout l'oeuvre peint de Poussin,*
Paris, 1974.

Valogne 1955

Valogne, Catherine. "Fragonard, mon grand-père,
par Théophile Fragonard." *Les Lettres françaises,*
17 February 1955, 1, 9. Letter from Théophile Frago-
nard, grandson of Jean-Honoré, to Théophile Thoré,
9 October 1847.

Vigne 1995

Vigne, Georges. *Dessins d'Ingres: Catalogue raisonné
des dessins du Musée de Montauban.* Paris, 1995.

Washington, D.C.-Paris-Berlin 1984–85

Washington, D.C., National Gallery of Art; Paris,
Galeries Nationales du Grand Palais; Berlin, Schloss
Charlottenburg. *Watteau 1684–1721.* Catalogue by
Pierre Rosenberg, Margaret Morgan Grasselli, and
Nicole Parmantier. English, French, and German
editions.

Wild 1980

Wild, Doris. *Nicolas Poussin.* 2 vols. Zurich, 1980.

Wildenstein 1956

Wildenstein, Georges. *Fragonard aquafortiste.* Etudes
et documents pour servir à l'histoire de l'art français
du dix-huitième siècle. Paris, 1956.

Wildenstein and Wildenstein 1973

Wildenstein, Daniel, and Guy Wildenstein. *Louis
David: Recueil de documents complémentaires au cata-
logue complet de l'oeuvre de l'artiste.* Paris, 1973.

Index

Photography Credits

The A. W. Mellon Lectures in the Fine Arts

Delivered at the National Gallery of Art, Washington, D.C.

1952 Jacques Maritain, *Creative Intuition in Art and Poetry*

1953 Sir Kenneth Clark, *The Nude: A Study of Ideal Form*

1954 Sir Herbert Read, *The Art of Sculpture*

1955 Etienne Gilson, *Art and Reality*

1956 E. H. Gombrich, *The Visible World and the Language of Art*

1957 Sigfried Giedion, *Constancy and Change in Art and Architecture*

1958 Sir Anthony Blunt, *Nicolas Poussin and French Classicism*

1959 Naum Gabo, *A Sculptor's View of the Fine Arts*

1960 Wilmarth Sheldon Lewis, *Horace Walpole*

1961 André Grabar, *Christian Iconography and the Christian Religion in Antiquity*

1962 Kathleen Raine, *William Blake and Traditional Mythology*

1963 Sir John Pope-Hennessy, *Artist and Individual: Some Aspects of the Renaissance Portrait*

1964 Jakob Rosenberg, *On Quality in Art: Criteria of Excellence, Past and Present*

1965 Sir Isaiah Berlin, *The Roots of Romanticism*

1966 Lord David Cecil, *Dreamer or Visionary: A Study of English Romantic Painting*

1967 Mario Praz, *On the Parallel of Literature and the Visual Arts*

1968 Stephen Spender, *Imaginative Literature and Painting*

1969 Jacob Bronowski, *Art as a Mode of Knowledge*

1970 Sir Nikolaus Pevsner, *Some Aspects of Nineteenth-Century Architecture*

1971 T. S. R. Boase, *Vasari: The Man and the Book*

1972 Ludwig H. Heydenreich, *Leonardo da Vinci*

1973 Jacques Barzun, *The Use and Abuse of Art*

1974 H. W. Janson, *Nineteenth-Century Sculpture Reconsidered*

1975 H. C. Robbins Landon, *Music in Europe in the Year 1776*

1976 Peter von Blanckenhagen, *Aspects of Classical Art*

1977 André Chastel, *The Sack of Rome: 1527*

1978 Joseph W. Alsop, *The History of Art Collecting*

1979 John Rewald, *Cézanne and America*

1980 Peter Kidson, *Principles of Design in Ancient and Medieval Architecture*

1981 John Harris, *Palladian Architecture in England, 1615–1760*

1982 Leo Steinberg, *The Burden of Michelangelo's Painting*

1983 Vincent Scully, *The Shape of France*

1984 Richard Wollheim, *Painting as an Art*

1985 James S. Ackerman, *The Villa in History*

1986 Lukas Foss, *Confessions of a Twentieth-Century Composer*

1987 Jaroslav Pelikan, *Imago Dei: The Byzantine Apologia for Icons*

1988 John Shearman, *Art and the Spectator in the Italian Renaissance*

1989 Oleg Grabar, *Intermediary Demons: Toward a Theory of Ornament*

1990 Jennifer Montagu, *Gold, Silver, and Bronze: Metal Sculpture of the Roman Baroque*

1991 Willibald Sauerländer, *Changing Faces: Art and Physiognomy through the Ages*

1992 Anthony Hecht, *On the Laws of the Poetic Art*

1993 Sir John Boardman, *The Diffusion of Classical Art in Antiquity*

1994 Jonathan Brown, *Kings and Connoisseurs: Collecting Art in Seventeenth-Century Europe*

1995 Arthur C. Danto, *After the End of Art: Contemporary Art and the Pale of History*

1996 Pierre Rosenberg, *From Drawing to Painting: Poussin, Watteau, Fragonard, David, and Ingres*

1997 John Golding, *Paths to the Absolute*

1998 Lothar Ledderose, *Ten Thousand Things: Module and Mass Production in Chinese Art*

1999 Carlo Bertelli, *Transitions*